Mucha

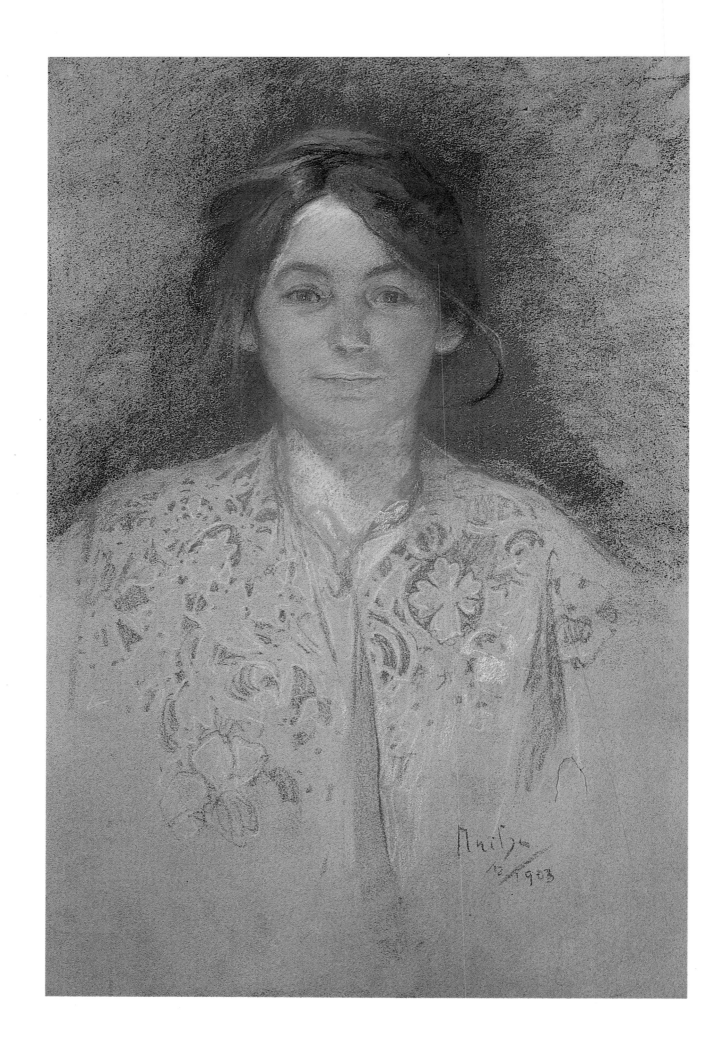

THE TRIUMPH
OF ART NOUVEAU

Mucha

ARTHUR ELLRIDGE

Cover:

Summer
1896
Decorative panel

Frontispiece:

Maruska
1903
Pastel on paper
28 $\frac{3}{8}$ × 19 $\frac{5}{8}$ in. (72 × 50 cm)

Opposite:

Self-portrait
1907
Oil on cardboard
17 $\frac{1}{4}$ × 11 $\frac{1}{4}$ in. (44 × 28.5 cm)

Following page:

Sarah Bernhardt
1903
Detail of a poster for LU Biscuits

Editors: Jean-Claude Dubost and Jean-François Gonthier
Cover design: Gérard Lo Monaco and Laurent Gudin
Art director: Bernard Girodroux
English adaptation: Frances Wister Faure with Eugène Clarence Braun-Munk
Typesetting: Targa
Filmsetting: Compo Rive Gauche
Photoengraving: Litho Service T. Zamboni, Verona

© FINEST SA / ÉDITIONS PIERRE TERRAIL, PARIS 1992
The Art Book Subsidiary of BAYARD PRESSE SA
English edition: © 1992
Publisher's number: 259
ISBN 2-87939-006-0
Printed in Italy

Published with the assistance of the French Ministry responsible for culture
Centre National du Livre (The National Book Centre)

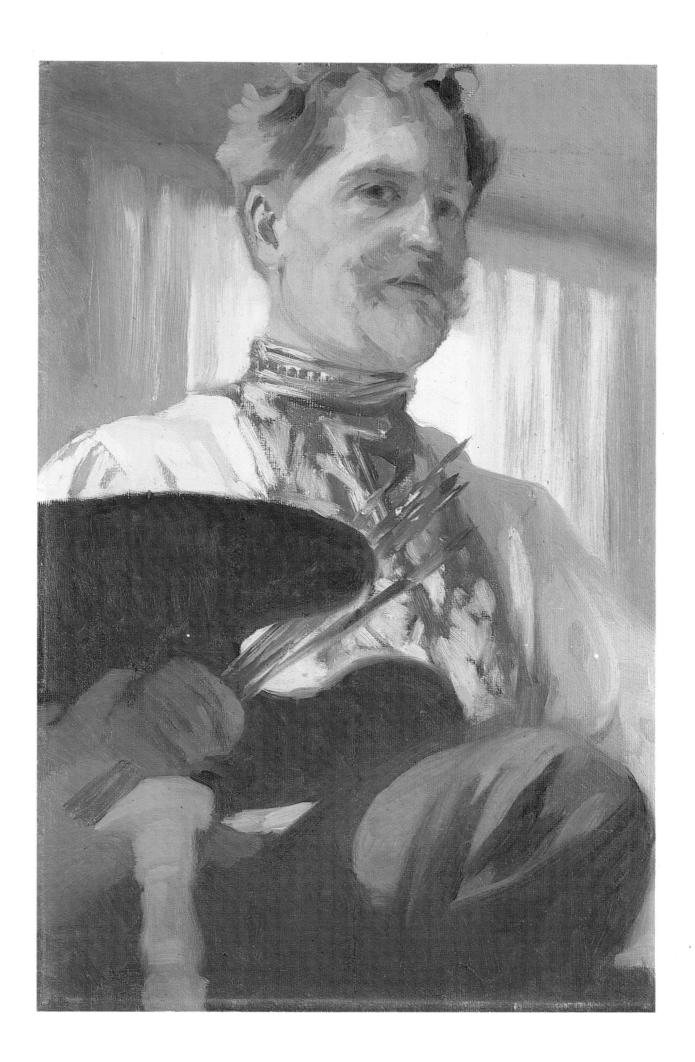

CONTENTS

I

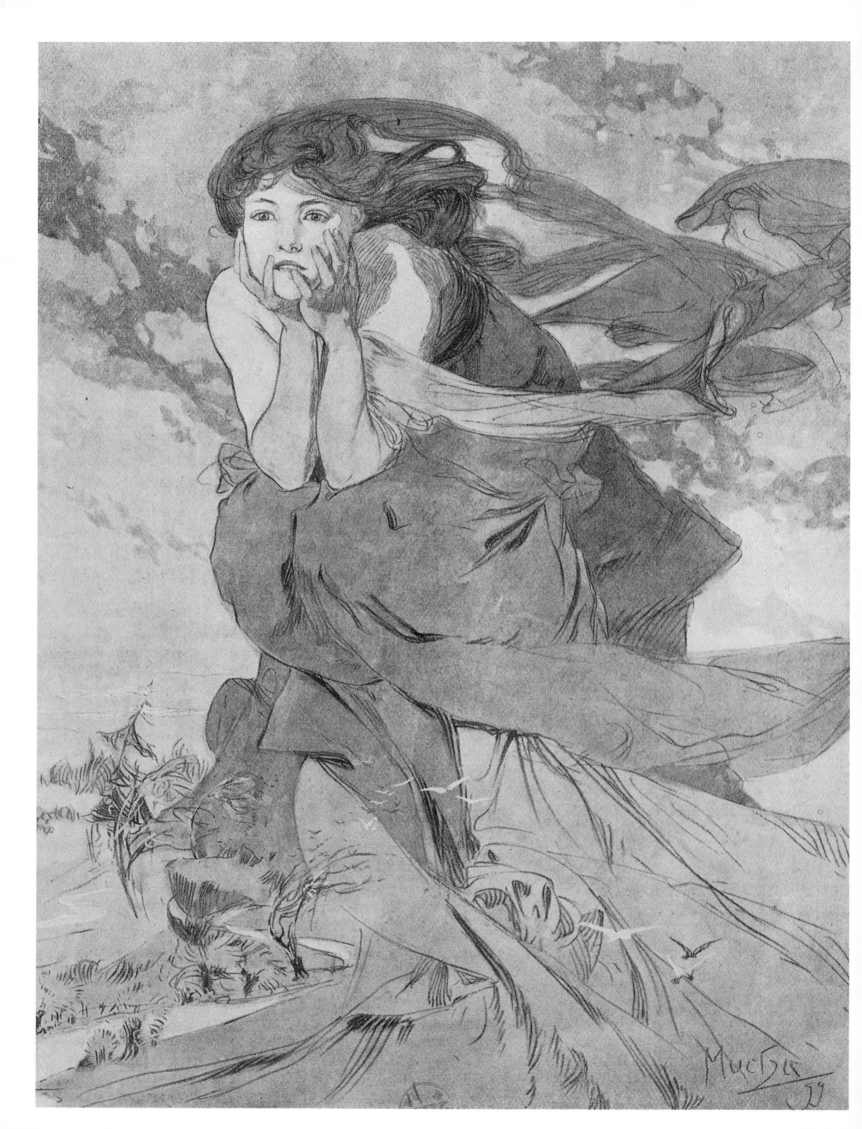

I

AN ARDENT ARTIST

AND FERVENT CZECH

Alphonse Mucha was born on July 24, 1860 in Ivancice, a small town in Southern Moravia. In those days this region (part of the Czech Republic today) belonged to the Austro-Hungarian Empire.

In the early 19th century the reigning Habsburgs replaced the name Holy Roman Empire, dating from the Middle Ages, with the more appropriate Austro-Hungarian Empire. Although it reached over all of Central Europe and a great part of Eastern Europe and Italy, this monarchy was no longer what it had been in the 16th century under the reign of Charles the Vth, who liked to say that the sun never set on his lands. In 1859, when France took the side of the Italian insurgents, the Austro-Hungarian Empire lost Milan, Florence and Parma, Northern Italy's most prosperous cities. Five years later, the Austrians, defeated by the Prussians at Sadowa (also in the Czech Republic today), were forced to abandon Venice and the Veneto. Mucha, then only six years old, was destined to grow up in a country facing even greater decline.

Mucha's birthplace was one of the strongholds of the rebellious disciples of Jan Hus (1369-1415), the Hussites. This early religious reformer, burned at the stake for heresy, stirred up a kind of nationalism, blending religion and patriotism. However, patriotic sentiment in that part of Europe was repeatedly thwarted by foreign rule. In 1620, a growing bitterness towards the Habsburgs prevailed in all of Bohemia and Moravia, and the Czechs rebelled again. The

The "Home Decor"
1894
Advertisement representing a decorative
panel in two sizes, sold by an interior
decorating store.

Opposite:
The Judgment of Paris
1895
Calendar
12³/₄ x 19⁵/₈ in. (32.5 x 50 cm)

insurgents fell victim to savage repression following the bloody Battle of the White Mountain. Towards the middle of the 18th century, Germanization and centralization increased in these regions to a degree that German was the only language taught in school. As a result, the Czechs lost what little autonomy they had.

Nevertheless, this was the Age of Enlightenment. In 1781, the Habsburg Emperor, Joseph II, influenced by this philosophical trend, permitted private religious practice and abolished serfdom. This relative emancipation, accompanied by the Industrial Revolution, brought profound modification to social structures and strengthened patriotic sentiment. The Society of Sokols, founded in 1862, gave vent to the same desires. This pan-Slavic Movement set up centers across the country to reinforce national and democratic ideas among Czech youth through physical training and gymnastics. Such was the atmosphere of Mucha's childhood in rural Moravia.

Meanwhile, Vienna, the capital of the Empire, was drowning its fears of decline in a frenzy of creation, intense intellectual activity and a social whirl. All this excitement took place in a thoroughly neurotic climate that surely fostered the development of psychoanalysis. The conflicting tendencies were aggravated by the final break up of the Empire after the First World War. The city's brilliant reputation and intellectual and artistic prestige during the *Belle Epoque* attracted people from all over the world. Within the Empire, it tempted the social climber as well as those in search of culture. As a young man, Mucha could not resist the fascination of this lively, cosmopolitan playground. Although many of his posters celebrating the ambient *joie de vivre* were soon to decorate the streets of Europe and America, the artist did not abandon his religious beliefs or his patriotism. Indeed, these characteristics inspired a large portion of pictorial work throughout his career.

Mucha's parents belonged to the lower middle class. His father worked as an usher at the Ivancice courthouse and his duties entailed accompanying petty criminals from the jail to the court room. He was a widower with three children and in 1858 remarried an exceptionally well-educated woman of thirty five who also bore him three children. Alphonse-Marie, a son of this second union, was not the easiest to raise. At a very young age he showed an extravagant enthusiasm for drawing and would amuse his friends with caricatures and portraits, but his precocious talent did not impress his teachers; in school he was considered a mediocre student, uninterested in his studies. Like most Czech boys Alphonse learned to play the violin, performed the duties of an altar boy and sang in the school choir. Later he paid for his own schooling by singing at the

VIEILLEMARD
ET SES FILS
IMPRIMEURS PARIS

Mucha

13

Saint Cyril and Saint Methodius
One of Mucha's first canvases, hanging in
the church in Pisek, North Dakota (USA).

Opposite:
The Twelve Months:
December
1899
For the magazine *Cocorico*
Pencil, wash and white gouache
15³/₄ x 11³/₄ in. (40 x 30 cm)

Baroque cathedral of St. Peter in Brno, some forty miles from
his home. Since Alphonse's religious faith seemed fervent and
sincere, his father even considered sending him to a seminary.
One meeting with the cleric in charge of admissions was
enough to persuade him that the young man in question was
not meant for the priesthood.

Afterwards, his father found him a position as registrar
at the court where he worked. Alphonse, however, as talented

The Twelve Months:
February
1899
For the magazine *Cocorico*
Pencil and wash on paper
15¾ x 11¾ in. (40 x 30 cm)

Opposite:
Four Drawings
1899
Red chalk on gray paper

at calligraphy as he was at drawing, took it into his head to adorn the court registers with portraits and caricatures of plaintiffs and defendants, which, considering the circumstances, was hardly fitting. Alphonse was asked not to return and no one knows what became of these portrayals of late 19th-century Moravians.

FROM ARTISAN TO ARTIST

At the age of 19, Mucha answered a classified newspaper advertisement placed by the firm of Kautsky-Briochi-Burghardt, designers of theatrical scenery in Vienna. He was hired by return mail as an apprentice painter. In this new position, he discovered not only applied art, but all the intense life of a great city. In his humble birthplace, the decoration of walls of churches and other public places brought no more consideration than merely painting them; an artist was still only an artisan. In Vienna, on the contrary, a painter could become an accepted member of society and even one of its idols, once his talent was recognized.

Mucha never had to adopt the extreme methods of his elder fellow-artist, Hans Makart (1840-1884), in order to attain recognition. This Austrian painter, who had been expelled from the Vienna Academy of Arts in his student days, went to great lengths to achieve a lofty social status. Mucha was in Vienna for Makart's triumphant rehabilitation to the Academy in 1879.

Makart achieved these goals thanks to his clever insight into public taste. A work like *Charles the Fifth Entering Antwerp,* with a theme representing the Austrians' days of glory was sure to be a success. The painting was not a commission but Makart's own idea and he was at work on it when he was sent to Antwerp as delegate to the ceremonies of the Rubens Tricentennial.

Upon returning to his studio in Vienna, Makart decided that in addition to portraying Rubens and himself in the painting, he would also make room for Dürer, who had actually witnessed Charles the Vth's entrance into Antwerp. According to Makart, the great German master made the following comment about the event: "Everywhere there was rejoicing... I had rarely seen more beautiful young women...." Makart then transposed the scene to contemporary Vienna by giving the faces of the beauties so admired by Dürer the likeness of certain charming Austrian ladies. Now, the "belles" of Vienna, like the "belles" of Antwerp-of-yore, showed themselves off to Charles the Vth in various stages of undress. The painting, with its pompous decor, could nearly be called a "strip tease." More than thirty-

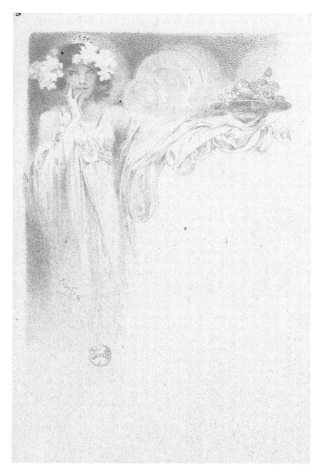

Opposite:
Untitled illustration
Watercolor

five thousand curiosity seekers flocked to Makart's studio, where the canvas was on display for a few days before being sent to the 1878 World's Fair in Paris.

Mucha reveled in the glorious adventures of his senior, a man who could deal with the most august aristocrats on an equal footing, while receiving flattering attention from their lovely wives. With such amenities in mind, he decided to become a full-fledged painter. Even while working on theater sets, Mucha was aware of the range of his own capacities.

At this point, a fire destroyed the Ring Theater and put Messrs Kautsky-Briochi-Burghardt and Alphonse out of work. He then decided not to go home but to wind his way across the country by train, hoping to avoid irritating advice from his family. When he ran out of money, he settled in a small hotel in Mikulov, a picturesque town in the shadow of a famous castle. This site, today a "historic monument," is situated in the beautiful hilly region of vineyards on the old imperial route which joins Vienna to Brno, the capital of Moravia. Here, the young artist sketched landscapes and was able to sell quite a few. Mucha was soon discovered by the ladies of local society and undertook another more lucrative genre, the portrait. Armed with confidence from his experience in Vienna, he painted the decor and drop-curtains for local theaters. Mucha did not balk at any task; he even drafted inscriptions on tombstones.

A PATRON APPEARS

The largest landowner in the region, Count Karl Khuen-Belasi, lived in Mikulov surrounded by his court. It was the custom of the courtiers to write an elaborate greeting to celebrate their lord's birthday. They took great pains to have it made into a beautiful object so that the Count would treasure it forever. Discovering that Mucha had not forgotten his talent for calligraphy, they put the young man to work on the project. After receiving the decorated scroll extending the courtiers' warmest wishes, Count Khuen decided to take a closer look at the work of an artist with such a variety of talents. Soon he commissioned Mucha to paint murals at Emmahof Castle, his principal residence. During these months of activity, Alphonse enthusiastically participated in the life of the aristocracy. Once the work was finished to the satisfaction of all, he went on to the Dolomites where Count Khuen's brother, Egon, commissioned him to decorate Gandegg Castle. There, too, Alphonse was successful.

Mucha had completed two difficult tasks to perfection; this moved the Count to help him fulfill his destiny. For seven

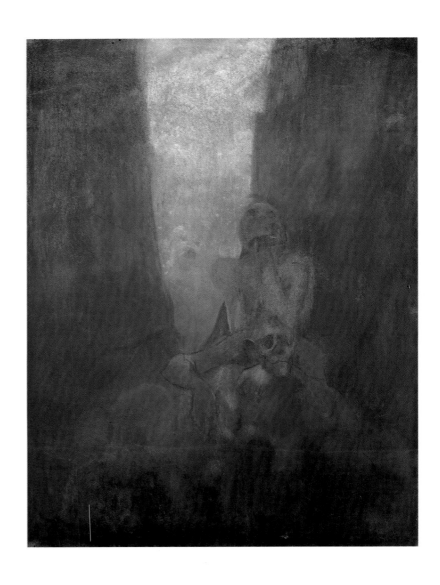

Above and opposite:
Abyss:
In the depths,
a Dead Body
1898 - 1899
Pastel on
marouflé paper
50³/4 x 39³/8 in.
(129 x 100 cm)

years this enlightened, art-loving and wealthy philanthropist gave Mucha an allowance that enabled the artist to pay for his studies and to live. Faithful to his rank, Count Khuen-Belasi assumed all the responsibilities befitting a true *grand seigneur*.

In 1885, Mucha entered the Munich Academy of Art where he was to study for the next two years. Prompted by patriotic enthusiasm, the young painter joined an association of Czechoslovakian expatriates and became its president. During this time he received a commission to make a painting of the Czechs' two best-loved Saints, Cyril and Methodius. Relatives of Mucha returning from America wanted it done for the Church of Saint John of Nepomuk in Pisek, North Dakota. The painting can still be seen today in this small American village of 150 inhabitants. It is not known how much Mucha earned for this work but he must certainly have been thrilled to be able to express the full measure of his Czech identity.

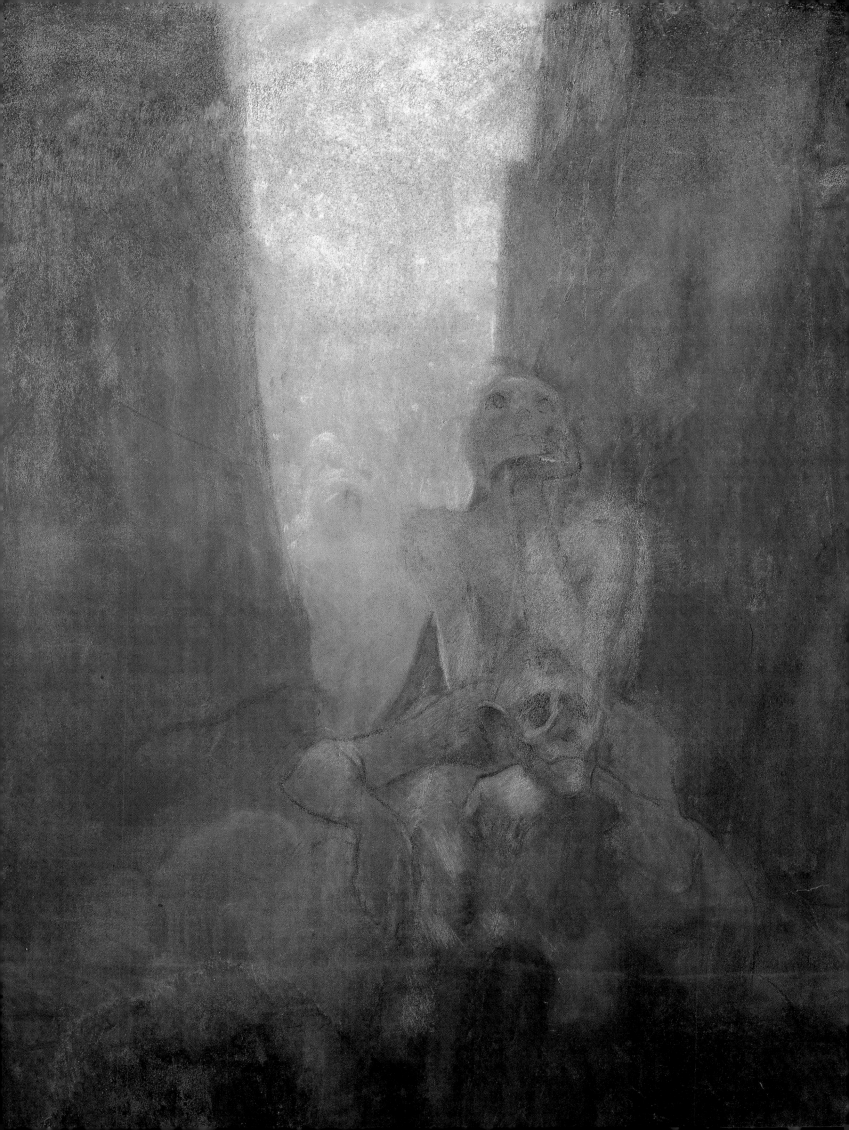

2

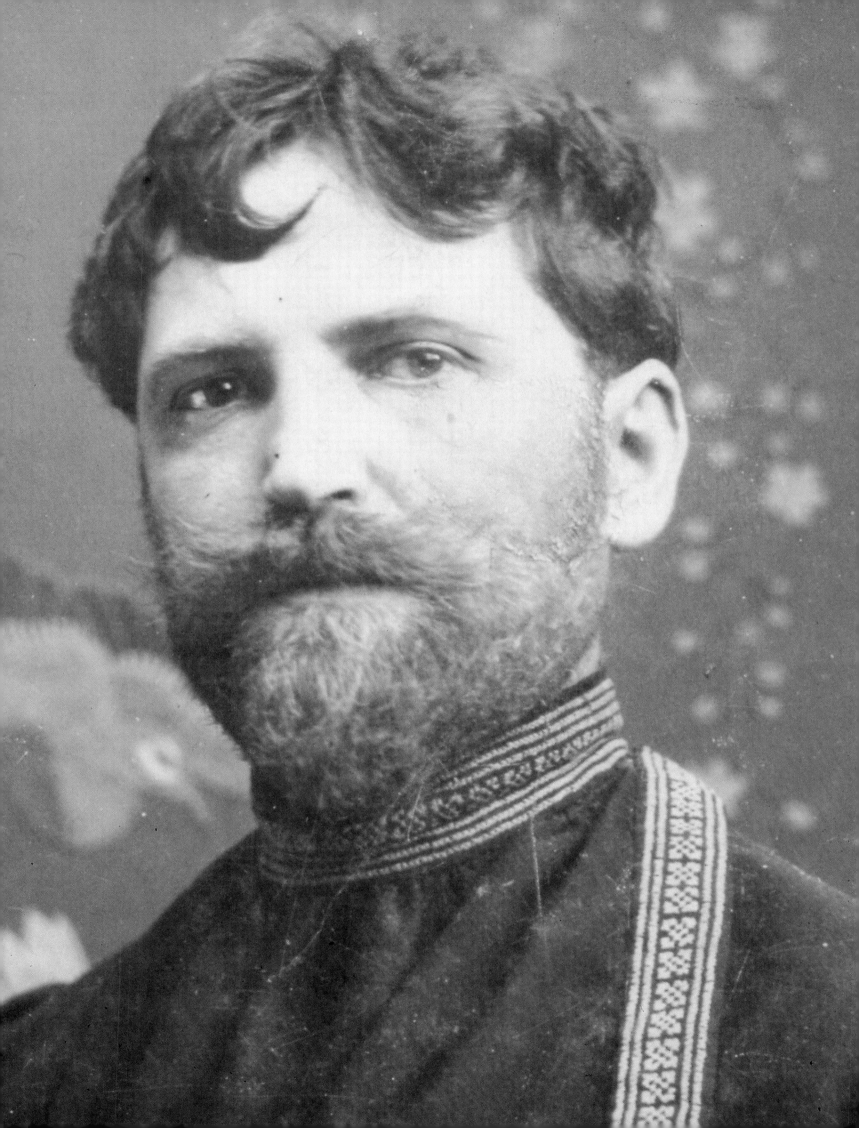

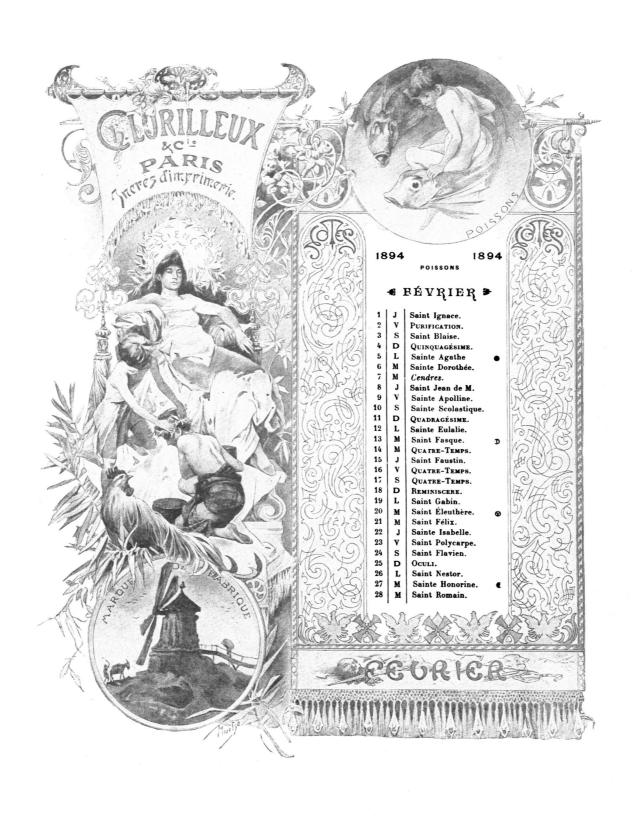

II

PARIS DÉBUT

In 1887, at the age of 27, Alphonse Mucha decided to leave for Paris, convinced that the Munich Academy of Arts and the city itself had nothing more to offer him. Upon arriving there he looked up his fellow countrymen and soon became one of the leaders of the Czech community. He entered the Académie Julian, breeding ground of the Nabis: a group of French artists working under the influence of Gauguin which included Sérusier, Bonnard, Vuillard, Vollard, Maurice Denis and Paul Ranson. For reasons unknown, he soon preferred to frequent the Académie Colarossi—a school that was never to be honored with pupils of such lasting fame, though Gauguin was said to have taught there for a short time.

In 1889, earning a living became a primary concern for Mucha when Count Khuen suddenly decided that his protégé would have to manage on his own. Mucha was not destitute, but for three or four years he experienced uncertain and hard times. His situation gradually improved thanks to unchallenging and often dull jobs, until the day when a chance encounter would bring his name into the limelight once and for all. It was not too difficult for a clever draftsman to find work in Paris at that time. Commercial activity had been stimulated by the 1889 World's Fair commemorating the centennial of the French Revolution. Mucha, still totally unknown, made ends meet by illustrating books, catalogs and calendars. More and more professionals began to notice the artist's ability and taste. Henri Bourrelier, co-owner of Armand Colin, a well-established

Mucha in 1900

Opposite:
Ch. Lorilleux & Cie
1893
Calendar, one of 12 sheets
10 x 12³/₄ in. (25.4 x 32.3 cm)

publishing house, had been looking for new talent and was pleased to come across the young Czech. By his work, Mucha asserted his talent despite the fact that he was almost invariably called upon to illustrating school books or popular novels. In due time, however, he was able to demonstrate his superb talent as a calligrapher and ornamentalist. The 1894 calendar for the Maison Lorilleux, a manufacturer of famous inks, demonstrates Mucha's outstanding skill. He was paid handsomely for this job —two thousand five hundred gold francs—and he deserved it. The individual plates that make up this calendar display superior taste and imagination, as seen on the month reproduced here. The children depicted in the calendar were all members of the ink-maker's family.

LA MERE CHARLOTTE

Once Mucha was established as a free-lance graphic artist, he settled into a well-lit room above a humble eating place of the kind that everyone simply called a *crèmerie*. This establishment was run by Charlotte Caron, better known as Madame Charlotte, who seems to have been one of the first of those women with a small restaurant and a big heart who greatly contributed to the legend of Montparnasse. She offered extensive credit to her painter clients, and, to keep them from running hopelessly into the red, would sometimes accept their works in exchange for payment. No one can say whether it was Charlotte's generosity, the quality of her food or just the location of her restaurant on a street filled with artists' studios, but it became a popular gathering place for painters and writers at the turn of the century. There are many anecdotes about the colorful crowd that frequented *La Mère Charlotte.*

A souvenir of Mucha's stay there remained in place for many years in the form of fruit and flowers painted on boards on either side of the entrance door combined with a clear inscription of the word *Crèmerie* above the door. The decorative motif was a joint effort executed with the Polish artist Wladyslaw Slewinski, who had introduced Mucha to the club-like establishment just across from the Académie Colarossi at 8, Rue Campagne-Première. Slewinski, also a student there, was a friend of Gauguin.

According to Verkade, the Nabi painter from Holland and a newcomer to Charlotte's place in February, 1891, foreign artists were beginning to gather there too. They were part of the young Parisian clique that formed a coterie around Gauguin, the "leader of the Nabis," from whom they drew inspiration. Gauguin, however, took no notice of them. Verkade recalls being presented to him one night: Gauguin, who was quietly sipping his soup in silence, threw a knowing glance at the new

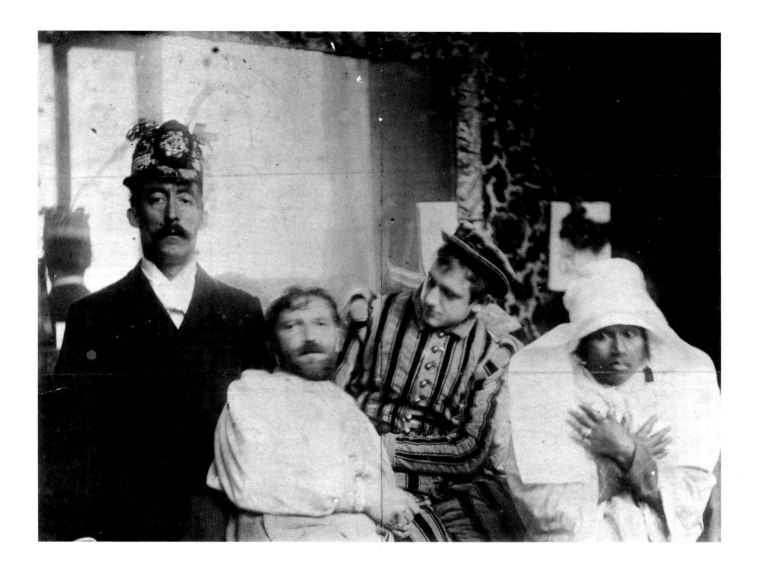

arrival as if to say: "Who is this new imbecile that Haan is introducing to me now?" Meyer de Haan, a Dutch painter, was one of Gauguin's early and most faithful admirers. At that time, the eccentric master was occupied with a public sale of his works to be held on February 23, at the Hôtel Drouot. It was an event that he himself had organized with the help of the literary celebrity, Octave Mirbeau and several other friends in order to finance his first trip to Tahiti.

When Gauguin returned from the Pacific in September, 1893, he resumed his old eating habits at the *Crèmerie*. Needless to say, the crowd had remained entirely faithful and some new converts had appeared on the scene. Gauguin made the acquaintance of one of them, the great Swedish playwright Adolf Strindberg, whom he subsequently asked to preface the catalog of his second sale at the Hôtel Drouot. Strindberg's views on the opposite sex were extremely negative, but did not

The Studio
1893
Photograph with Gauguin, Mucha, the Czech painter Marold and Anna, Gauguin's "Javanese" model

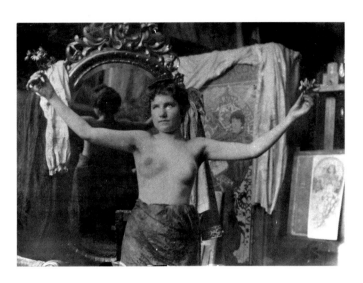

A model
Photograph by Mucha

Opposite:
Anna, la Javanaise
Photograph by Mucha

prevent him from going to bed with a woman from time to time, and gossip had it that Charlotte may have invited him into hers. All that is known for sure, however, is that the two corresponded until 1912. Strindberg set the plot of *There are Crimes and Crimes* (1899) in Charlotte's *Crèmerie*. The play's set, in keeping with his instructions, gives a good idea of the establishment where the playwright was so regularly to be seen.

In December, Gauguin, having inherited a little money from an uncle, moved away from Rue Campagne-Première, but continued to return to the *Crèmerie* for his meals. Still in Montparnasse, but on Rue Vercingétorix, his new lodgings were in a odd house built with bits and pieces left over from the dismantling of the 1889 World's Fair. Although we have several photographs of his huge studio, they do not do it justice. Certain descriptions by visitors, including Mucha's, are more evocative. The chrome-green and yellow walls were covered with the paintings that had not been sold from his latest exhibition at Durand-Ruel. Objects from Africa left to him by his uncle and exotic furniture from the flea market littered the room. The most beautiful photographs of Gauguin taken by Mucha show him in his former lodgings. It is unfortunate that he did not take more in his friend's new studio.

MUCHA PHOTOGRAPHS HIS MODELS

As soon as he arrived in Paris, Mucha began to take photographs of his models. He developed and printed them himself, taking great care with the negatives and put together a large catalog which he consulted whenever the need arose. Because of this way of working, certain of his early drawings bear a curious resemblance to later ones. The photographs themselves constitute a remarkable repertory of women at the turn of the century. Being an efficient organizer, he jotted down notes in French or Czech with cold precision: "Madame de Nevers—young, good for nudes, flat-chested, good back and buttocks, also legs; Madame Misian—too old; Lucie Charpentier—fat, no breasts; Mademoiselle Gisel, 15, Rue Casimir-Delavigne—very good, blond, fat, for the menus for Nice."

During these months, Mucha increased the number of his clients. Admired for his ability and his conscientiousness, he was called upon more and more often to do illustration work. He avoided hiring professional models, however, because of the expense, and would ask his friends at Charlotte's place to let him draw or photograph them in different costumes. This is how Kupka, a young compatriot and future pioneer of abstract painting, came to be one of his frequent models. At least once Gauguin accepted to sit for him: wearing a hairdresser's smock,

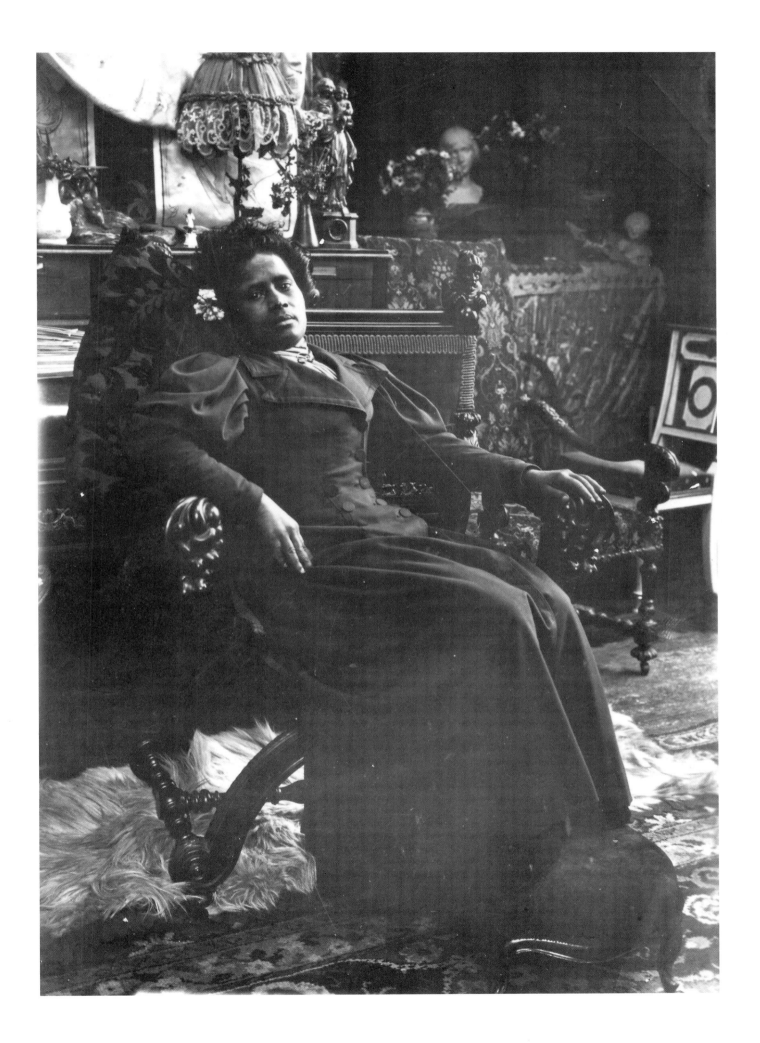

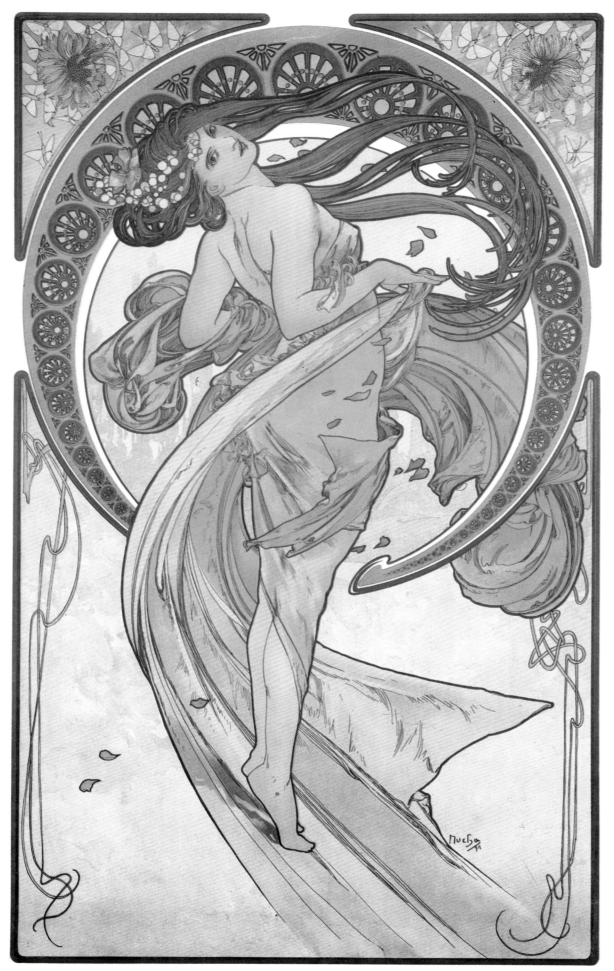

Dance
1898
Decorative panel of one of the four
Muses
14⁷/₈ x 23⁵/₈ in. (38 x 60 cm)

Opposite:
Manhood
1897
A calendar for a brand of chocolate
One of four sheets
8¹/₂ x 11³/₄ in. (21.5 x 29.9 cm)

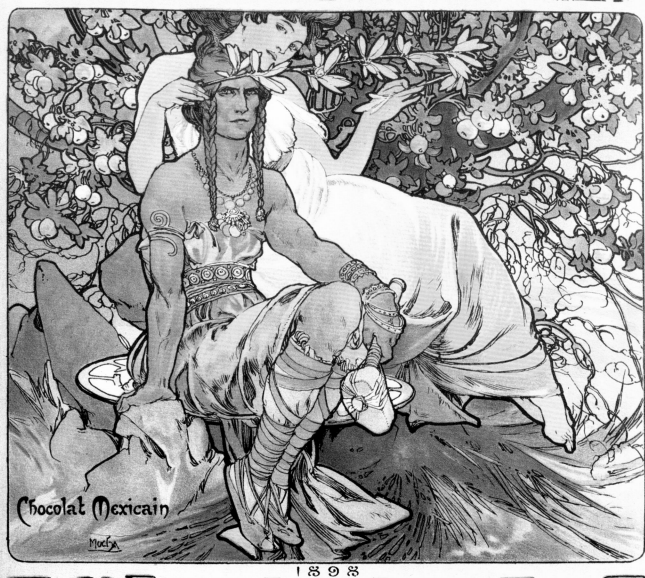

Chocolat Masson

Chocolat Mexicain

1898

JUILLET	AOUT	SEPTEMBRE
1 v s Martial	1 l s Pierre ès L.	1 j ss Leu et Gilles
2 s Visit. de la V.	2 m s Alphonse PL	2 v s Lazare
3 D s Anatole PL	3 m s Geoffroy	3 s s Grégoire
4 l ste Berthe	4 j s Dominique	4 D ste Rosalie
5 m ste Zoé	5 v s Abel	5 l s Bertin
6 m ste Colombe	6 s Transf. N.-S.	6 m s Onésiphore
7 j s Elie	7 D s Gaëtan	7 m s Cloud DQ
8 v ste Virginie	8 l s Justin	8 j Nativ. de la V.
9 s s Cyrille	9 m s Amour DQ	9 v s Omer
10 D ste Félicité DQ	10 m s Laurent	10 s ste Pulchérie
11 l s Norbert	11 j ste Suzanne	11 D s Hyacinthe
12 m s Gualbert	12 v ste Claire	12 l s Séraphin
13 m s Eugène	13 s ste Radeg. v.j.	13 m s Maurille
14 j FÊTE NATⁱᵉ	14 D s Eusèbe	14 m Exalt. stᵉ Cr.
15 v s Henri	15 ASSOMPT.	15 j s Nicomède
16 s s Hélier	16 m s Armel	16 v s Cyprien NL
17 D s Alexis	17 m s Septime NL	17 s s Lambert
18 l s Camille NL	18 j ste Hélène	18 D ste Sophie
19 m s Vincent de P.	19 v s Flavien	19 l s Janvier
20 m ste Marguerite	20 s s Bernard	20 m s Eustache
21 j s Victor	21 D ste Jeanne	21 m s Mathieu Q-T
22 v ste Marie Mad.	22 l s Symphorien	22 j s Maurice
23 s s Apollinaire	23 m ste Sidonie	23 v s Lin Aut. PQ
24 D ste Christine	24 m s Barthél. PQ	24 s s Andoche
25 l s Christophe	25 j s Louis, roi	25 D s Firmin
26 m ste Anne PQ	26 v s Zéphirin	26 l ste Justine
27 m ste Natalie	27 s s Césaire	27 m ss Côme et D.
28 j s Samson	28 D s Augustin	28 m s Wenceslas
29 v ste Marthe	29 l s Médéric	29 j s Michel PL
30 s s Abdon	30 m s Fiacre	30 v s Jérôme
31 D s Germain l'A.	31 m s Aristide PL	

F. Champenois - Paris.

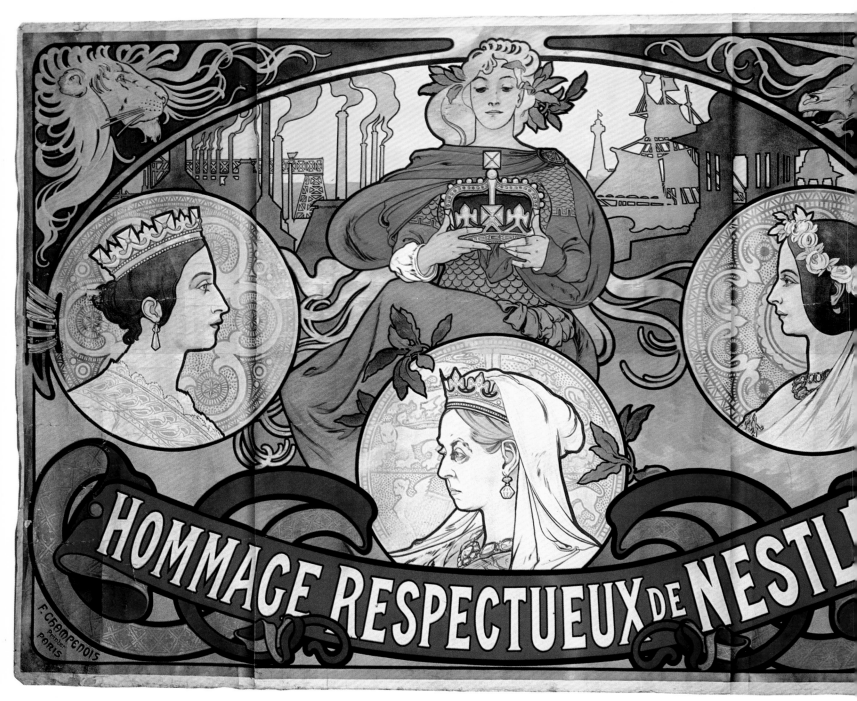

HOMMAGE RESPECTUEUX DE NESTLÉ

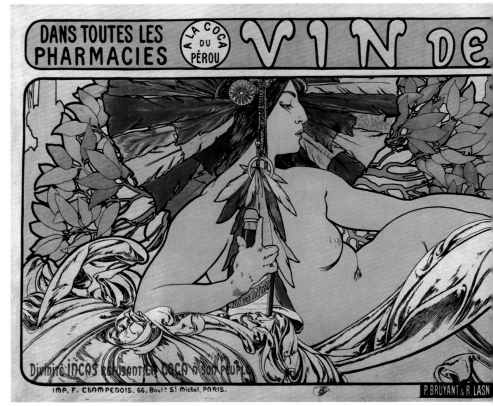

DANS TOUTES LES PHARMACIES · A LA COCA DU PÉROU · VIN DE

Divines INCAS apportant la COCA a son peuple

Hommage Respectueux
Nestlé poster celebrating the 60th
anniversary of Queen Victoria's reign
118 x 78³/₄ in. (300 x 200 cm)

Below:
Vin des Incas
Poster for a tonic
1897
83¹/₂ x 30¹/₄ in. (212 x 77 cm)

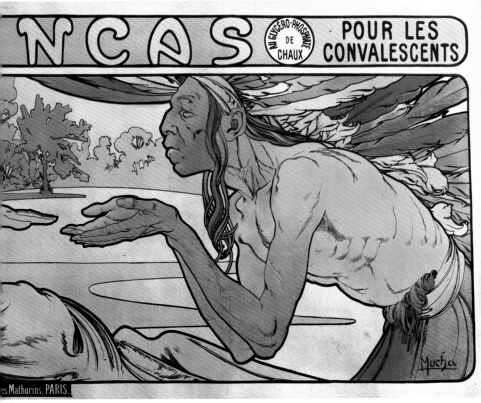

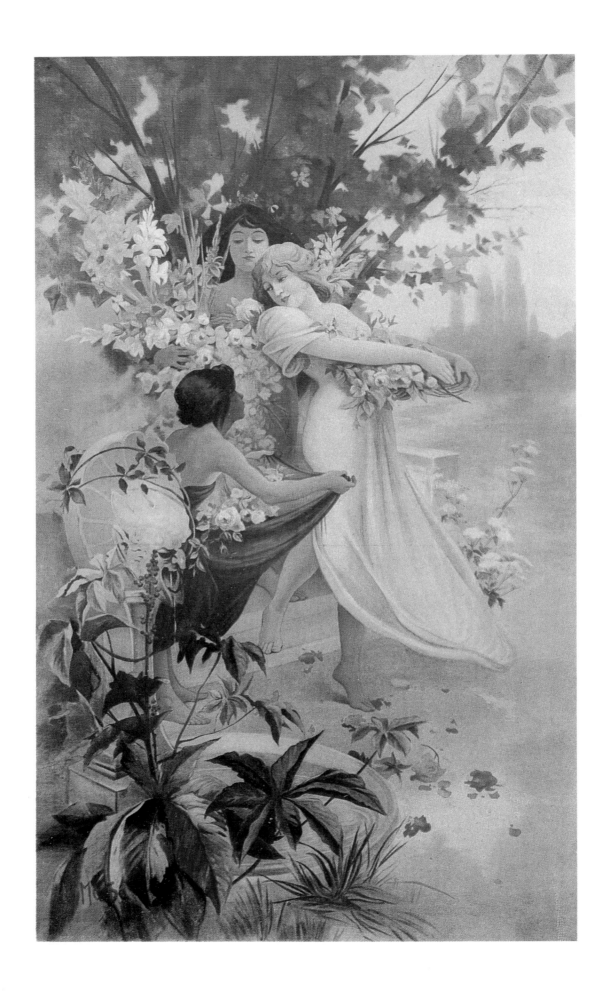

he posed as young Absalom for a story published in *Le Petit Français Illustré*. During this same period, Mucha was asked to make illustrations for *Le Figaro Illustré*, *La Vie Populaire* and *l'Illustration*.

Through a friend, Mucha found intermittent work at a trade periodical called *Le Costume au Théâtre*. Though poorly paid, he was given free tickets to many theaters. This job—the equivalent of what a stage-photographer does today—left little scope for his imagination. Steinlen decorated the covers of this colorful magazine and Mucha was able to have a close look at how this artist used stylized flowers for his bold Art Nouveau motifs. Mucha had them in mind when he designed lottery tickets called *Les Bons de la Concorde*.

The Armand Colin publishing house gave Mucha a flattering order to execute, in collaboration with Georges Rochegrosse, a well-known Salon painter. *Les Scènes et Episodes de l'Histoire d'Allemagne* by the famous historian Charles Seignobos offered Mucha an occasion to exercise his creativity, but the commission posed certain problems to him as an enthusiastic Czech patriot. He came up with a simple solution. He would emphasize the episodes in which his Slavic ancestors played a role, yet be careful not to completely disregard the scenes of Teutonic cruelty on the rampage.

AN UNFORTUNATE SET-BACK

Mucha soon fell ill and, unable to work, received no more money. In a letter to Bourrelier, he began with humorous intent as follows: *"De profundis clamavi at Te Domine. Domine claudi vocam meam."* Mucha went on to announce that he had only 3,50 francs left to his name. Bourrelier, ignoring his accountant's reservations, let himself be swayed by this plea.

Mucha's sister, Maria, appeared suddenly in Paris, sent by a worried family. She entered his room dressed in mourning clothes convinced that he was dying; but his health eventually improved. Maria took her brother back to Moravia for his convalescence. In the meantime, Bourrelier's accountant became increasingly reticent to send any more advances.... As soon as he was back on his feet, Mucha returned to Paris, put his nose to the grindstone and produced a series of drawings of such post-romantic flavor that certain critics claimed that they were worthy of Gustave Doré.

SMALL CAUSES, SMALL EFFECTS

Sometime towards the end of 1894, Mucha was lunching at Charlotte's when a Hungarian friend, the etcher Kadar, also a regular customer, came over to him and asked: "Could you give

Opposite:
Flowers
1894
Decorative panel for "Home Décor," an interior decorating store.
45 1/4 x 74 3/4 in. (115 x 190 cm)

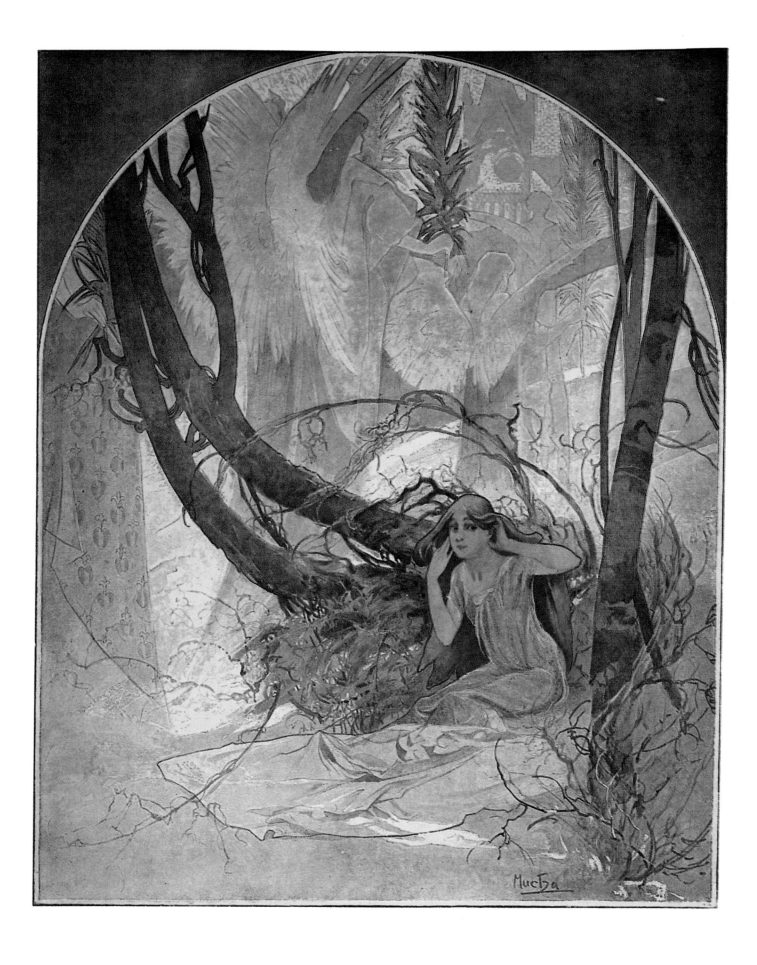

me a hand? I have just finished a big job for Brazil and I have to review the proofs. If you can do it for me, I can get away from Paris for Christmas." Mucha accepted and spent the next day at Lemercier's printing shop. He was quite familiar with the premises and also well acquainted with de Brunhoff, the director. To speed things up he returned on Christmas Day and worked all through the night and the entire following morning. It was the feast of St. Stephen and he had decided to dine at Makovski, a restaurant on the Boulevard de Port-Royal, so he rushed to get the work done. A true Czech patriot could not let St. Stephen's day go by without a meal of roast goose....

Opposite:
Easter Chimes Awaken Nature
1896
Print sold at the time for 10 francs, 46 copies made

3

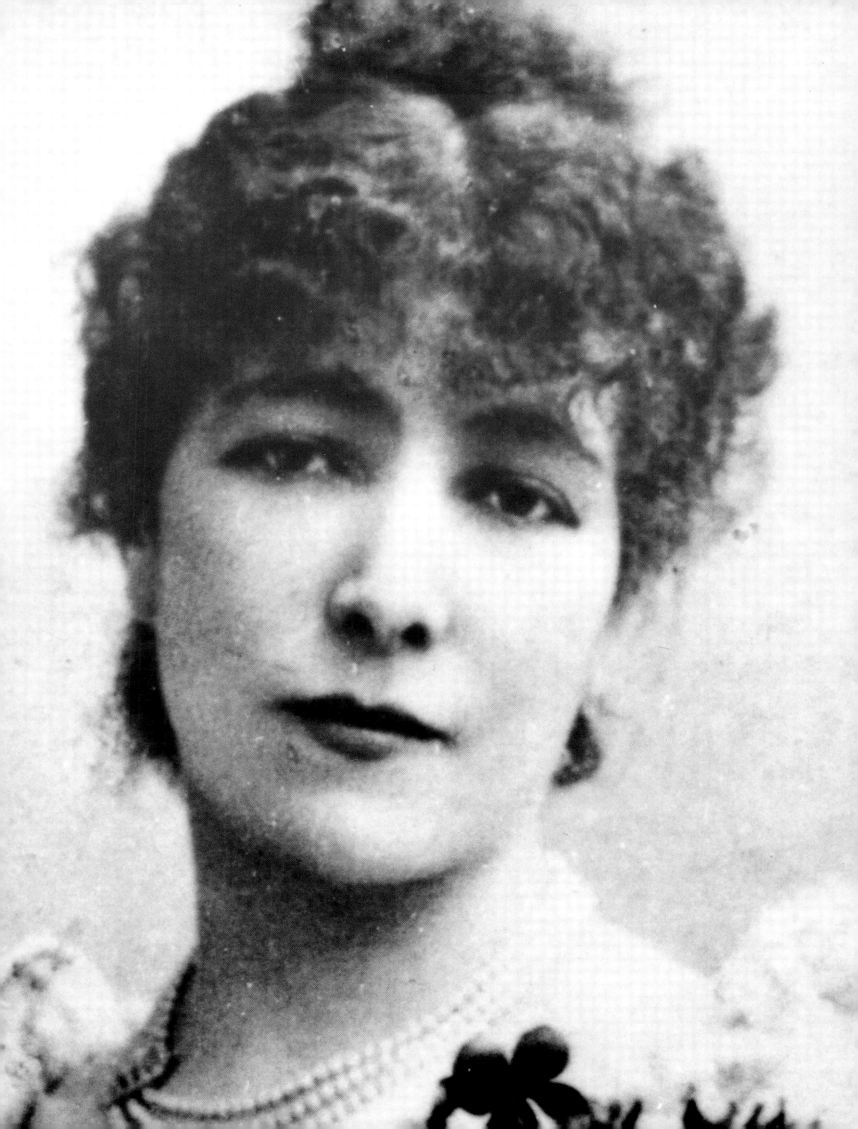

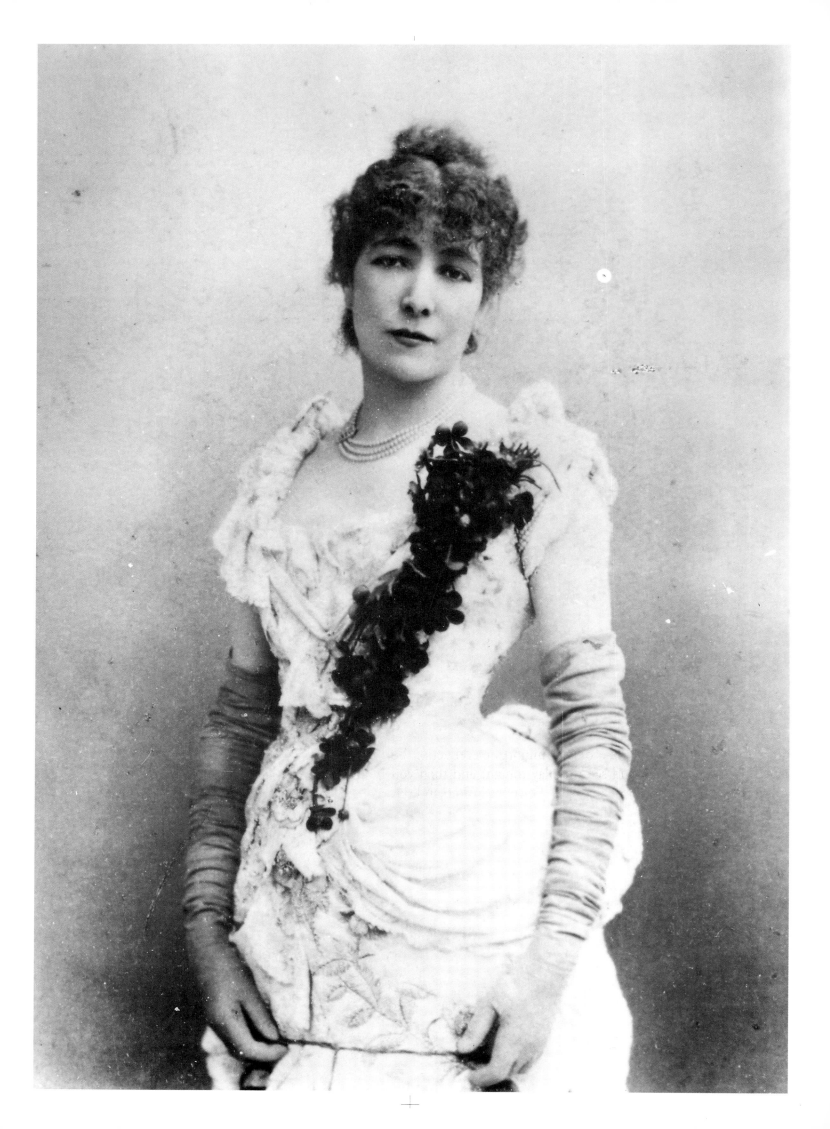

III

SARAH BRINGS LUCK

While Mucha was going over the last proofs in the beginning of the afternoon—as he reported—a very agitated Brunhoff came to see him and gasped: "'I'm in trouble. Sarah Bernhardt has just telephoned. She needs a poster for her play and wants to see it up on all the hoardings by New Year's Day.' He stood shuffling his feet for a moment, looking at me searchingly: 'Have you ever done anything like this before?' 'Well, no, I replied, but I could try.' 'There's no time for trying,' Brunhoff sighed. 'We'd have to get down to it straight away.' Brunhoff, underscoring once again the difficulty of the task, suddenly hesitated. After one or two minutes of reflection he added: 'Good, we'll go and see the play tonight and then you can tell me how you propose doing it.' For now, just go and put on evening clothes.'"

DESTINY'S CLOTHING

"I didn't have any evening clothes," recounted Mucha. "I managed to rent a tail-coat for ten francs and, as none of the trousers would fit, I decided to wear my own: they would do if no one looked at them too closely. A top hat was still needed to complete the outfit. A friend lent me one dating back from the 1840s. Rigged out in this fashion and having forgotten all about roast goose, I sat down in a corner of the theater with my drawing-pad and plenty of pencils." They were showing *Gismonda,* a play written especially for Sarah by her lover, the

Opposite:
Sarah Bernhardt
Photograph by Mucha for the poster

41

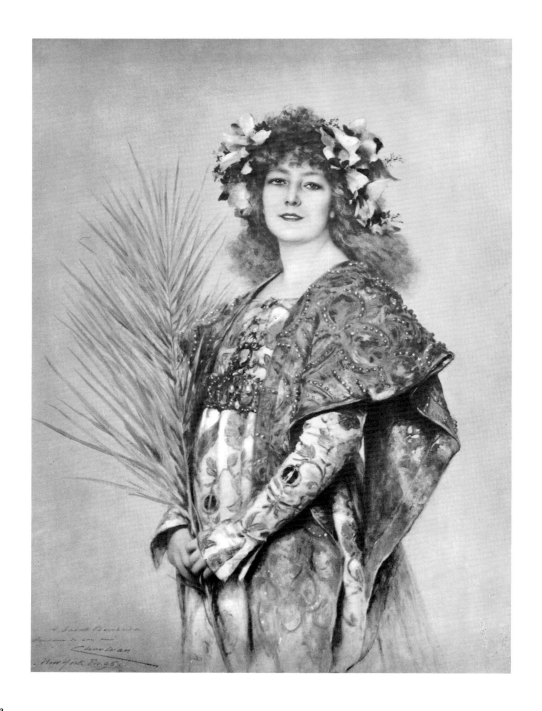

Sarah Bernhardt in Gismonda
1894

witty playwright Victorien Sardou. Mucha found Sarah magnificent, particularly when she entered the church to the sounds of Gregorian chants. As it happened, Sardou had, in fact, placed the action in a Byzantine setting which, in spite of its whimsical context, was the ideal atmosphere for a nostalgic painter steeped in sacred music and a strong religious tradition. "Well?" inquired Brunhoff when the play was over and they went to drink hot chocolate at a café near the Renaissance Theater. Mucha took out one of his pencils and drew a sketch of the poster on the marble top of their table.

Brunhoff liked the sketch and the next day Mucha began

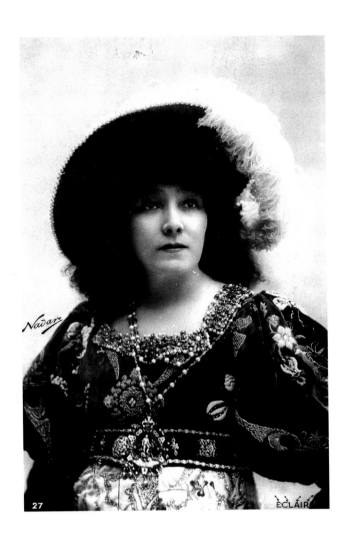

Sarah Bernhardt
As *Gismonda,* photograph by Nadar

to work on it. When he brought his full-color design to the printers, he only got a disapproving glance from Lemercier, passing by on his way out. Since Brunhoff had already left on vacation, there was no one left to defend his project. "It's not our style—a waste of time," declared Lemercier, adding, as he, too, was leaving for the holidays: "It's too late. Send it to the theater. We'll see what they think." On December 28, Mucha received word from the theater director that Sarah liked the project and that he should go ahead with it as quickly as possible.

On the 30th, the posters were all printed, drying and waiting to be pasted up on the walls of the city according to the schedule the actress had set up. When the scrupulous Brunhoff returned to Paris and saw them, he blanched and stammered: "It's a disaster, no one will want them." At the same moment

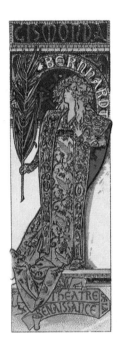

Gismonda
1898
First Mucha postcard of
Sarah

Opposite:
Gismonda
1894
First poster for Sarah
Bernhardt which brought
Mucha immediate fame, a
landmark in Art Nouveau
29¹/₄ x 85 in.
(74,2 x 216 cm)

the telephone rang. It was someone calling from the theater where Sarah was getting impatient. Brunhoff loaded the posters into a vehicle and went to confront *La Divine* (who could also sometimes be the *La Terrible)*. Mucha was disheartened, more for the printers who were about to lose an invaluable client, than for himself, and he was also sorry to have ruined his Christmas.

Alone at the printer's, he became more and more depressed. Then the telephone rang once again. It was from the theater asking him to come over immediately. As soon as Mucha arrived at La Renaissance he was brought to Sarah's dressing room. The actress was examining the poster which she had hung on the wall. She turned around and kissed him, initiating a collaboration which was to last for the next six years.

Alphonse Mucha was catapulted into the international art world almost overnight. Witnesses to his success were all astonished by the unusual chain of events that had permitted an obscure graphic artist—known before to only a few professionals—to receive the sublime kiss of recognition in Sarah's dressing room.

SOCIOLOGICAL BACKGROUND

In order to grasp the whole picture, we should also portray who Sarah Bernhardt was and define the nature of the intellectual and social climate of the times. It is hard to imagine today the magnitude of Sarah's fame and the fascination that she exercised on her contemporaries. Her mother and her aunt came from Holland to Paris aspiring to become *grandes cocottes* or *demi-mondaines*. According to Edmond de Goncourt, these ladies kept beautiful houses and their elegant, tasteful dress made the women of the aristocracy jealous.

We know nothing of Sarah's father except that a lawyer would arrive from Normandy from time to time with a certain sum of money for the child. Not very much is known of her childhood. Sarah was placed in a foster home while her mother and aunt took the difficult steps to attain the standing they so coveted.

After a rough start, her mother, Julie, reached a fairly high position in her profession. Her aunt Rosine did even better and became the favorite of the Duc de Morny, half-brother of Napoléon III. At the time, the duke presided over a group of protectors to which Rossini and Alexandre Dumas *père* belonged—a kind of family affair so to speak—composed of present and past admirers of the two ladies. With the approbation of all the members, it was decided to send Sarah to a religious institution in Versailles. Julie and Rosine were Jewish but once at the convent, the child felt drawn towards

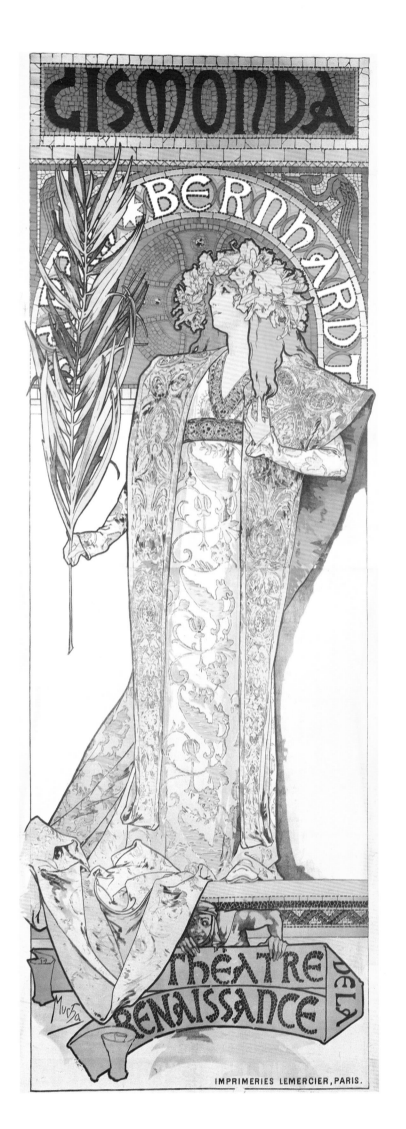

IMPRIMERIES LEMERCIER, PARIS.

Sarah Bernhardt
Photographed in 1880

Christianity and asked to be baptized. A grand ceremony took place which all the gentlemen of the "family council" attended, as well as Madame Faure, a third sister who had donned the cloak of respectability and married a man so pious that, at her death, he entered a monastery. It ended up being a family christening, because Julie took advantage of the situation to have both Jeanne, her oldest daughter and Régine, her youngest then aged 3, baptized as well.

When Sarah—her spirit having blossomed in a hot-house of devotion, tradition and chastity—left the convent, she had to adjust to her mother's life of carefree promiscuity and willing submission to the changing humors of the rich gentlemen who would appear and disappear without apparent reason. These were difficult months for her; at the age of 14, Sarah longed to become a servant of God; she wished fervently to join an order and become a nun, yet she declared, and continued to declare throughout her life, that she was proud to be a Jew. Julie toyed with ideas of marriage or other such means to settle this daughter, described by Dumas *père* as "the head of a virgin on a broomstick."

After many quarrels and much weeping, it was finally decided that Sarah should continue her studies with a private tutor for another two years and then see whether she still wished to enter a convent. The governess chosen by Julie was an excellent one, and Sarah turned out to be an exceptionally gifted student. The next two years were very fertile intellectually; but, much to her mother's dismay, Sarah's figure remained flat at a time when the feminine ideal was curvaceous. Distressing, too, was the fact that Sarah showed no aptitude whatsoever for the piano, one of the attributes of an accomplished courtesan. At the next family reunion, Sarah asserted her intention to be wed exclusively to Our Lord Christ. The lawyer from Normandy, who also sat in on the meeting, announced that a dowry was not foreseen in the case of such a union.

The discussion dragged on until someone finally suggested wrapping up the evening at the Comédie Française. It was probably Rosine and Morny who thought up this scheme. It has never been established whether Sarah actually fainted during the performance of Racine's tragedy, as she wrote in one version of her *Mémoires*, or if nothing of the sort took place, as she says in another version of the same book. It so happened, however, that she entered the Conservatoire a month later and a very short time after joined the Comédie Française.

The stage door opened by Morny was never shut again. Sarah devoted the rest of her life to the theater. Photographed by Nadar at her beginning, she appears ravishing dressed in crinoline. This great star of the Second Empire died in 1923,

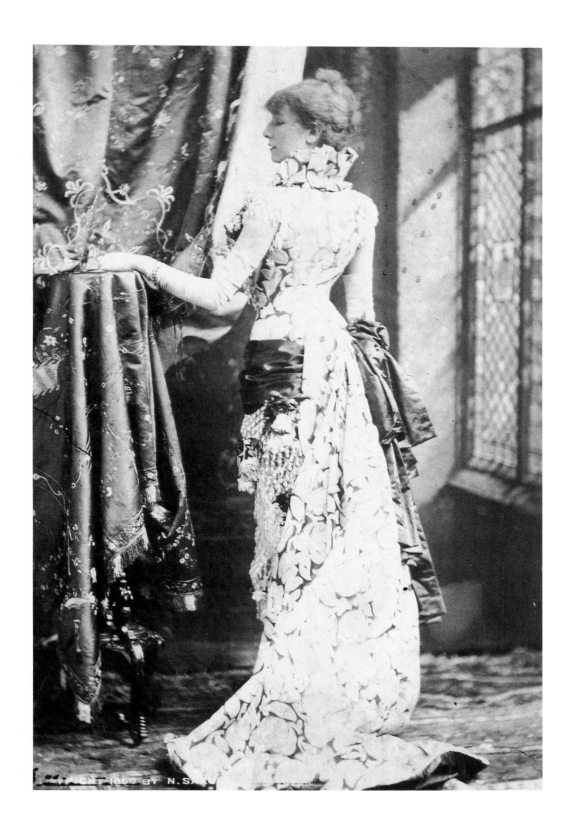

Opposite:
La Dame aux Camélias
1896
The poster Sarah Bernhardt preferred;
for her American tours (1905-1911)
28½ x 81⅝ in. (72.2 x 207.3 cm)

while making a film. Never would another actress, even Garbo, attain such glory. As early as 1893, the writer Emile Bergerat, a reliable observer of the era, wrote that in France only Victor Hugo and Gambetta became as famous as Sarah Bernhardt. When Mucha met her a decade later, her fame was world-wide, and, to be chosen by the *La Grande Dame* was an international stamp of approval.

The poster for *Gismonda* was greeted by the public with the same enthusiasm as it had been by Sarah, and for the same reasons. She personified an authentic style—Art Nouveau. If Sarah had done nothing else but discover Mucha, she would still deserve to belong among the pioneers of the phenomena that the French dubbed *Modern Style*.

During the 1890s throughout Europe the Art Nouveau esthetic imposed a vocabulary of coherent and original forms that transformed the decor of the Western world. This exaggerated, asymmetrical, decorative style was an offshoot of Symbolism with roots in French Rococo and Japanese art. It also bore the name of *Style Nouille,* and was subjected to as much sarcasm as the *Style Rocaille* had been until each found its proper place in the history of art. When tastes changed again, Art Nouveau lost its vogue and was rejected with as much vigor as Rococo had been swept away by Neo-Classicism.

Architects like Guimard, the creator of the graceful, ornate entrances to the Parisian Metro stations (fortunately, many of them have been preserved) came to epitomize Art Nouveau. This new style quickly spread to interior decorating under the designation of *"Le Home Esthétique"* and included all forms of art, from architecture to posters, household objects, book bindings, furniture, ceramics, wallpaper, textiles and jewelry.... Mucha mastered several crafts at once, using all of Nature's undulating curves in vegetation, flames, waves and the flowing hair of female figures as the basis for his designs.

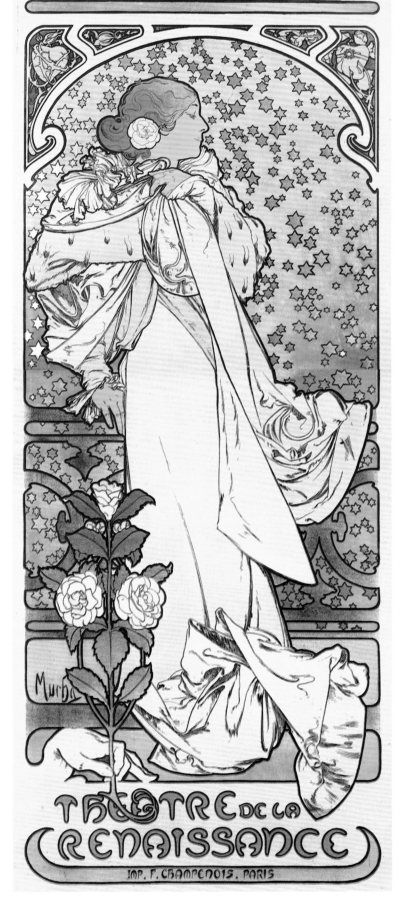

4

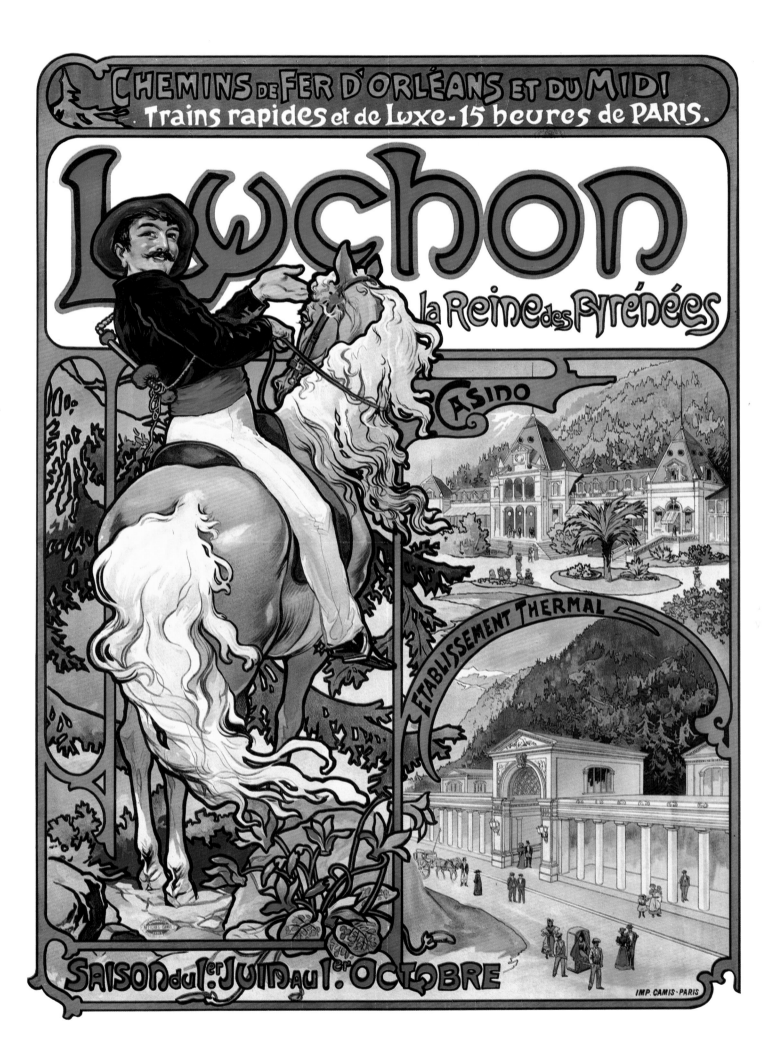

IV

A PERIOD

AND ITS STYLE

At the turn of the century, the younger artists lost interest in the Impressionists whose work, however, had not yet been accepted by the public at large. This new generation was attracted to symbolic content and felt that painting must be architecture, poetry and music all at the same time; they criticized Impressionism because it had sought to capture an immediate vision of things and ignore their inner meaning. It was also the heyday of the written word. Vallotton, a painter of the Nabi Movement, once noted: "The spirit of a period springs from literature; revolutionary movements in the arts get their initial impulse from writers." Gallé, the famous glass-maker and a great admirer of Sarah Bernhardt, wrote: "The poet, master of the word, is also the master of decoration."

THE "MOUVEMENT DE L'AFFICHE"

Mucha had stepped into well-explored territory, yet even the influential backing of the great actress would not have been enough to establish the *Gismonda*-poster style of graphism had its exceptional quality not been immediately evident. Although colored posters had been blooming on city walls since the middle of the century, they were now considered a serious art form known as the *Mouvement de l'Affiche.* The most important factor in the progression of this trend, however, was the role played by the Arts and Crafts Movement of William Morris and his friends. As both socialists and esthetes, they believed that art

Opposite:
Luchon
1895
Poster for a spa, also attributed
to Eugène Grasset
29⅝ x 41⅝ in. (75.2 x 105.7 cm)

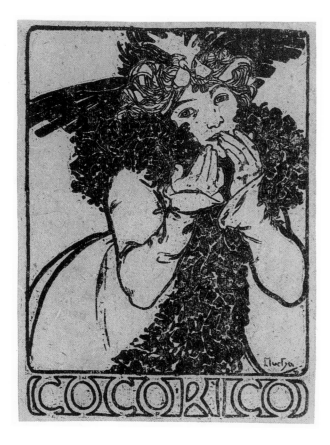

Cocorico
Cover of the periodical
December 1899

Opposite:
La Plume
1897
Cover of the periodical, special
issue on Mucha

should be accessible to all. What better method could there be of achieving this than by pasting fine posters on walls, transforming them into museum-like displays? These theories found their way across the Channel and French painters, convinced that art should reach the masses, coated the wall of Paris with posters. Bonnard, Ibels, Steinlen and Vallotton, among others were members of this group. Toulouse-Lautrec, a remarkable, prolific and inspired poster designer, aired no opinions on social issues or fads in art. He decorated walls with billboards advertising anything from bicycles to popular novels, music-halls, cafés and performers. Like Bonnard, he was one of the illustrators of the excellent periodical, *La Revue Blanche.* The tendency towards linear decoration already apparent in the 80s continued to develop thanks to the high quality of the work of Eugène Grasset, one of the most fervent champions of *Modern Style.*

Collecting placards announcing the publication of books had become a hobby in its own right, distinct from the traditional pastime of collecting engravings. These small posters were the works of such remarkable illustrators as Granville, Johannot, Monnier, Gavarni or Doré. In 1891, it is estimated that Chéret, head of the Chaix printing house, had produced at least a thousand posters which were not necessarily all of his creation, but his influence could be felt in most of them. Many represented themes centered around the music halls or cabarets that were then part of the thriving night life in Montmartre. Other poster designers, like Willette, also worked for this expanding market.

In Paris posters proliferated not only on hoardings but were also seen featured on special sidewalk columns (*colonnes Morris*). Posters combining advertising with the sensual appeal of a female figure covered omnibuses and public lavatories.

Mucha, with his incomparable sense of graphic energy, arrived on the scene at precisely the right time. With the rich esthetic influence of the Byzantine icon and curvilinear forms, his style was just right for the era. *Modern Style* demanded curves and these, wrote Reynaldo Hahn, the composer, "were the linear forms preferred by Sarah. There is something curvaceous in all her gestures... she sits down with a spiral-like movement, her clothes wind about her body, enfolding it tenderly into a rounded form. This shape is repeated again, by the train of her dress curled on the ground, and higher up again as her head and bust curve in the opposite direction."

The poster for *Gismonda* created a sensation. Chéret and his followers systematically used reds and vermilions—in schemes designed to catch the eye in any environment. Mucha chose more delicate hues and combined them with gold. This made his work all the more impressive. An article by Jérôme

N° 198 — 15 Juillet 1897

LA PLUME

2e FASCICULE
DU
Numéro exceptionnel consacré à MUCHA

Mucha

DUCOURTIOUX & HUILLARD, Sc.

Imp. de Vaugirard, G. de M. & Cie, Paris.

Opposite:
Self-Portrait
1909
Oil on cardboard
17¼ x 11¼ in. (44 x 28.5 cm)

Doucet in *La Revue Illustrée* clearly shows his contemporaries' reaction: "The name of Mucha became known immediately all over Paris thanks to his posters. With its white window and the mosaics on the wall, it is a first-rate creation that deserves its acclaim.... It seemed that when Chéret covered our walls with his posters, each more beautiful than the other, no one could compete with him in the *Salon de la Rue* (The Streetside Salon). We were afraid that when the great and good Master, fed up with being poorly imitated, turned towards the decorative arts, our publishing houses would go into mourning, since neither Grasset's elaborate graphics nor the rare posters of Toulouse-Lautrec would be able to fill up the void left by Chéret. But now, another artist worthy of taking Chéret's place has come on the scene. Mucha has triumphed in a field where success seemed impossible."

THE SWEET SMELL OF SUCCESS

The six-year contract signed the night of the *Gismonda* opening gave Sarah exclusivity over Mucha's work for the theater. He was free to do as he pleased in other areas and the simple charm of the work that he was now producing brought in a flood of orders. Lemercier had originally paid him 150 francs for the *Gismonda* poster. The contract with Sarah brought in three thousand francs a month and one thousand five-hundred francs for each new poster. This was fair but not excessive, especially when taking into consideration the actress' profits on the sale of individual posters were taken into consideration.

In July 1895, when the theater season ended, *La Divine*, who had a good business sense but showed a certain extravagance in other matters, ordered four thousand more posters from Lemercier. The public's appetite was immense; the posters were torn away or cut off walls with razors. Sarah sold—retail—copies that had cost her about fifty centimes a piece wholesale; the profit that she made on this deal has been estimated at one hundred and thirty thousand francs. Because five hundred of the posters were never delivered, the temperamental Sarah sued Lemercier. She won a case that didn't amount to much, but Lemercier lost a precious client. Sarah brought her business over to *La Maison Champenois* and Mucha followed.

Manufacturers of liqueur, bicycles, champagne and perfume lined up at Mucha's door, delighted to pay the prices set by an artist who held the key to their success. At the time, he was working on a project with Sarah; she had been very impressed by *Les Romanesques*, a play being given at the Comédie Française, and written in verse by a twenty-nine year

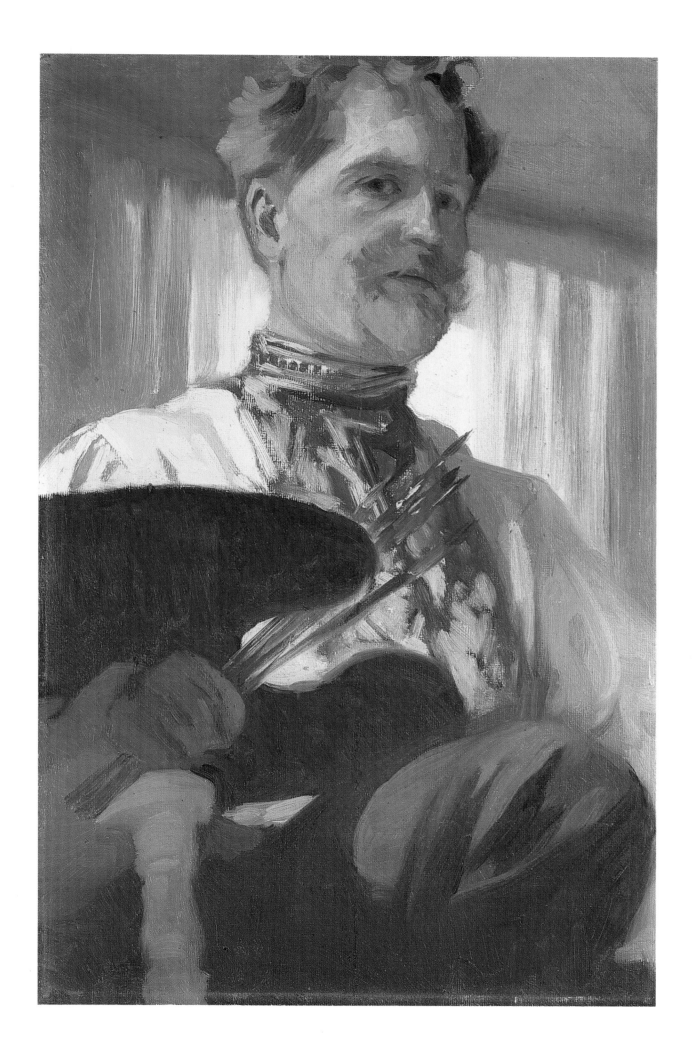

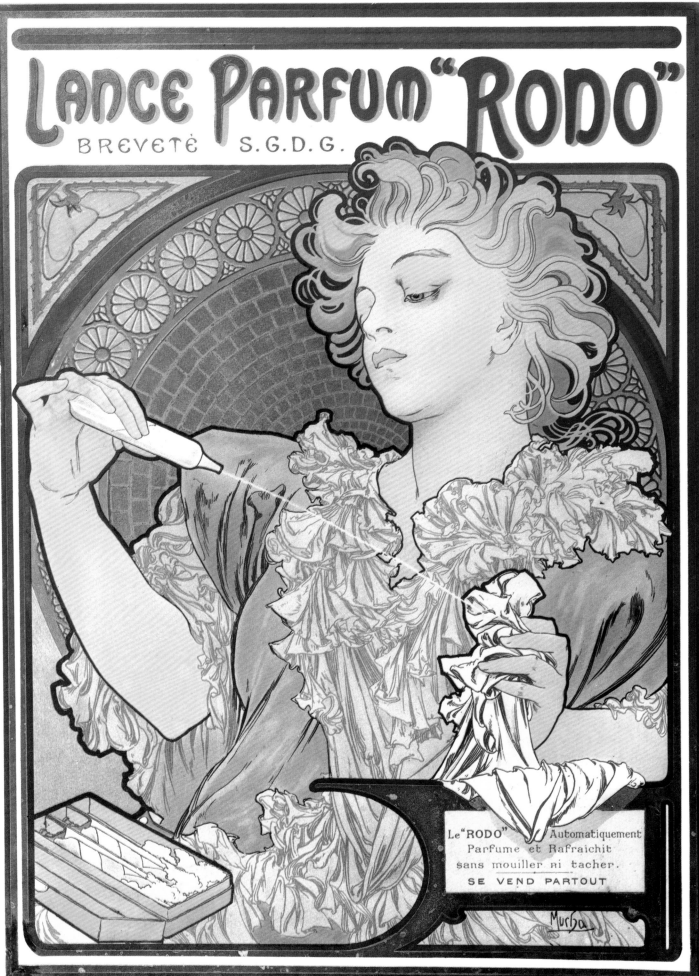

F. CHAMPENOIS, 66, BOUL⁰ St MICHEL _ PARIS.

old playwright, Edmond Rostand, for whom she had predicted a glorious future. Sarah gave Mucha another manuscript to read, and he was delighted with this new play by the same little-known author. Sarah offered the painter the opportunity of co-producing *La Princesse Lointaine* with her. Directing the production with Sarah entailed so much work that Mucha could not find the time to make a poster. They contented themselves with a meticulously designed program, enhanced with reproductions of several projects for the sets and costumes. Later, Mucha created a costume for the *Princesse Mélisande* production that was to incarnate the essence of Sarah's personality. She appeared crowned with a headdress made of lilies and wearing a long flowing dress.

The two collaborators were as united by their success as by their mutual taste. Mucha played host at the house on Boulevard Péreire that Sarah had turned into a museum with luxurious *bric-à-brac*, and where the cream of the intellectual, political and social scene gathered. Sarah told stories of how she took part in several séances of spiritualism in the studio on Rue de la Grande-Chaumière. Mucha, in a much better frame of mind owing to his ever increasing income, moved to an apartment on Rue Vavin.

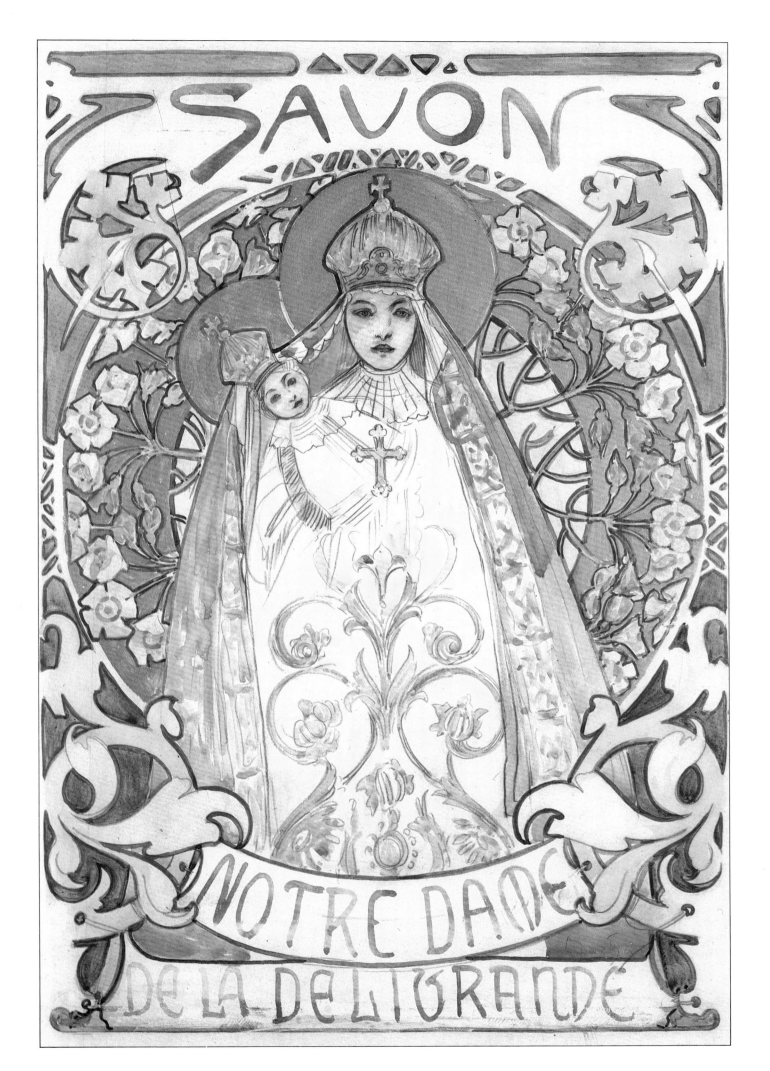

61

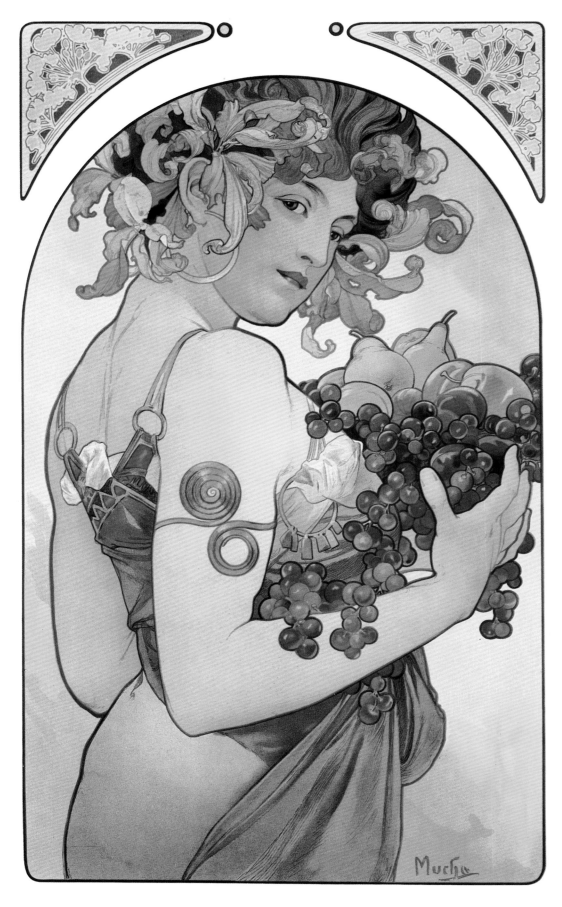

Fruit
1897
Color lithograph
17¼ x 26 in. (44.4 x 66.2 cm)

Opposite:
Heidsieck & Co.
1901
Poster for champagne
19½ x 26⅛ in. (49.7 x 66.5 cm)

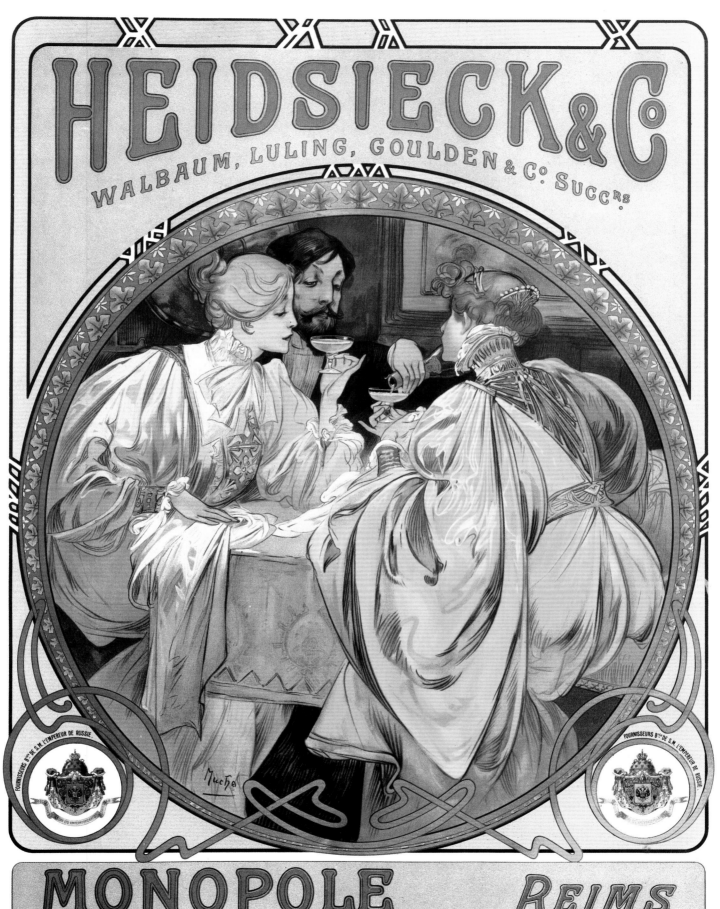

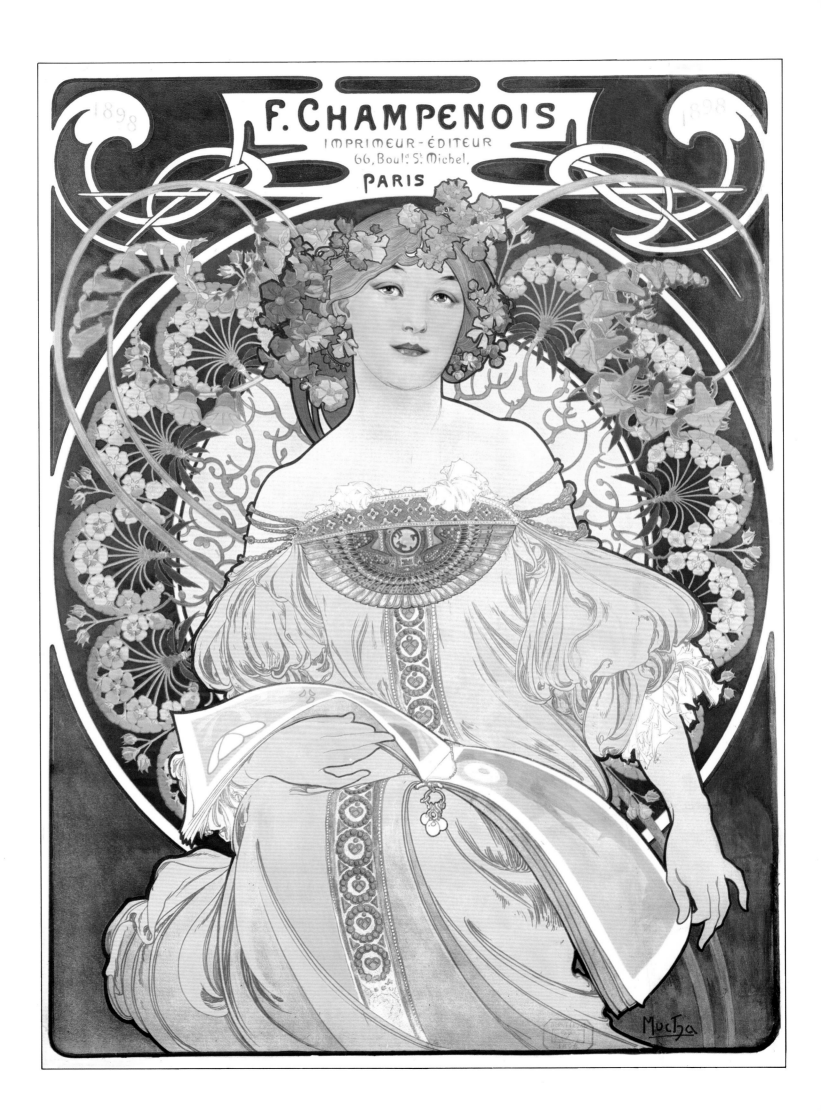

Daydream
1896
Postcard for the publisher-printer
Champenois

Opposite:
F. Champenois Imprimeur-Editeur
1897
New Year's poster for 1898
21³/₄ x 28⁵/₈ in. (55.2 x 72.7 cm)

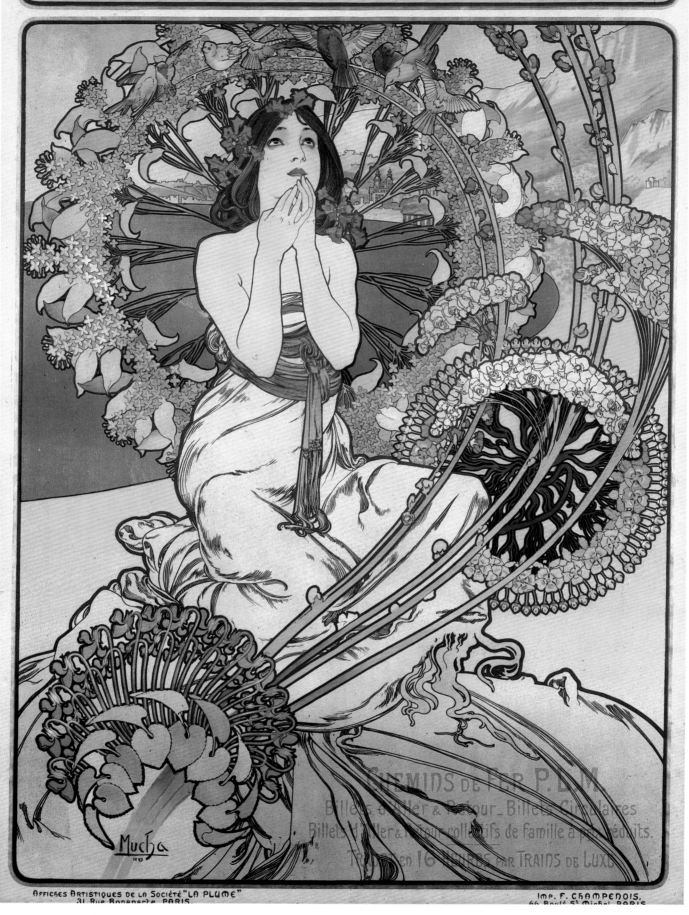

MONACO · MONTE-CARLO

Monaco - Monte-Carlo
1897
Poster for PLM Railways
29³/₈ x 42¹/₂ in. (74.5 x 108 cm)

Bénédictine
1898
Poster for a liqueur showing the Abbey of
Fécamp where it is manufactured
30¹/₄ x 80⁷/₈ in. (77 x 205.7 cm)

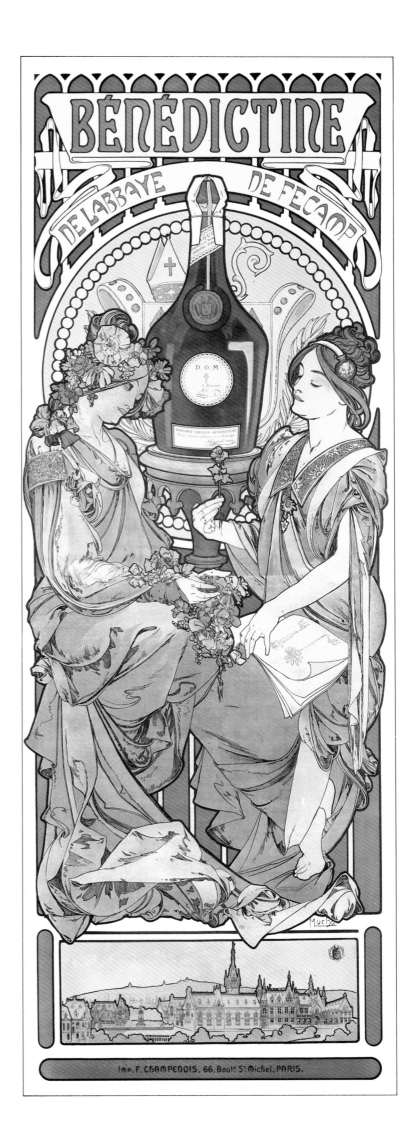

5

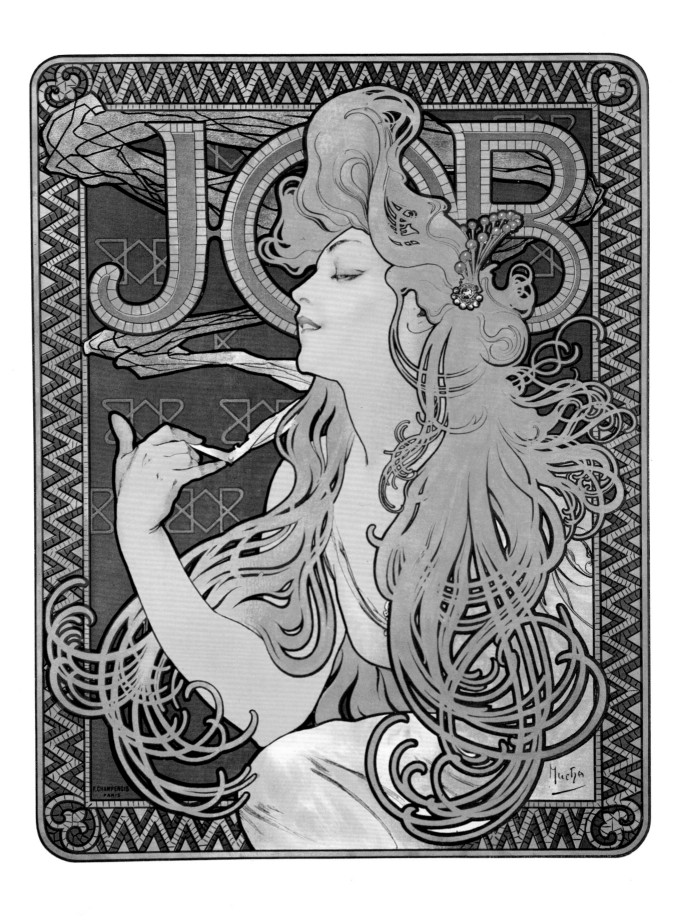

V

A MUCHA FOR EVERYONE

AND EVERYWHERE

The artist's posters had by now spread to all the walls of Paris and the provinces. Thousands of representations of curvaceous ladies resembling Sarah advertised such products as Job cigarette paper, Ruinart champagne, LU biscuits and many others.

The "Mucha Style," as it came to be called, often replaced the name Art Nouveau to designate this fashion. It became a feature of everyday life, not just because of the vast numbers of posters designed by the artist but also because of the decorated biscuit boxes, chocolate bars and labels on perfume or liqueur bottles. At the same time, Mucha contributed further to the prevailing esthetic by painting decorative panels. These occasional off-shoots of his poster production became elements of interior decoration. The panels were executed by Champenois with whom the painter had signed a contract netting a minimum of thirty thousand francs a year—an arrangement that turned out to be very advantageous to both. Champenois, an excellent business man, was able to exploit Mucha's graphic work to the hilt. He applied his knowledge of newly-improved lithographic techniques to produce some fifty fine decorative panels. Most of them were paper lithographs, but those printed on satin— of which few have survived—render the artist's color schemes to perfection. Occasionally the subject-matter would change, such as the astrological theme of the *Zodiac* panels (1896), whose four versions were used on many calendars. A fifth

Opposite:
JOB
1896
Poster for cigarette paper, successfully sold on ordinary (3 francs) and on high quality paper
23¼ x 68 in. (59 x 173 cm)

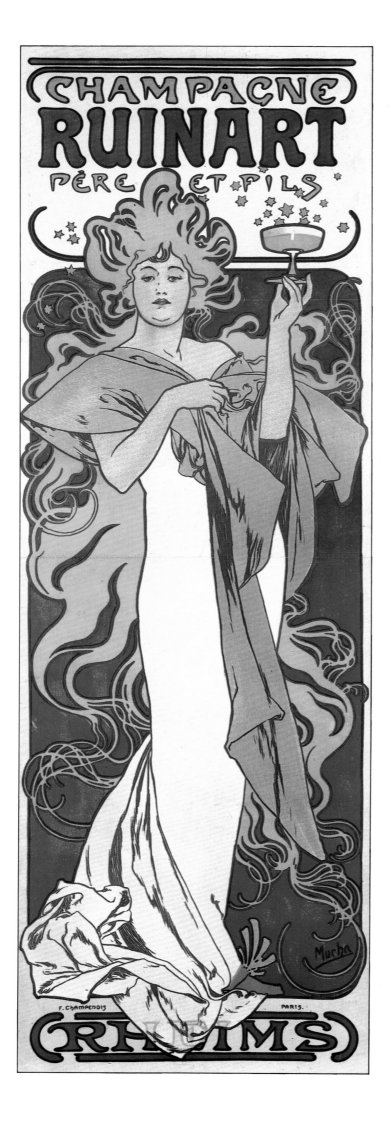

Champagne Ruinart
1896
Specially printed for the November 1996
Poster Art Show in Rheims

Opposite:
Biscuits Champagne Lefèvre-Utile
1896
LU Biscuit poster for interior display
13^7/$_8$ x 20^1/$_2$ in. (35.5 x 52 cm)

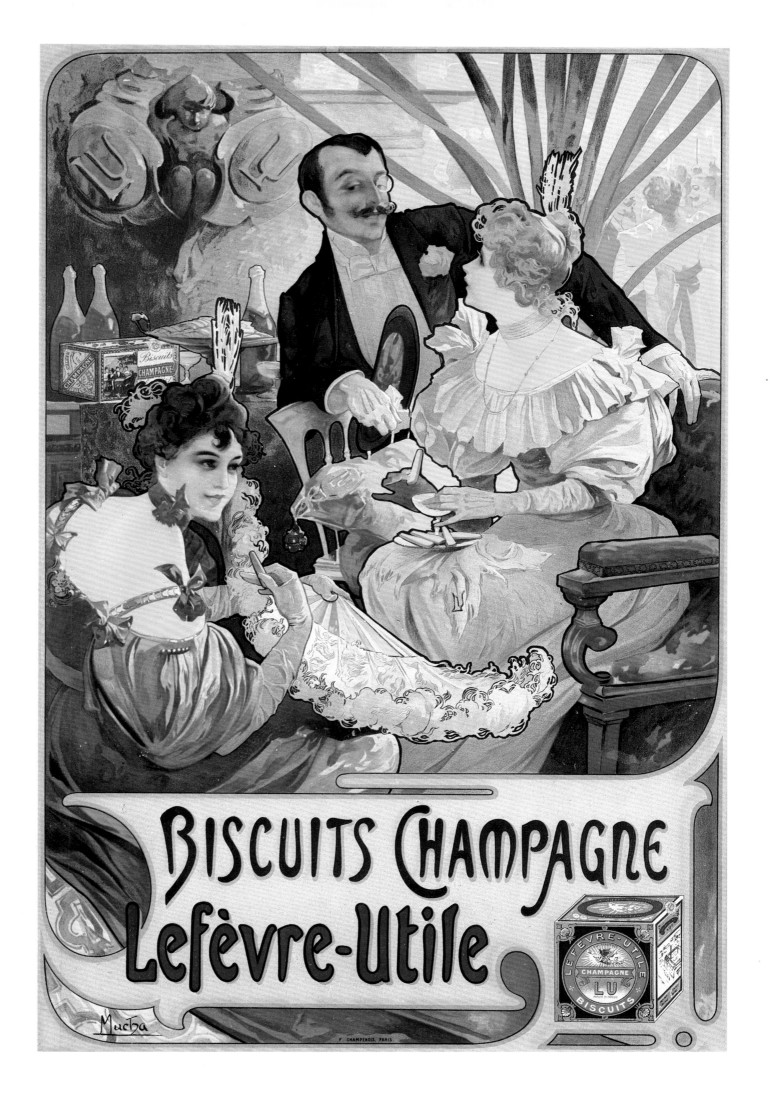

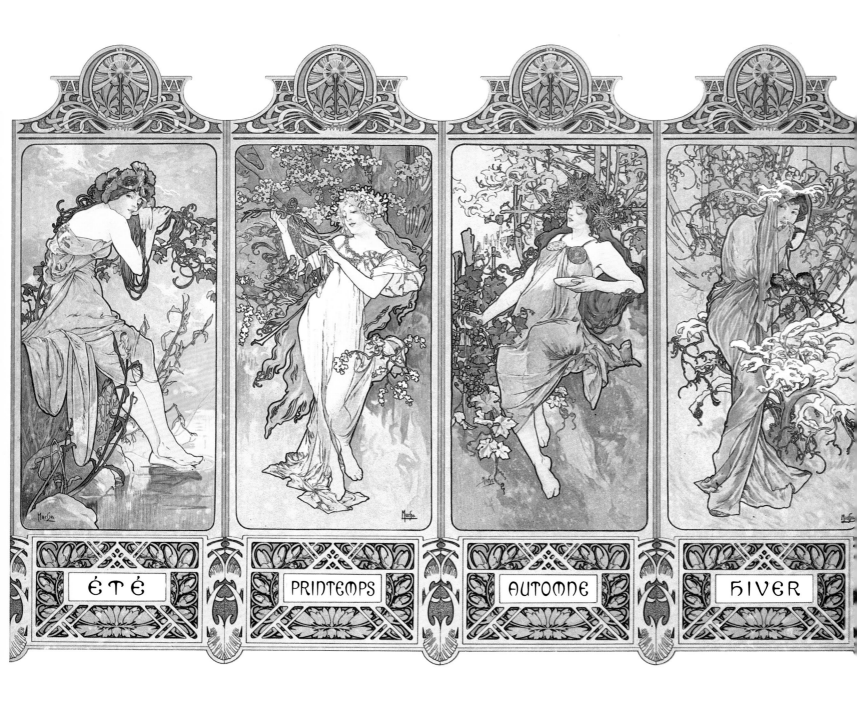

The Four Seasons
1896
Four decorative panels in an ornamental
frame, sold with enormous success for 40
francs.
21¼ x 40½ in. (54 x 103 cm)

Opposite:
Winter
1896
Decorative panel

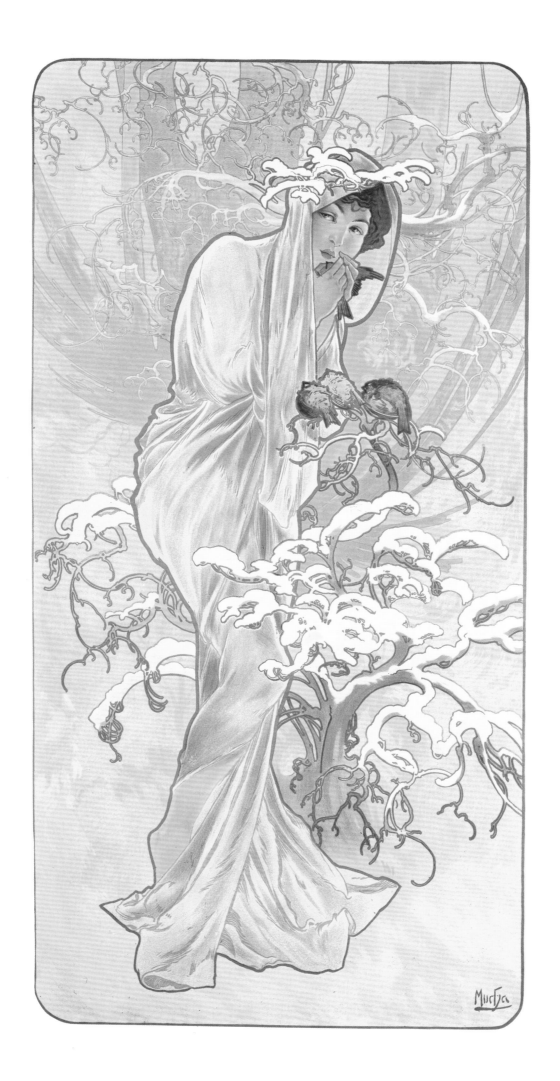

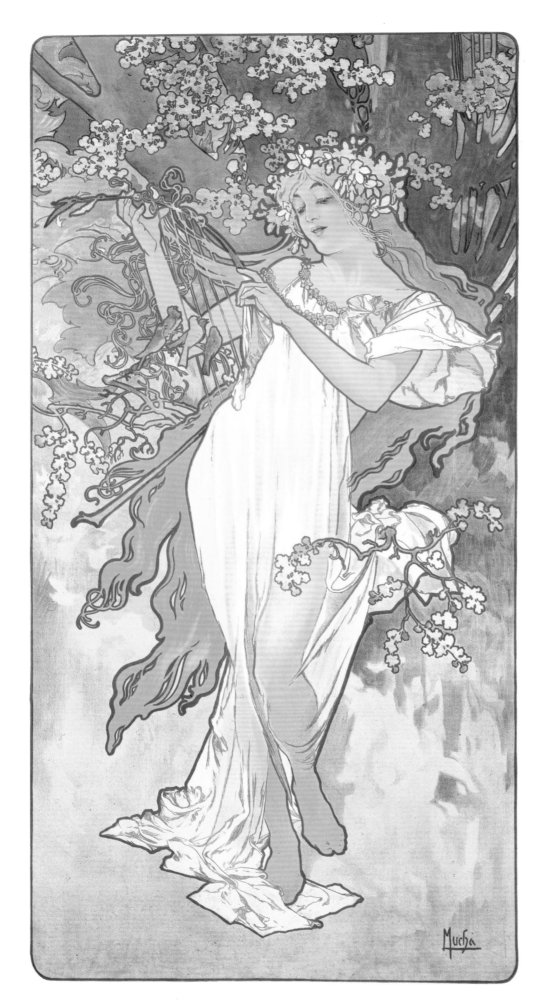

Spring
1896
Decorative panel

Autumn
1896
Decorative panel

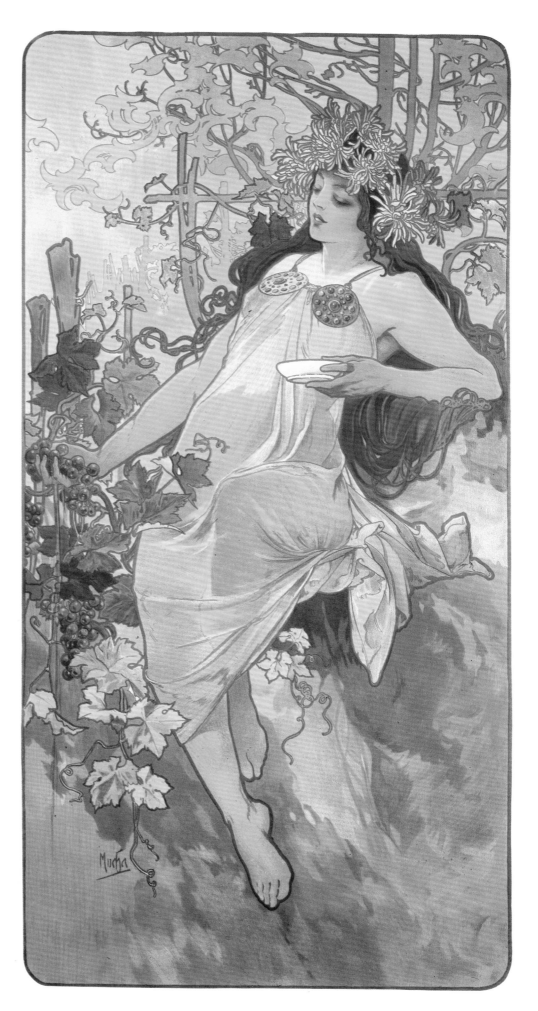

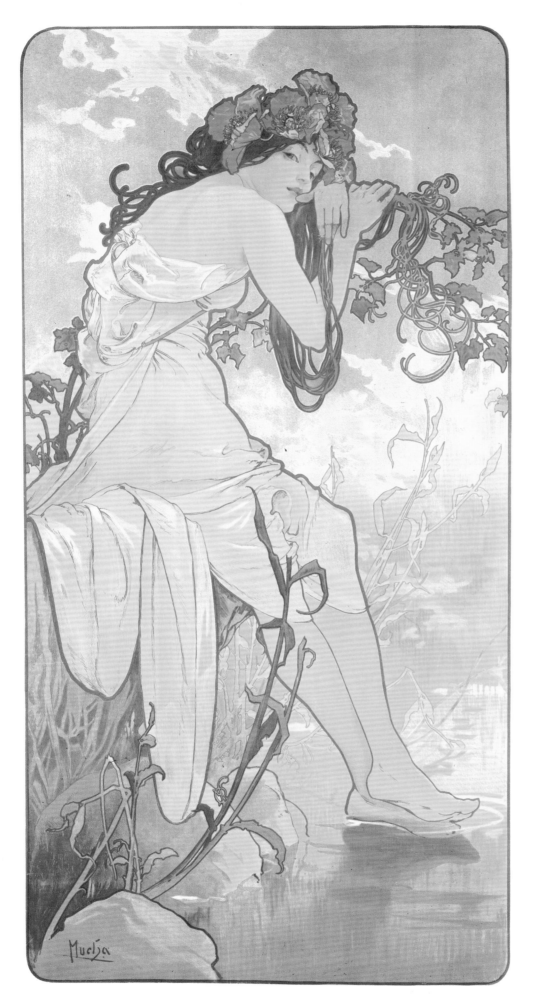

Summer
1896
Decorative panel

Opposite:
Carriage Dealers
1902
Poster for American exhibition printed in the USA, discovered at the Museum of Modern Art in Barcelona, variation on the theme of *Summer*.

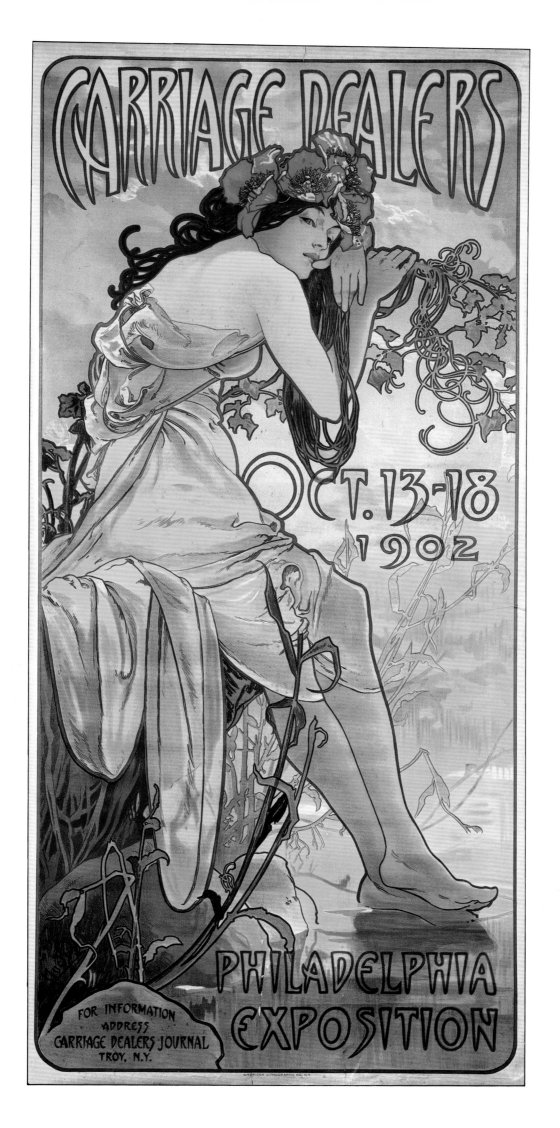

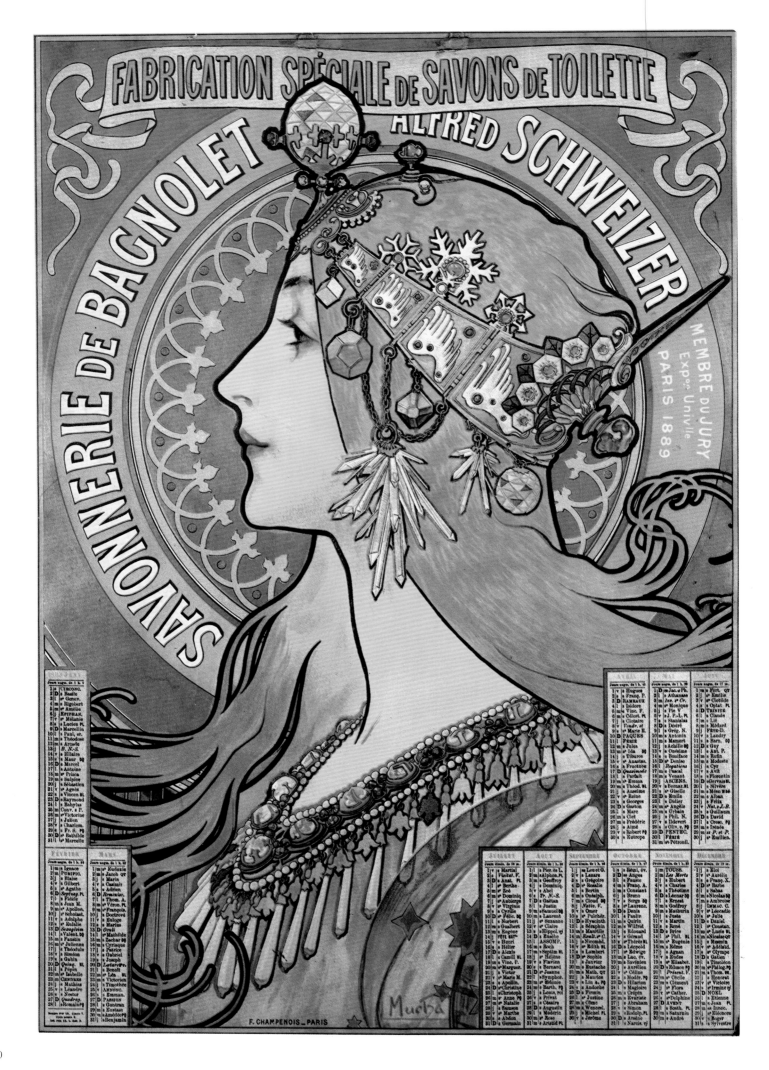

Byzantine Head-Blonde
1899
Very successful postcard from a
decorative panel of profile in
cameo

Opposite:
Savonnerie de Bagnolet
Calendar for a soap manufacturer
1897
$14^1/_2$ x $20^1/_4$ in. (37 x 51.5 cm)

Morning Awakening
1899
Exceptional-quality postcard identical to
the original panel

Opposite:
Perfecta Cycles
1902
Poster for the English bicycle
manufacturer,
each dealer put on his own stamp or
added a sticker.
41 x 60⁷/₈ in. (104.3 x 154.6 cm)

version found duty on a poster advertising soap. The subjects ranged from allegories of the seasons to flowers, the moon, the stars and even emblematic portraits (*Byzantine Head*, 1897). No matter which subject was treated (*Morning Awakes, Evening Reverie, Amethyst, Ruby*, etc.), each fully represented Mucha's feminine ideal. Some of the panels measure up to a meter or slightly more; their normal size is 24 to 28 in. by 14 to 16 in. (60 to 70cm x 35 to 40cm). A series on any given theme could easily be adapted to decorating interiors.

Aside from the series of decorative furnishings for the home, whether original works or inspired by the posters, he had the designs silk-screened or reproduced on large sheets of paper. Avid collectors grabbed them up as fast as they were made. The printer did not sniff at producing calendars, menus and postcards—minor items that would bring the "Mucha chic" into daily life.

The postcard trade had developed tremendously since 1870, when the Western powers reached an agreement that facilitated the use of this inexpensive form of correspondence. The astute printer, therefore, systematically reproduced the subjects from the posters and decorative panels. It is easy to imagine the piles of Mucha postcards sold to the visitors of the 1900 World's Fair and sent through the mail. Simultaneously, numerous printings of promotional subjects of all kind would be reproduced, like *Souvenirs de la Belle Jardinière*. When Mucha dedicated himself to militant action for Czechoslovakia, he had many postcards of his own design published until the end of his career.

At the same time, Mucha worked relentlessly on posters for French and foreign companies. (He often felt that Champenois, his impresario, was too pushy.) This body of work constitutes a perfect catalog in honor of the leading brand names of the time. The bicycle, then called *La Petite Reine,* was the master of locomotion before the coming of the motor car. Mucha made a poster for Waverley Cycles, an order from the manufacturer's American agent in France (1898). The very subtle design hardly shows us the handlebars but depicts a "truly Mucha" young woman of an athletic disposition. She is holding a laurel branch to symbolize the victories of the Waverley. He did another poster that was shown throughout Europe for the English manufacturer's model, Perfecta (1902). This more explicit poster presents a Perfecta cycle being ridden by a young girl whose wavy hair flying in the wind symbolizes speed.

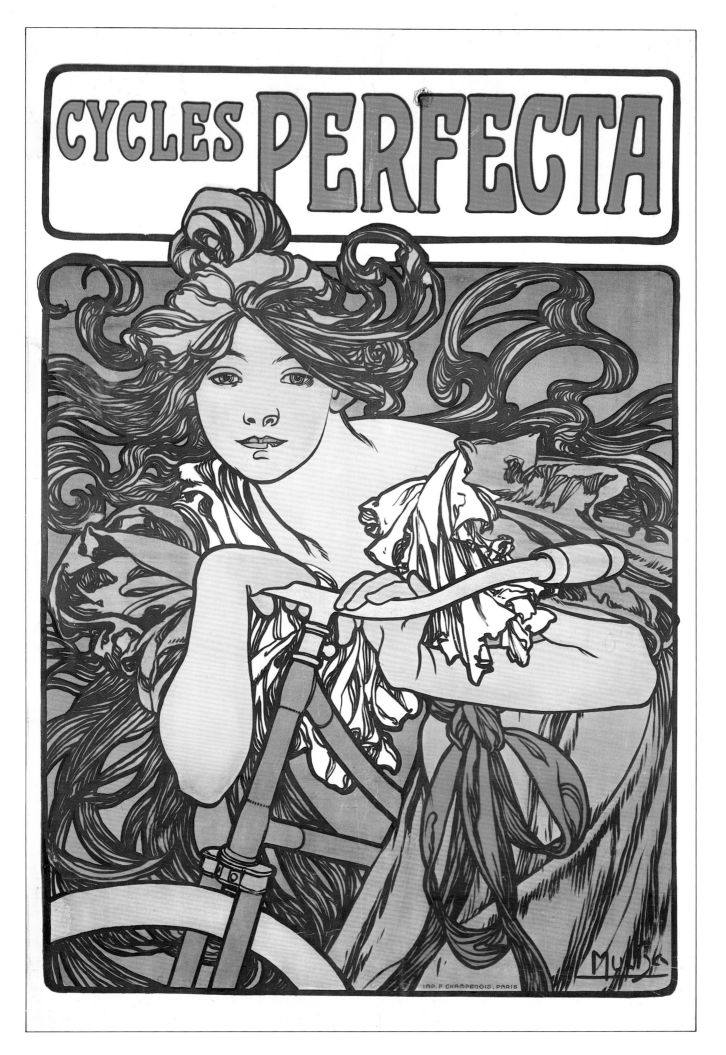

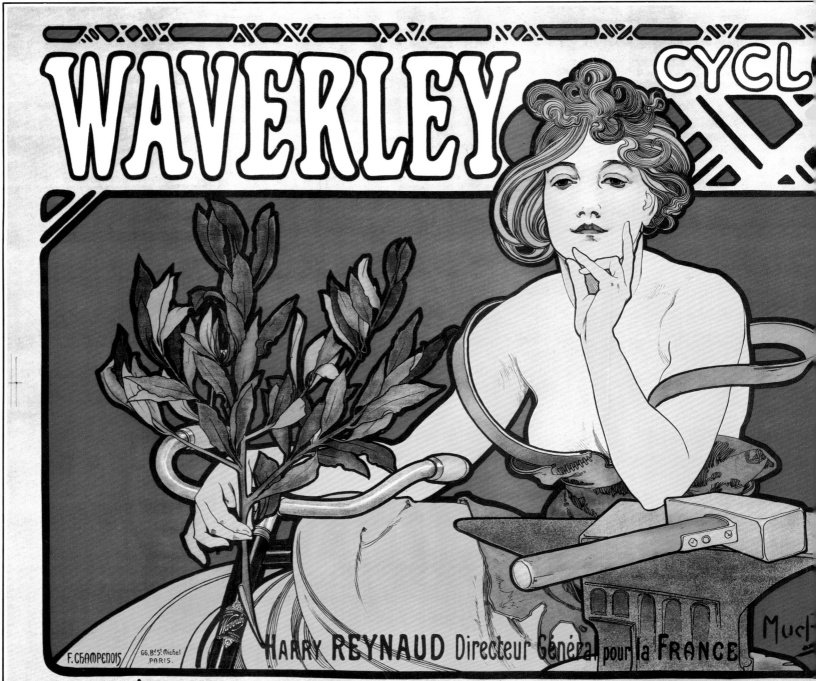

Waverley Cycles
1898
Postcard reproducing the poster

Opposite:
Waverley Cycles
1898
Poster for very sturdy American bicycles
built in Indianapolis, Indiana
45 x 34⁷/₈ in. (114.2 x 88.5 cm)

Brunette
1911
Postcard (left side) reproducing a
poster from 1898 for cigarette paper

Opposite:
Nestlé's Food for Infants
1897
Poster for the firm's British subsidiary
13½ x 28⅜ in. (34.5 x 72 cm)

VARIATIONS ON THE THEME OF WOMAN

No matter whether it involved a brand of champagne, a soap powder or a liqueur, the theme always revolved around artful variations of the "Eternal Woman" that Mucha had typified. This personal evocation of the female form varied according to the subject-matter. The design of a young mother giving baby food to her child (executed in 1898 for Nestlé) was made up of endless curves in the same way as *Mademoiselle Job* (1897) was based on the spiral. The sophisticated brunette, who has just rolled a cigarette with this famous paper, does not appear at all disreputable, but is certainly not preoccupied with the joys of motherhood.

We can enlarge on these examples to demonstrate the ease with which the painter gave the "Mucha female" a dual value; a way of being herself and yet someone else too. Moët et Chandon's *White Star*, the champagne of traditional family gatherings, was a little sweet, in keeping with the taste of the times. It was the drink that ladies would accept while they whispered: "Just a drop, please." The young woman in the poster, wearing a pink gown with a spiraled train, is surrounded by flowers and holds a grape-filled basket. Even the fruit seems to have been grown with love. Another young beauty shows off *Brut Imperial*—a champagne recently put on the market to cater to American taste. Again this represents a Mucha female with Byzantine overtones. She is not holding a basket of grapes but a richly-enameled cup that promises sweet cosmopolitan lightheadedness.

Of all his various clients, Mucha surely gave his best to Lefèvre-Utile, the biscuit-maker from Nantes. His biscuit boxes remained famous for a long time. He also created a series of posters that caused the manufacturer to become—after Sarah—his major client. His last poster shows the actress in an evocative pose from *La Princese Lointaine.* She had written on the red dress worn by Mélisande: "I cannot think of anything better than a *Petit LU*; oh, yes, I can, two *Petit LU* (s)". This poster is the only one of all those created by the Czech painter advertising a brand that exploits the image of a celebrity.

The wide variety of *LU* biscuits provided great scope for Mucha's imagination, and he took full advantage of it. *LU* champagne biscuits, which had become synonymous with an elegant lifestyle, provided the theme for two of his posters. One of them shows a young couple in a Belle Epoque setting, but dressed in Directoire fashions. They are engrossed in private conversation and dip their biscuits into a glass of sparkling wine. The other poster is much richer in every sense of the word. In the corner of an elegant salon, two curvaceous

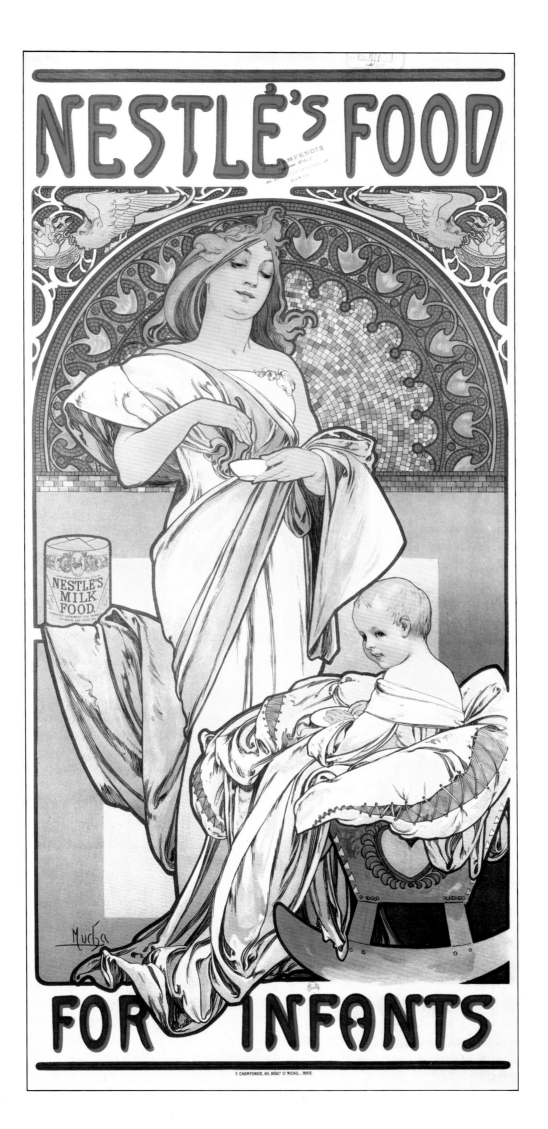

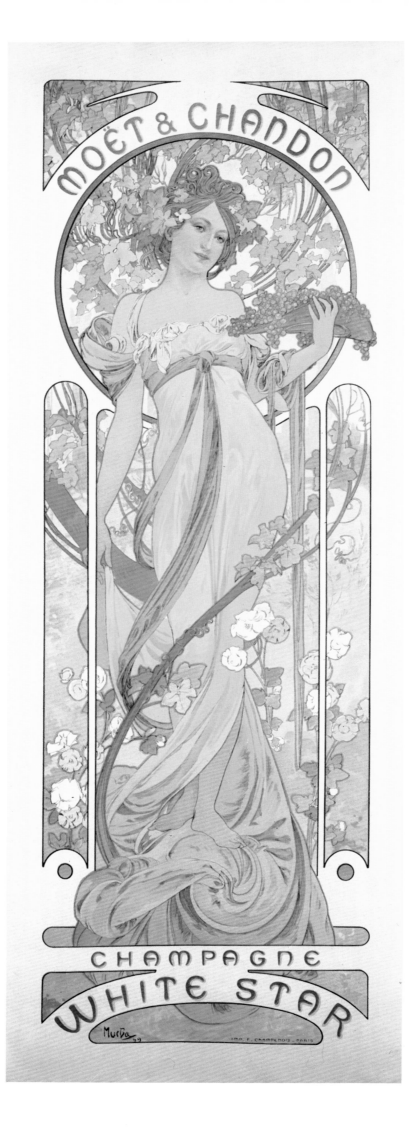

Moët & Chandon
White Star
1899
Poster for champagne
9 x 23⁷⁄₈ in. (23 x 60.8 cm)

Moët & Chandon
Crémant Impérial
1899
Poster for champagne
9 x 23⁷/₈ in. (23 x 60.8 cm)

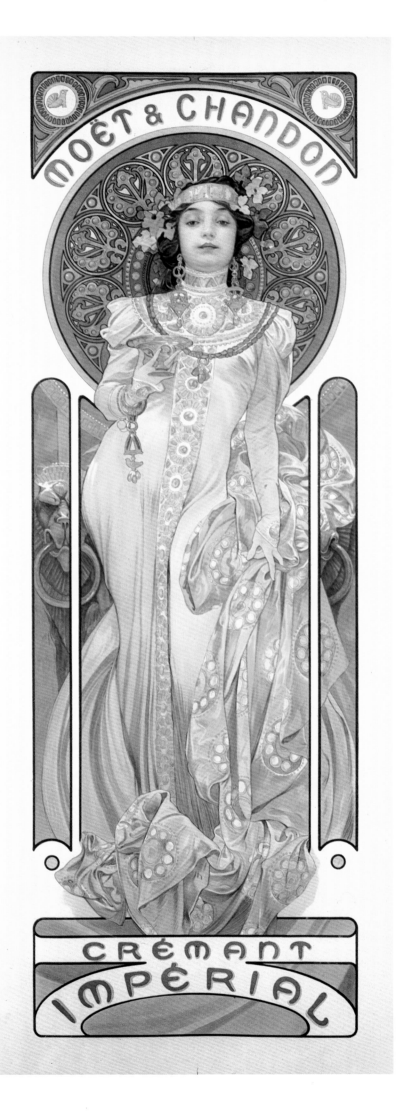

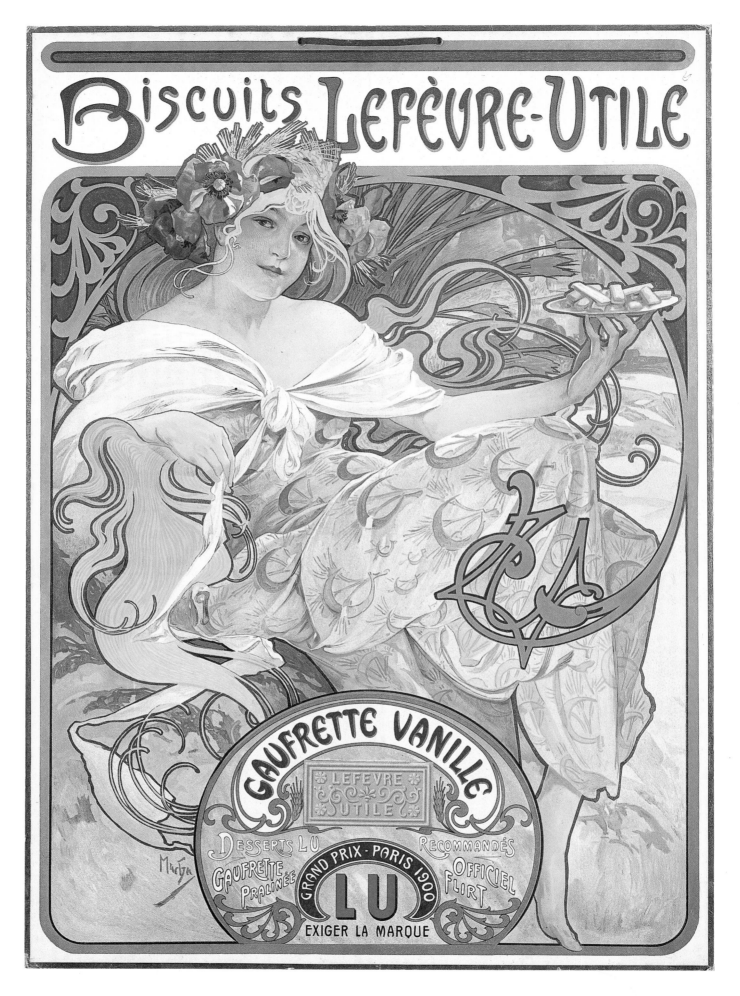

Biscuits Lefèvre-Utile
1896
Color lithograph, first used as a calendar for 1897, then as a poster. 17½ x 24⅛ in. (44.4 x 61.4 cm)

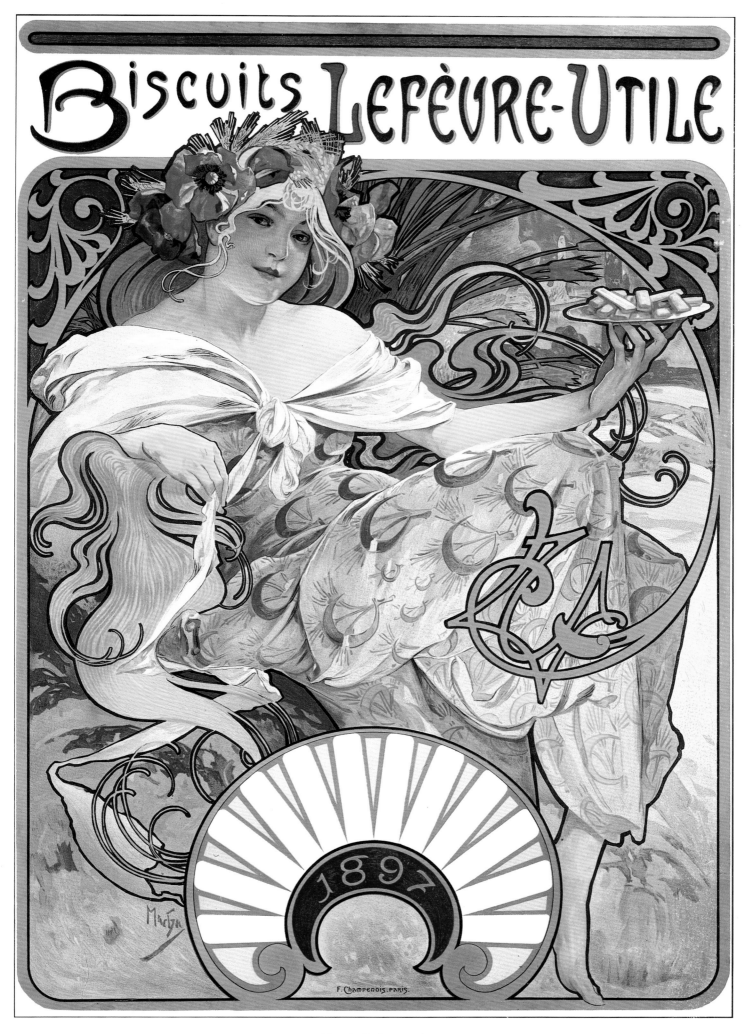

Biscuits Lefèvre-Utile
1896
Color lithograph used as a 1897 calendar. 17 1/8 x 24 3/8 in. (43.5 x 62 cm)

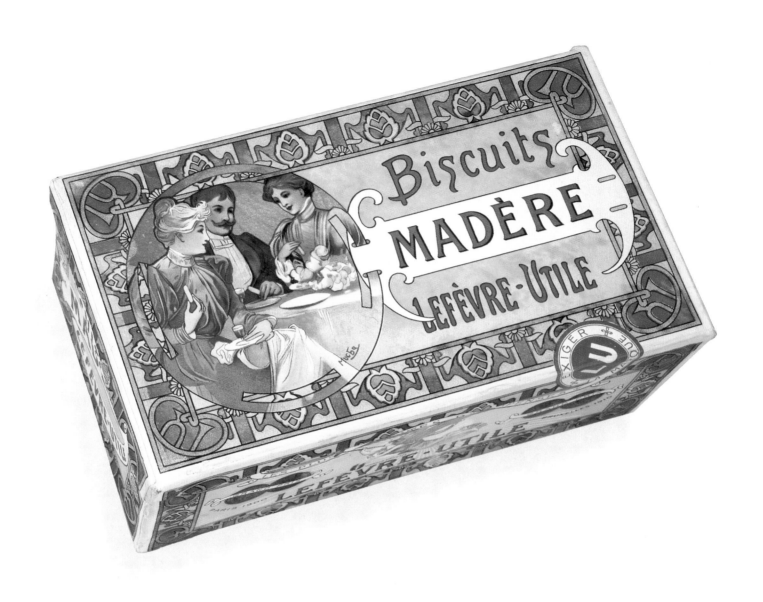

Lefèvre-Utile
1900
Biscuit tins

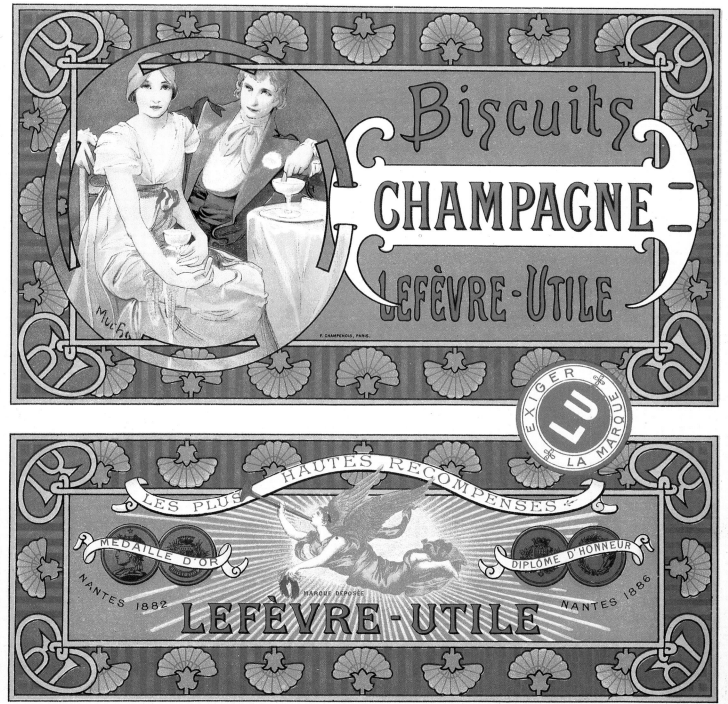

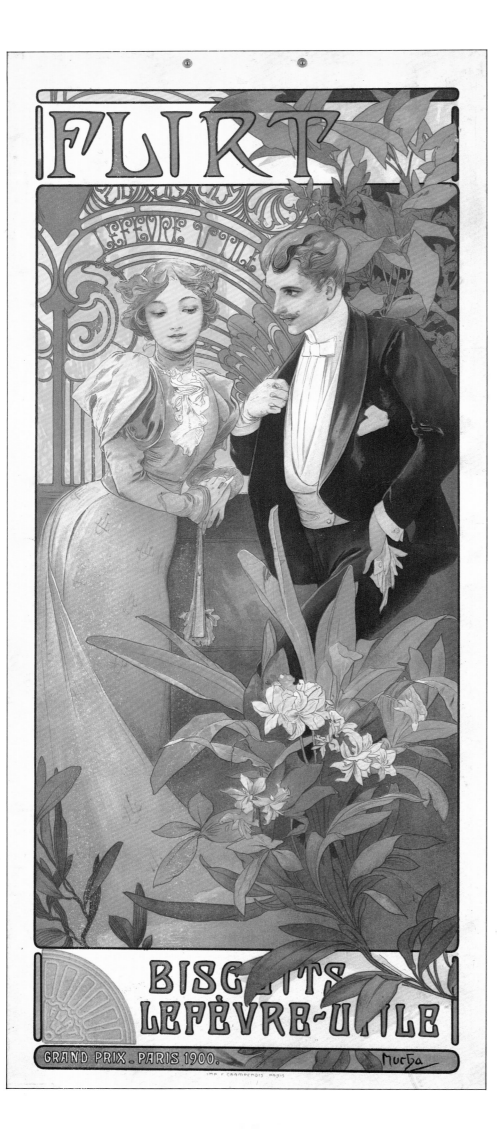

Flirt
1899
LU Biscuit poster distributed to
dealers for indoor display
11¾ x 25¼ in. (30 x 64.2 cm)

Lefèvre-Utile
1900
Biscuit wrapping

young women flirt with a dashing gentleman who is dressed as one should be dressed: a flower in the buttonhole of his tail-coat, white gloves and holding an opera hat. One of the ladies, under the spell of the moment, gazes at the young man without really taking in the large box of champagne biscuits and several bottles on a side table.

The English word "flirt," the latest expression in fashion, had just recently been imported to France. Lefèvre-Utile used it for one of its biscuits. It is a word that is full of overtones. In the image depicting the couple in the poster, the "flirt" is pure. The young virgin gracefully clothed—one of Mucha's most beautiful creations—remains very coy, her eyes downcast as she listens to a young man dressed in evening clothes. The man, however, has his eyes wide open. The scene is set in a winter garden graced with a good example of Belle Epoque ironwork. The couple is surrounded by the kind of plant and flower arrangements that only Mucha knew how to design. Love is on hand; a betrothal is imminent, and the dowry will certainly not be overlooked.

Lefèvre-Utile
1902
Two biscuit wrappings

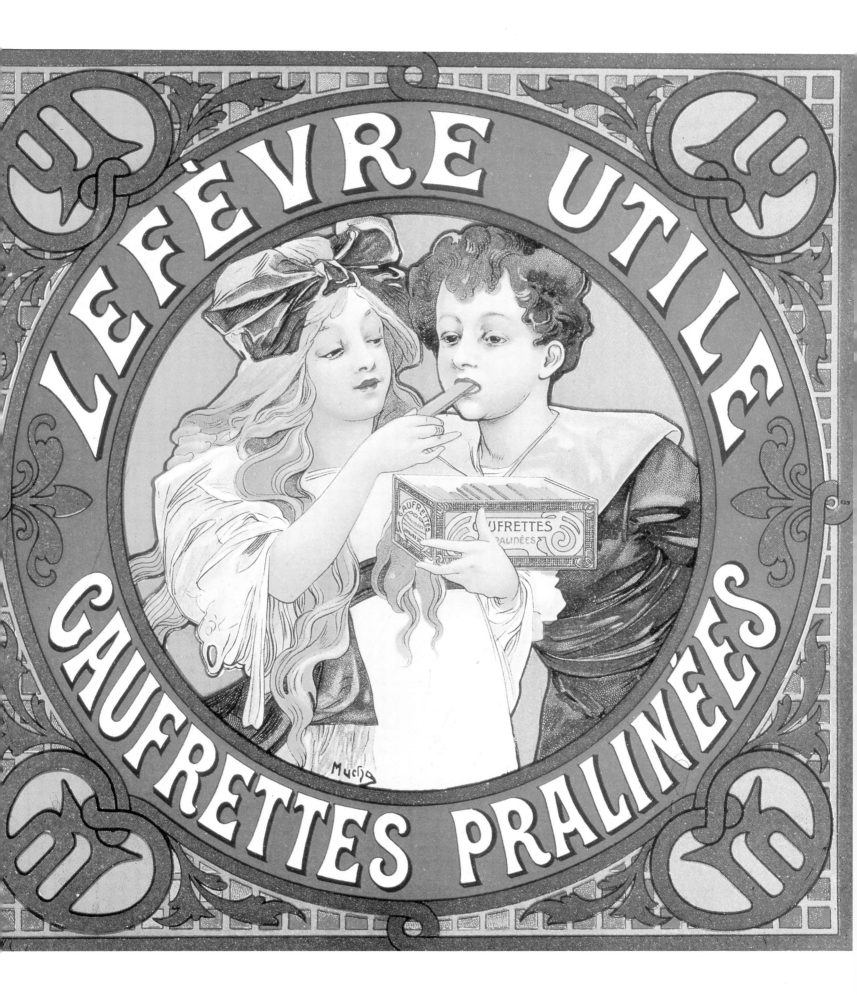

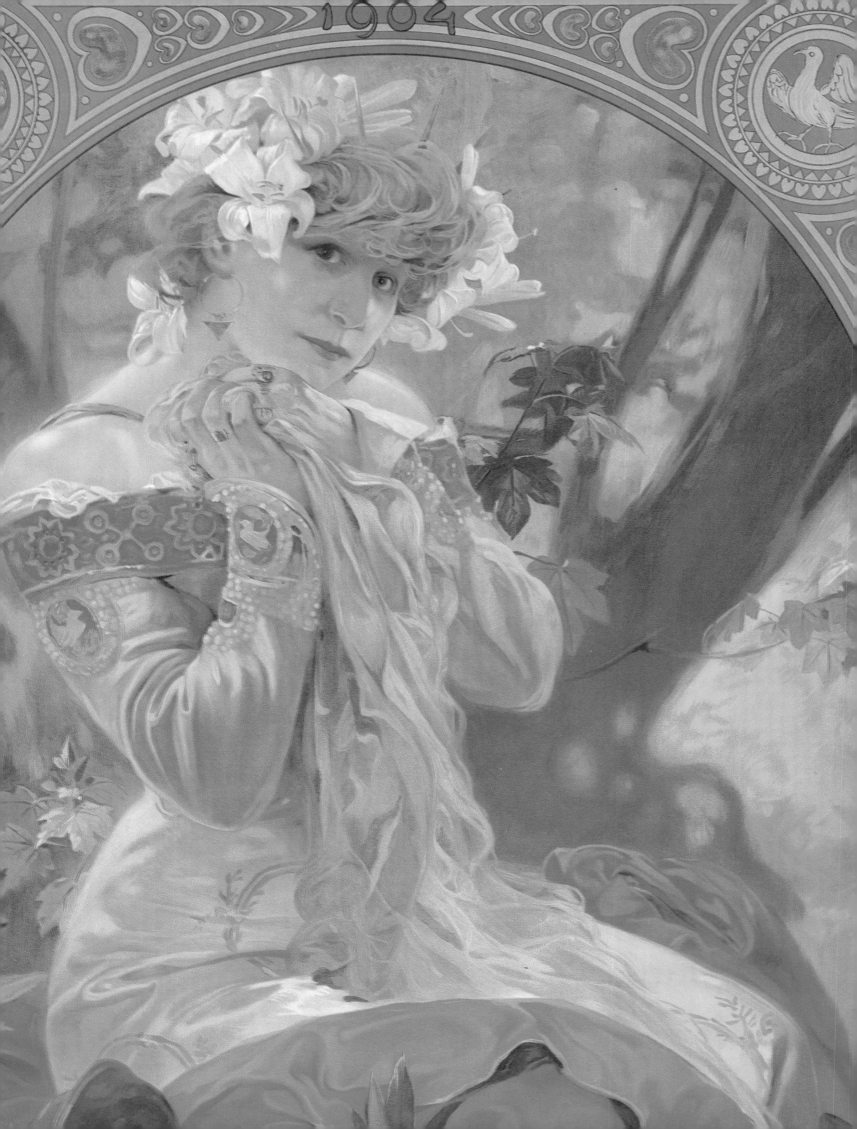

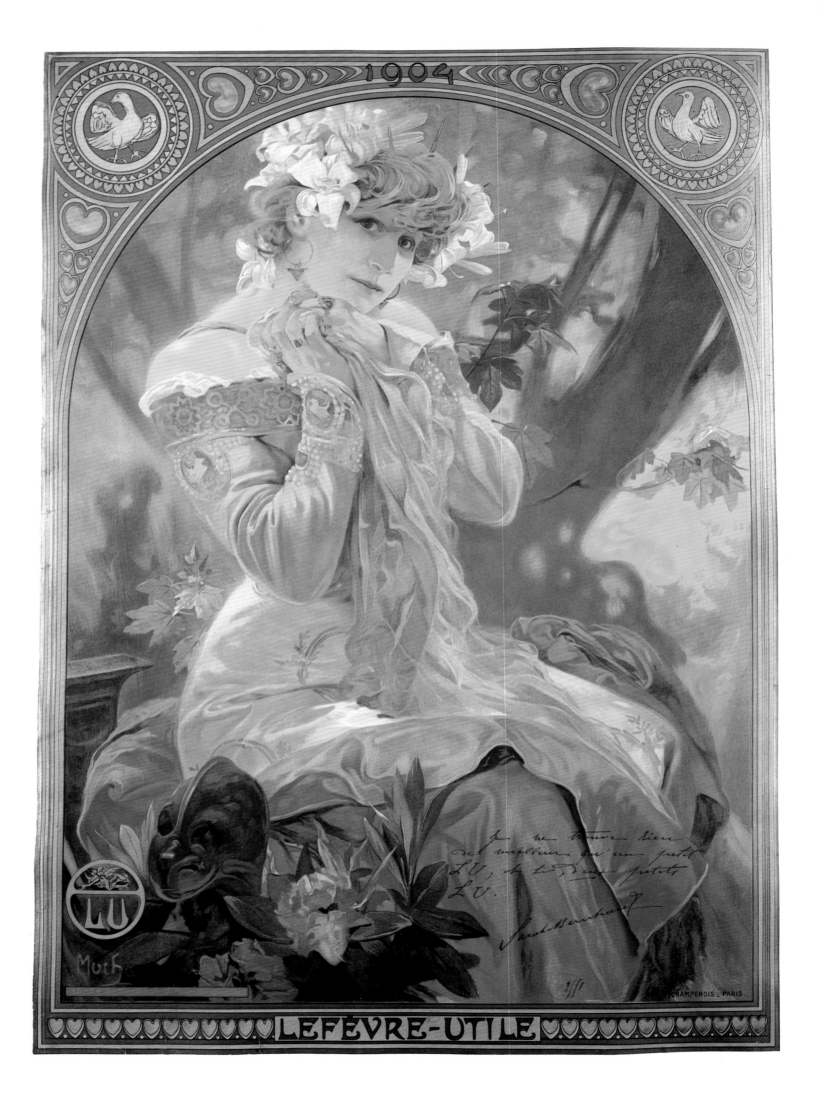

Lefèvre-Utile
1904
Postcard reproducing poster on facing page

Opposite:
Lefèvre-Utile
1903
Poster publicizing LU biscuits with Sarah Bernhardt in *La Princesse Lointaine* by Edmond Rostand, one of her greatest successes; with a handwritten testimonial by the actress herself
$20^{7}/_{8}$ x $28^{3}/_{8}$ in. (53 x 72 cm)

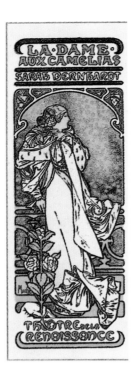

La Dame aux Camélias
1898
Postcard reproducing the poster for
Sarah Bernhardt's production;
the stars and the lettering were
printed in silver ink

WORKING FOR *LA DIVINE*

At the same time that he was extolling the merits of bicycles and of biscuits, Mucha continued to work for Sarah. The second poster that she commissioned him to do, while she was away on one of her many tours in America, was for a play to be performed at the Théâtre de la Renaissance. Mucha also designed one for Maurice Donnay's play, *Amants* (1895), starring Jeanne Granier and Lucien Guitry. This poster with a horizontal format was very unlike the ones he generally made for Sarah; it depicted a group of people in a decor closely resembling the interior of Maxim's, the restaurant which had opened three years earlier.

Immediately afterwards, he designed one of his most glorious posters for the theater—*La Dame aux Camélias.* Sarah, having decided to stage Dumas *fils'* famous play from 1852, had to compete with Jeanne Granier, then a runaway success in *Madame Sans-Gêne.* At the same time, Coquelin was making a name for himself in *Cyrano,* and Eléonora Duse, the famous Italian dramatic actress was generating tremendous enthusiasm in Paris with her own version of Dumas' drama. Even so, *La Dame* became Sarah's most popular role and she was to perform it over three thousand times. One could almost say that it was she who did the poster justice! Mucha already knew the best way to prepare for the opening. His poster, certainly one of the most beautiful, appeared all over the capital on the evening before the premier performance (September 30, 1896). It truly expressed all the pathos of the heroine's tragic end, and with the greatest simplicity of means.

There were other posters just as successful, both for the artist and for the actress. Tempted by masculine roles, Sarah wanted to put on a drama by Alfred de Musset that had never been produced before. She was fascinated by the part of the main character, inspired by Lorenzo de' Médici, who gives the work its title, *Lorenzaccio.* Mucha's poster shows *La Divine* impersonating a young man dressed in a highly-stylized Renaissance costume. An arch bearing the inscription SARAH BERNHARDT ANNO DOMINI MDCCCXCVI frames the meditating Florentine prince wrapped in a long trailing coat curling into an elegant swirl. This poster, considered one of the artist's masterpieces, hangs at the Actor's Studio in New York— the Mecca of the dramatic arts in America. The posters of *The Samaritaine* (1897), *Medea* (1898), *Hamlet* (1898), *Tosca* (1899) are all brilliant variations with Sarah as subject; they are admirable evocations of the characters personified by *La Grande* who, at the age of fifty, still appeared extremely youthful.

Only one of Mucha's creations never became successful; it was done for *L'Aiglon* (1900), another of Sarah's

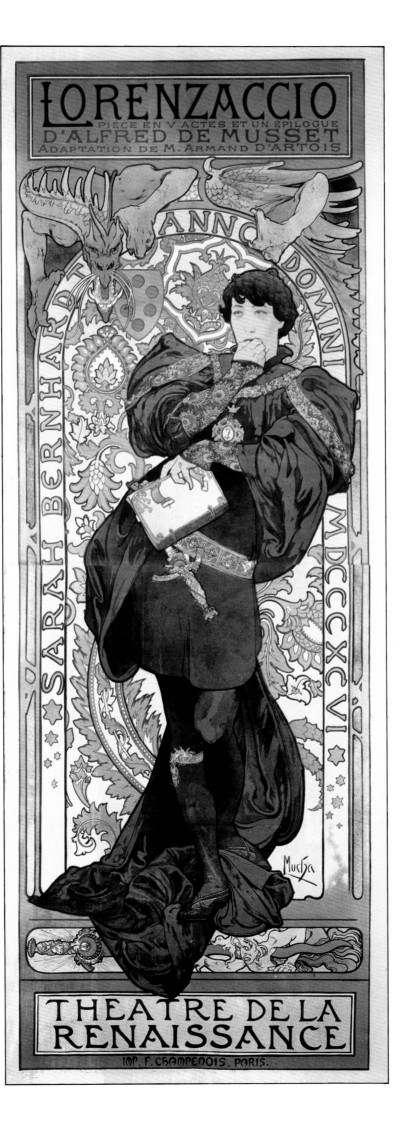

Lorenzaccio
1896
Poster for Alfred de Musset's
play with Sarah Bernhardt in
the male title role at the
Théâtre de la Renaissance
29⅞ x 80⅛ in.
(76 x 203.7 cm)

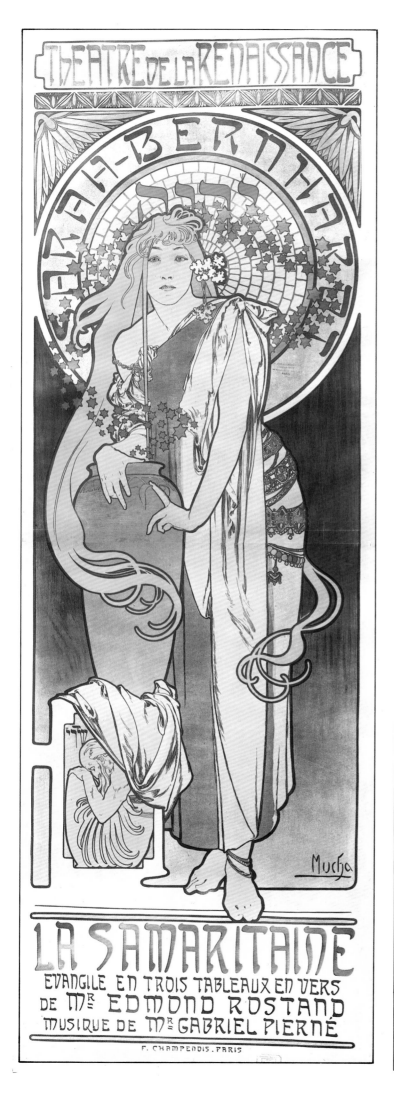

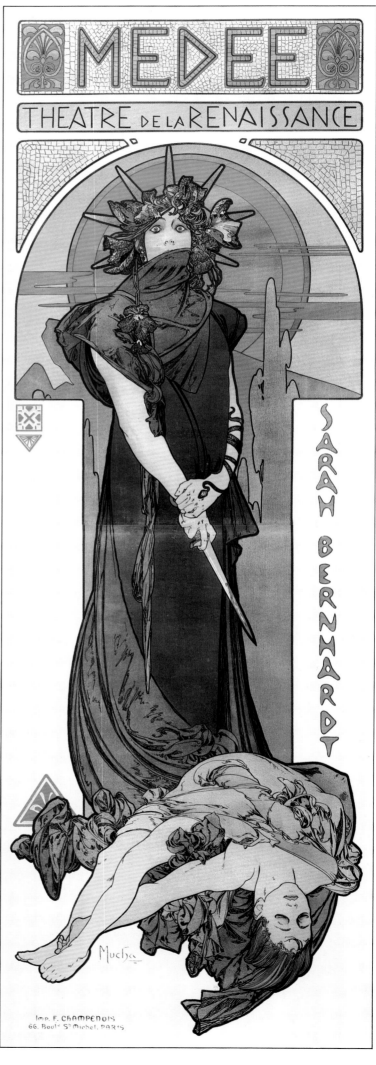

Opposite page, left:
La Samaritaine
1897
Poster for Edmond Rostand's play with Sarah Bernhardt
at the Théâtre de la Renaissance
22⅞ x 68 in. (58.3 x 173 cm)

Opposite page, right:
Médée
1898
Poster for Catulle Mendès' play with Sarah Bernhardt at
the Théâtre de la Renaissance
29⅞ x 81 in. (76 x 206 cm)

Hamlet
1899
Poster for the French adaptation of Shakespeare's play
with Sarah Bernhardt, below Ophelia recumbent
30⅛ x 80⅞ in. (76.5 x 205.7 cm)

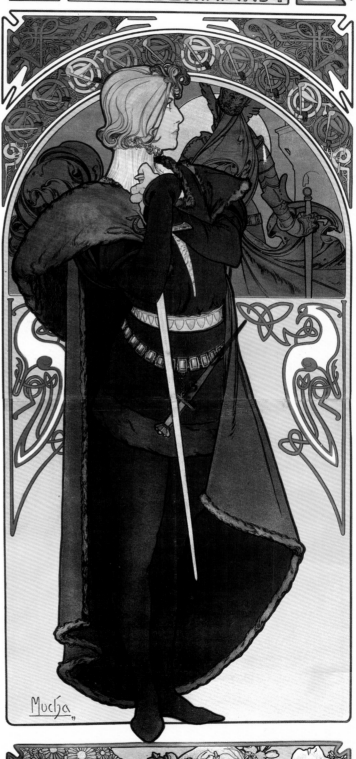

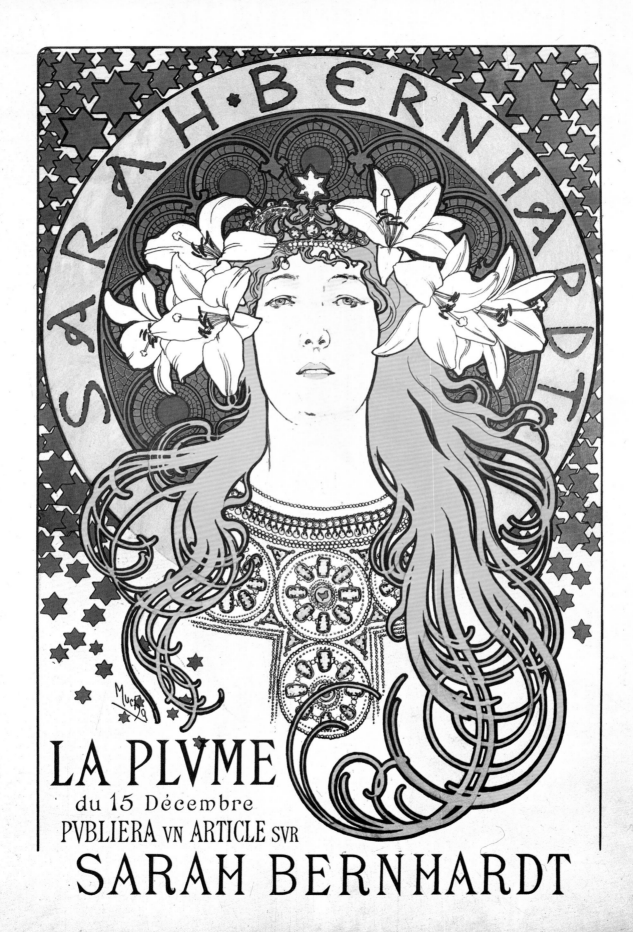

Sketch for Documents Décoratifs
1902
Crayon on paper. 17³/₄ x 13³/₄ in. (45 x 35 cm)

Opposite:
Sarah Bernhardt
1896
Poster for *La Plume*. 19 x 26¹/₄ in. (48.5 x 66.6 cm)

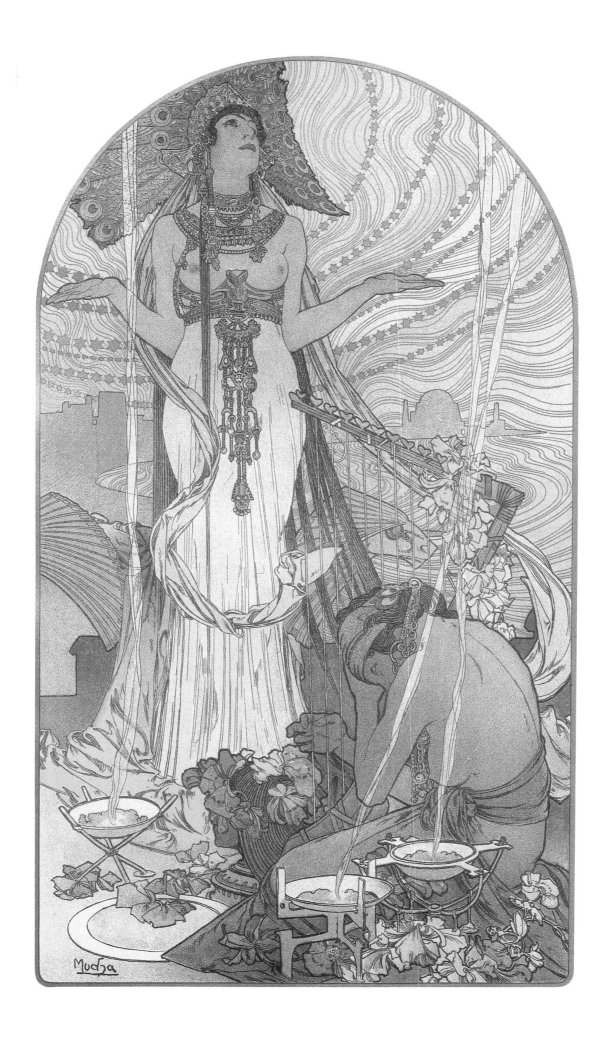

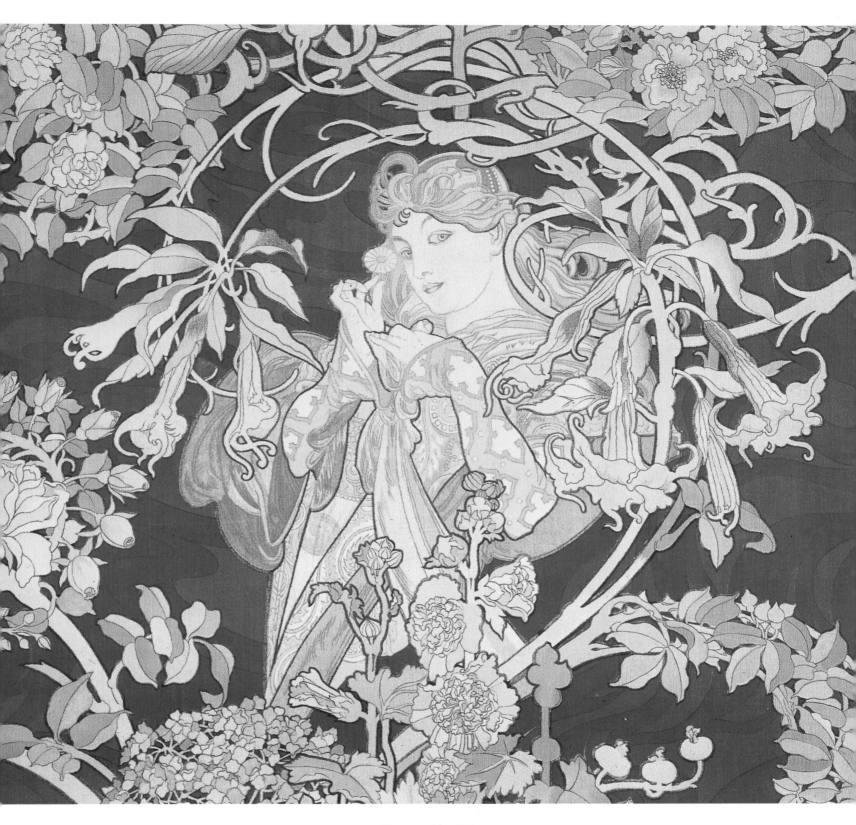

Woman with a Daisy
1898-1899
Printed velvet
$31^{1}/_{2}$ x $23^{5}/_{8}$ in. (80 x 60 cm)

Opposite:
Salammbô
1896
Color lithograph
$15^{3}/_{8}$ x $8^{1}/_{8}$ in. (39 x 21,5 cm)

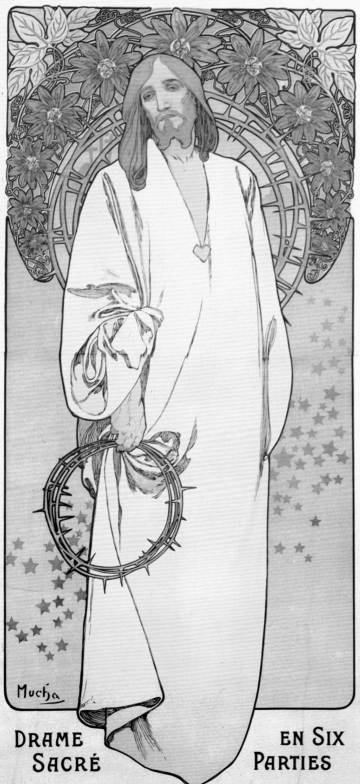

La Passion
d'Edmond Haraucourt

DRAME EN SIX
SACRÉ PARTIES

MUSIQUE DE JEAN SÉBASTIEN BACH

Adaptaption à l'Orchestre de M.M^{rs} P.L.HILLEMACHER

L. PATRIS Impresario IMP. F. CHAMPENOIS _ PARIS

La Passion
1904
Poster for the revival of Edmond Haraucourt's play at the
Théâtre de l'Odéon
29 1/8 x 79 1/2 in. (74 x 202 cm)

Opposite:
The Litany of the Virgin
1898
Designed by Mucha, stained-glass acid engraved by
Champigneulle, for the Assumptionist Chapel in Rue
François 1^{er} in Paris, the chapel no longer exists, the
windows are at the Musée d'Orsay
20 x 4 3/4 ft. (590 x 146 cm)

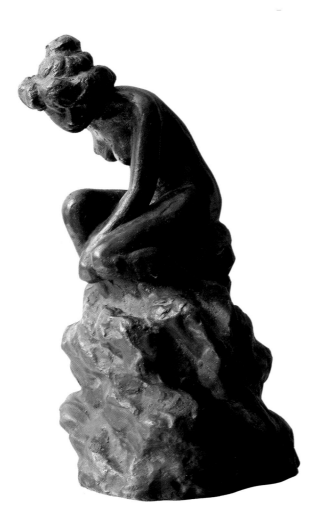

Nude on a Rock
1899
Bronze
10⅝ in. (27 cm)
(Mucha Collection)

Opposite:
The Pavilion to Man
1899
Pencil on paper
25⅝ x 19⅝ in. (65 x 50 cm)
(Musée d'Orsay)

brilliant triumphs. The play opened on March 15, a month before Paris' famous World's Fair (Exposition universelle). In the agitation that preceded the event, Champenois fell far behind schedule. His lithographs for the cover of the program turned out badly transposed and poorly printed.

THE 1900 EXHIBITION

Mucha, whose name is synonymous with the style of the 1900's, was solicited from all sides for the events marking the beginning of the new century. The name, "the Mucha Style," entered factories and workshops. The artist was heard to say later on: "My art was in fashion. My only recollection of all this," he added, "is of being exhausted." He even made a statue of a woman, gilded and crowned with a diadem, for Houbigant perfumes, upon which the *Figaro* newspaper remarked: "*Maître* Mucha has created the floral quintessence of the perfume trade." The statue sat in the middle of the perfumer's showroom surrounded by violets, irises and roses.

He found himself associated with Rodin, Falguière and others, in an extravagant project for the World's Fair pavilion dedicated to Man on the esplanade of the Eiffel Tower (which was supposed to be torn down). He created the decors commissioned by the Bosnian government for their pavilion, but this work has unfortunately been lost. He also designed the carpets and tapestries for an Austrian firm. One of these was bought for the Elysée Palace. Finally, he participated in the various manifestations of Austrian and Czech art and sculpted a statue for Bosnia-Herzegovinia.

Following the 1900 World's Fair, for which Rodin had erected an independent pavilion for his own work, the Czech Fine Arts Movement—the Mánes Society—invited the sculptor to show in Prague. In 1902, Mucha was asked to accompany Rodin for the opening. As fate would have it, Mucha's future wife, Maruska attended the gala given in Rodin's honor at the Narodni Theater. She was a twenty-year-old student at the time, studying at the School of Industrial Arts and attended this opera performance because of her fascination for the famous Frenchman. However, it was Mucha who caught her eye, and she managed to arrange things so that she would meet him later on in Paris. Mucha persuaded Rodin to leave the city with him for a few days of sightseeing in his native province of Moravia. Everywhere they went, they were wined and dined by the local population. After his return to Paris, Rodin gave Mucha a small bronze as souvenir of their trip together. He added a note with the generous proposal: "If the subject doesn't please you, I'll have them cast something else."

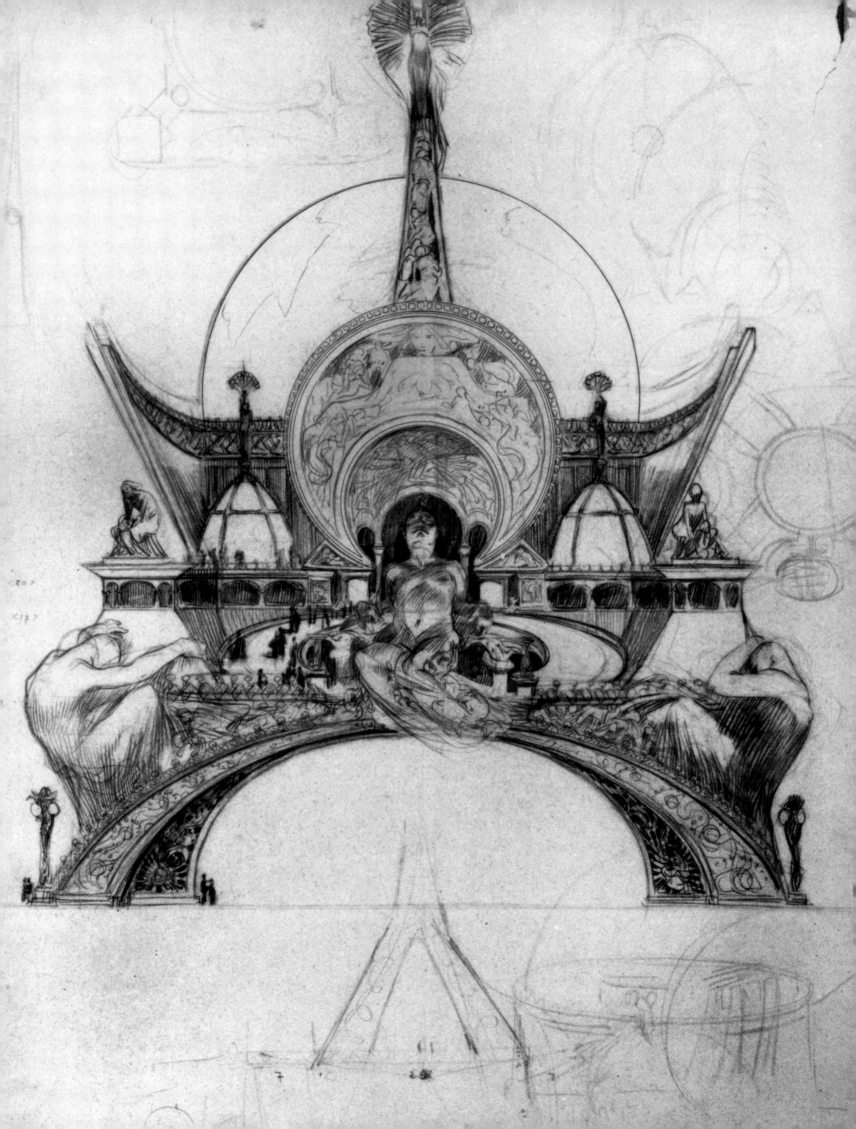

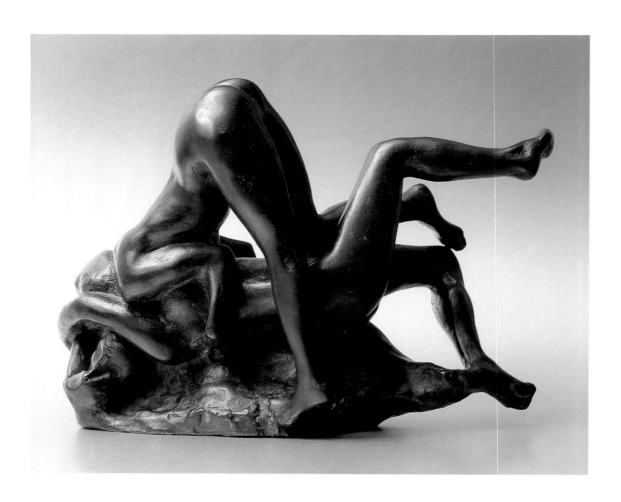

Condemned Women
Bronze by Rodin with dedication to Mucha;
figures from *The Gates of Hell*,
8¹/₄ x 11 x 4³/₈ in. (21 x 28 x 11 cm)
(Prague, Mucha collection)

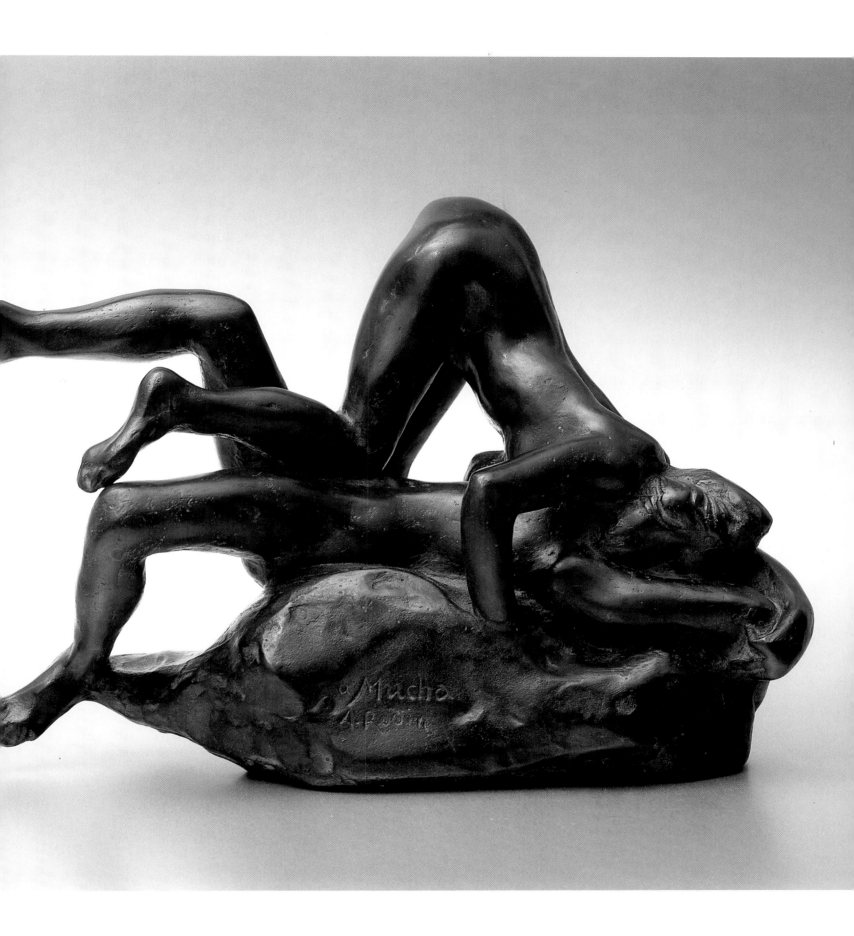

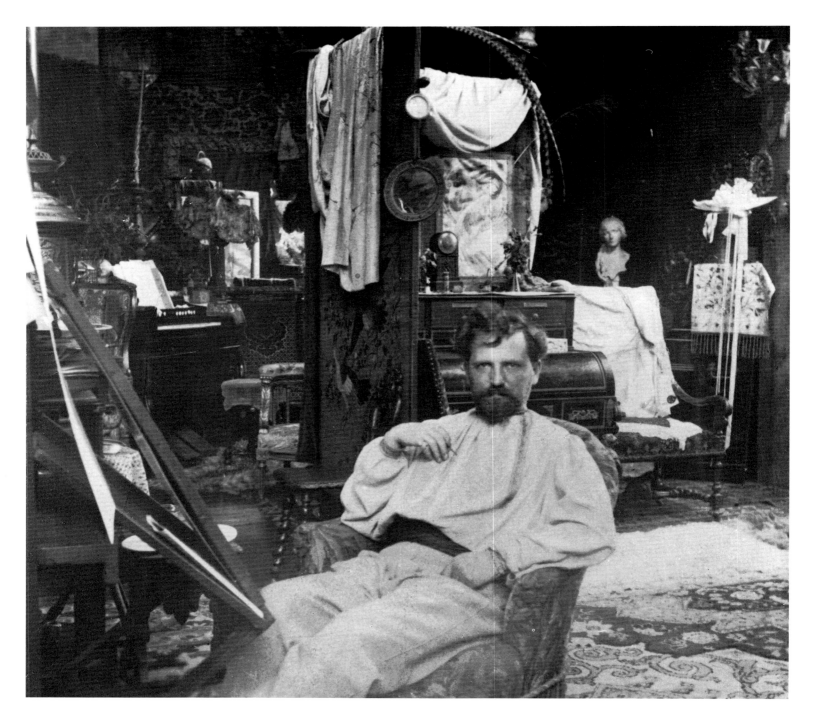

Mucha
1900
In his studio Rue du Val-de-Grâce

Opposite:
Study of Drapery
1900
Crayon with white gouache highlights
24 x 18 in. (61 x 46 cm)
(Mucha Collection)

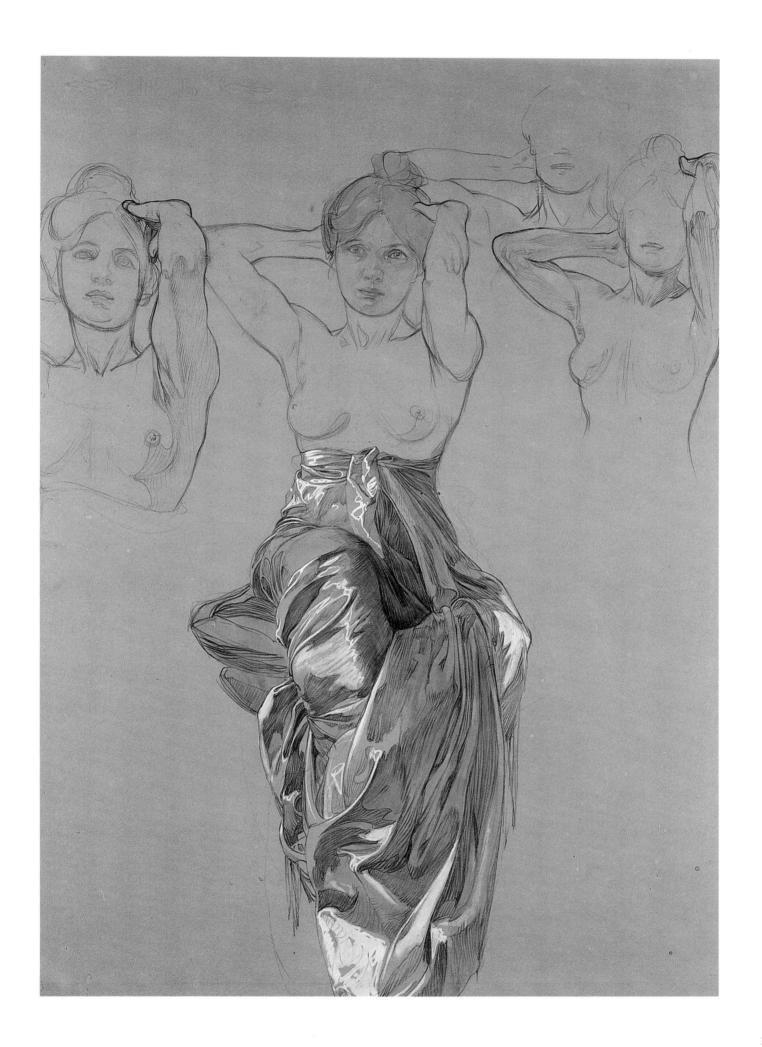

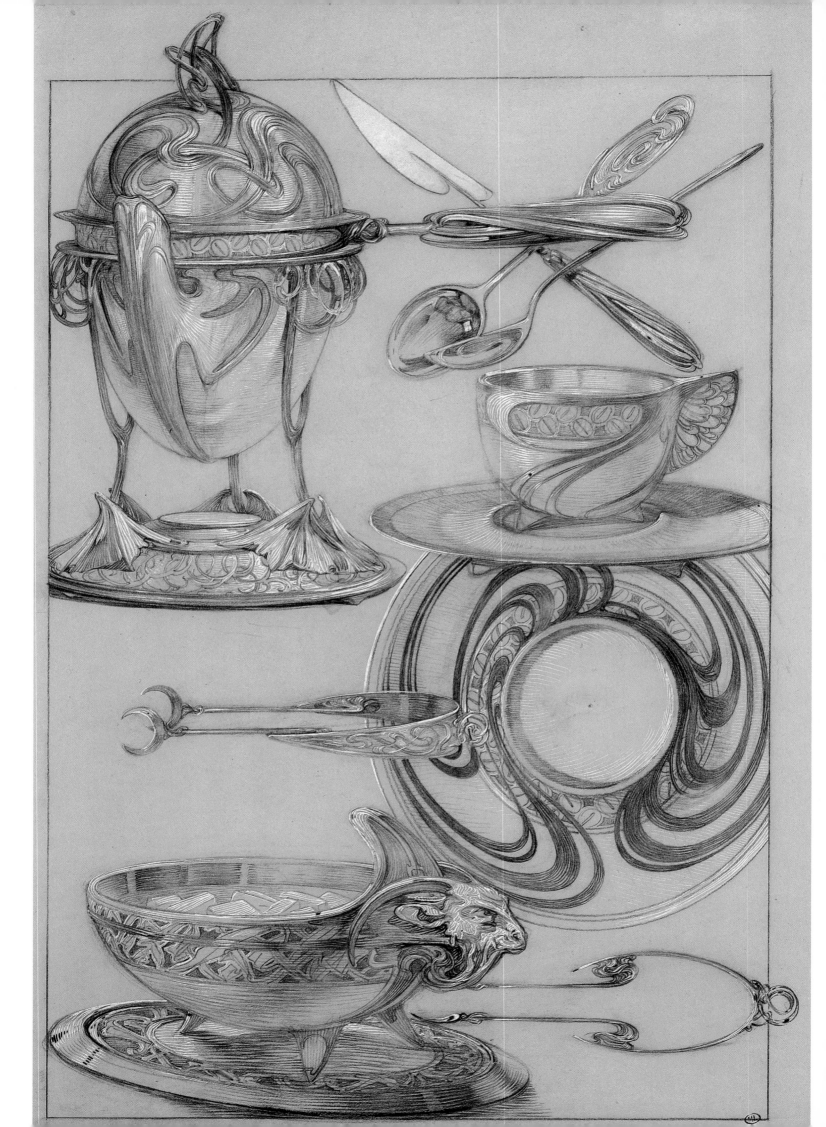

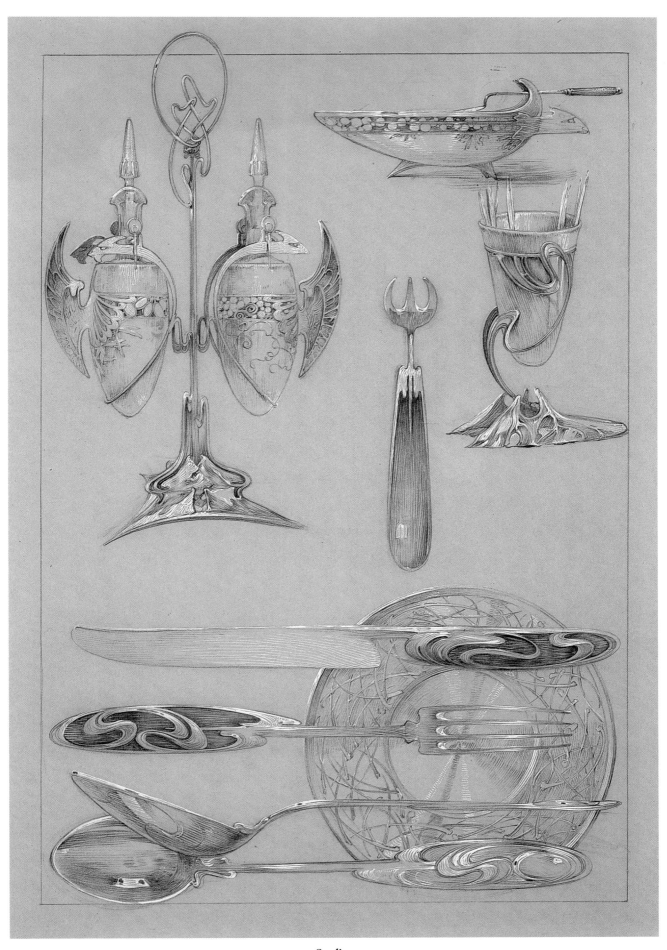

Studies
1902
Illustration published in *Documents Décoratifs*
Crayon with white gouache highlights on beige cardboard
20^1/$_2$ x 15^3/$_8$ in. (52 x 39 cm) (Prague, Mucha collection)

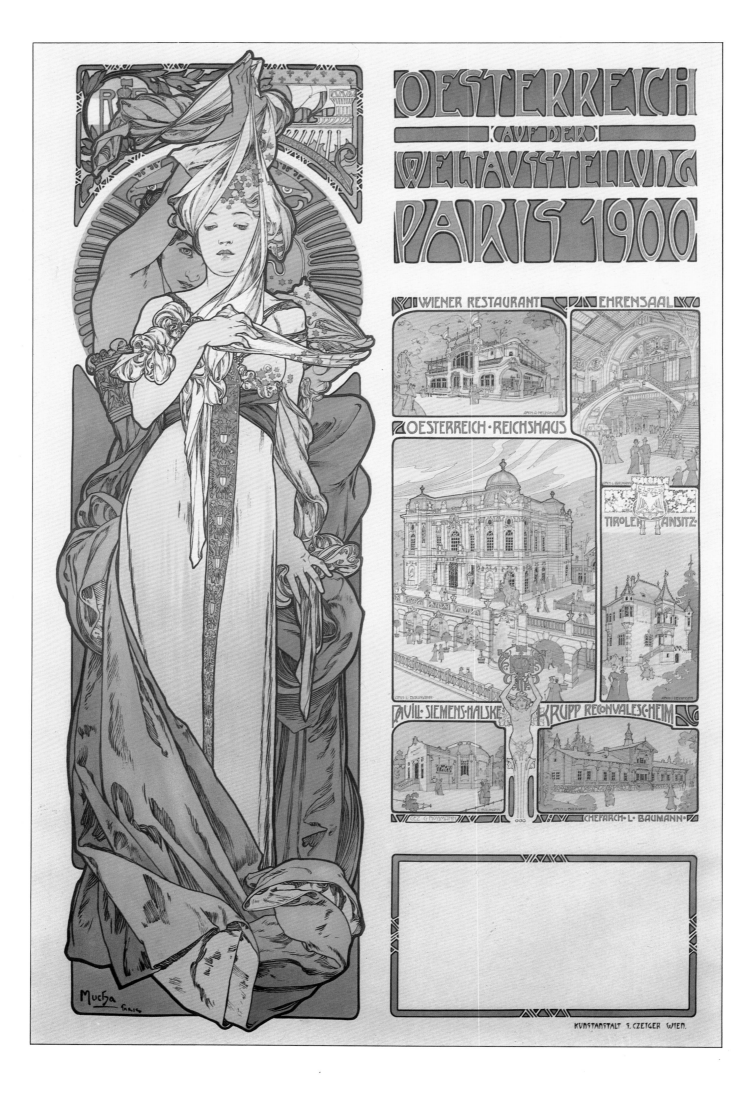

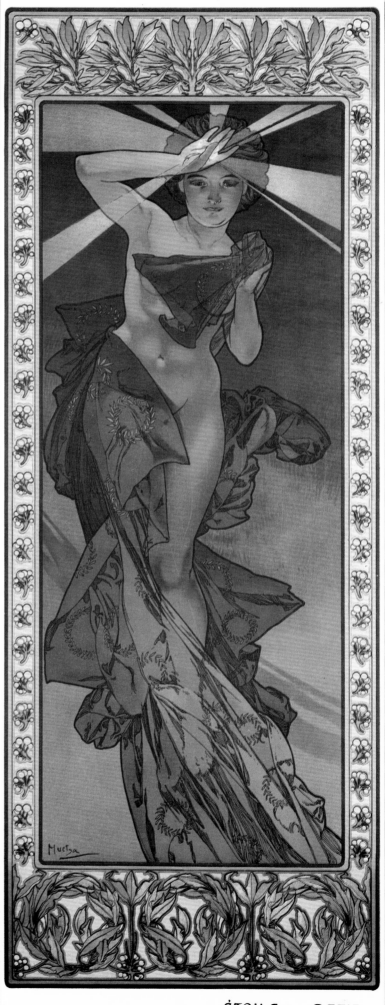

ÉTOILE ᴅᴜ MATIN

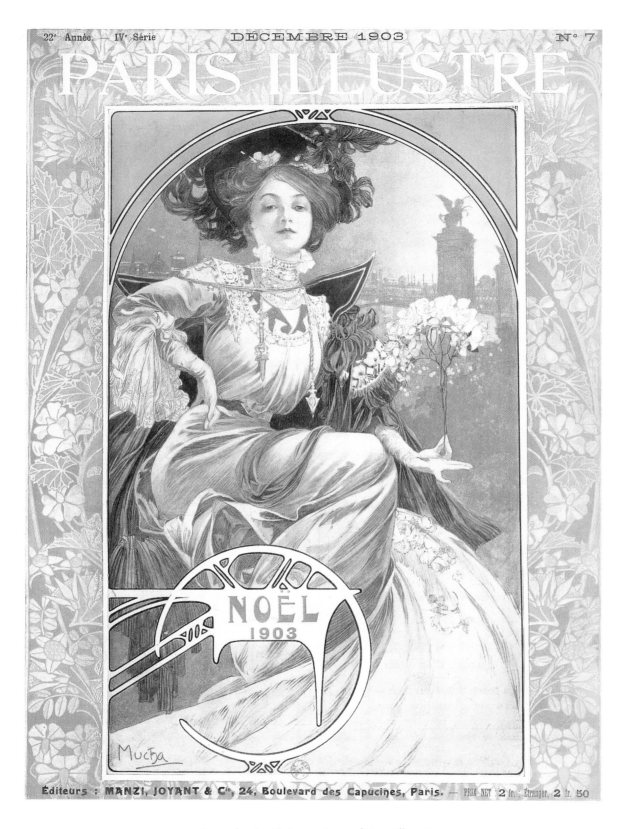

Cover for the Christmas issue of Paris Illustré
1903

Opposite:
Studies
1902
For a plate published in *Documents Décoratifs*
Pencil, ink and gouache on tinted paper
20¹/₂ x 15³/₈ in. (52 x 39 cm)
(Prague, Mucha Collection)

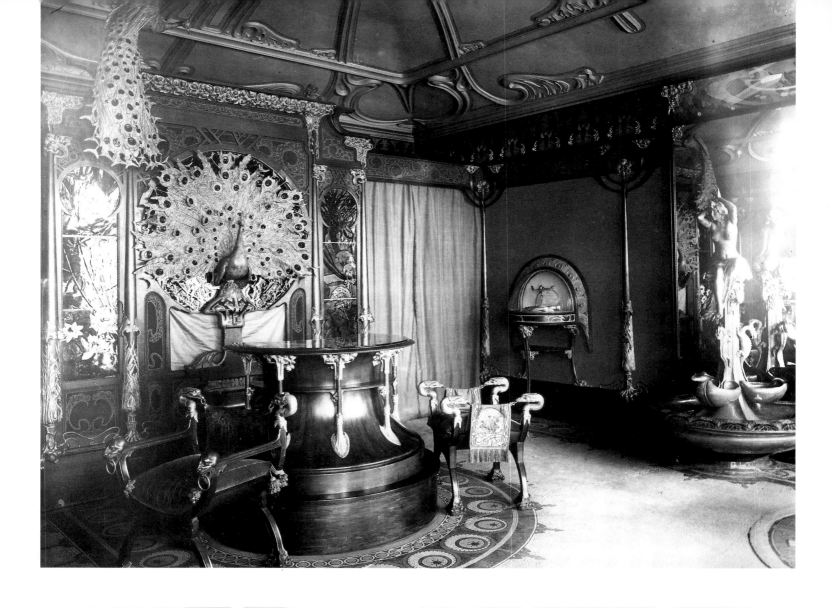
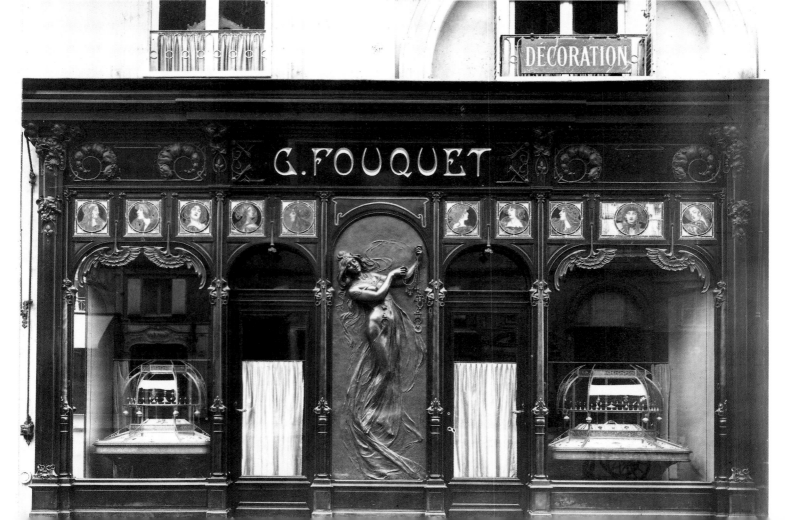

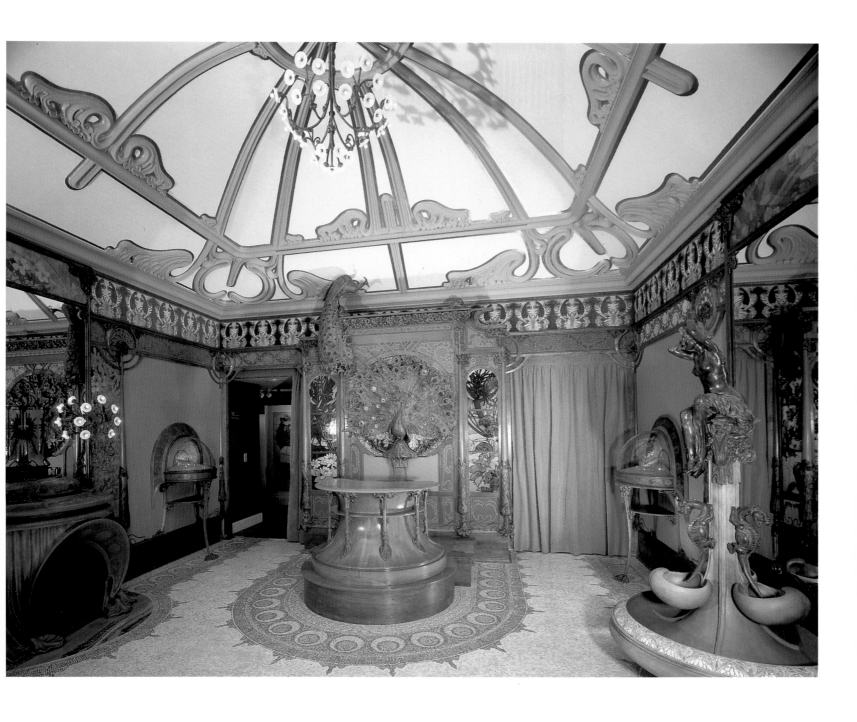

The Fouquet Jewelry store; original elements reconstructed
at Musée Carnavalet in Paris

Opposite:
Photographs of the interior and the store front Rue Royale in
Paris which was subsequently torn down.

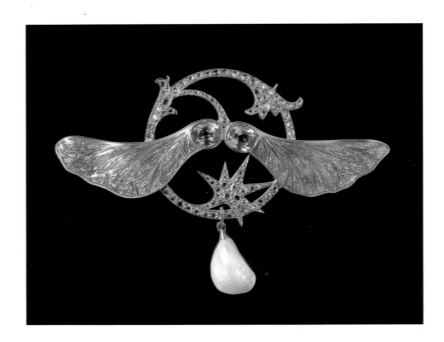

Sycamore
1905-1910
Cloisonné-enamel gold brooch, diamonds, teardrop baroque pearl, gold mount, designed by Mucha for the jeweler Georges Fouquet

Opposite:
Bracelet
1899
Designed by Mucha for Sarah Bernhardt, made by Georges Fouquet

INSPIRED JEWELRY

In time, Mucha preferred to devote himself entirely to painting yet was unable to refuse the orders that kept pouring in. The jeweler and goldsmith Fouquet, a strong defender of Art Nouveau, asked the artist to design a boutique that he was about to open on Rue Royale. A reconstruction of what remains of this rich and harmonious example of Modern Style can be seen today at the Musée Carnavalet in Paris (the establishment was torn down in 1923).

Much of the jewelry made in Fouquet's workshops was designed by Mucha, as was that of Vever and Grasset. In 1902 Gustave Kahn, the symbolist poet and a perceptive critic wrote: "Mucha, as a decorator, or, to be more specific, as a visionary, brought all his innate talent to jewelry.... We find that his pieces display the same subtle polychromy and use the same harmonious colors as his posters. Mucha's work is monumental. His jewelry bears no resemblance to the charming baubles made by his imitators. Each object is a masterpiece and gives an impression of solidity and force." Indeed, Mucha's jewelry (e.g., the extraordinary serpent bracelet he made for Sarah) was never drab, but so enticing that the women of this period were unable to resist it.

Mucha's work continued to show great diversity. He continued to illustrate books, such as *La Vallée des Colibris* by

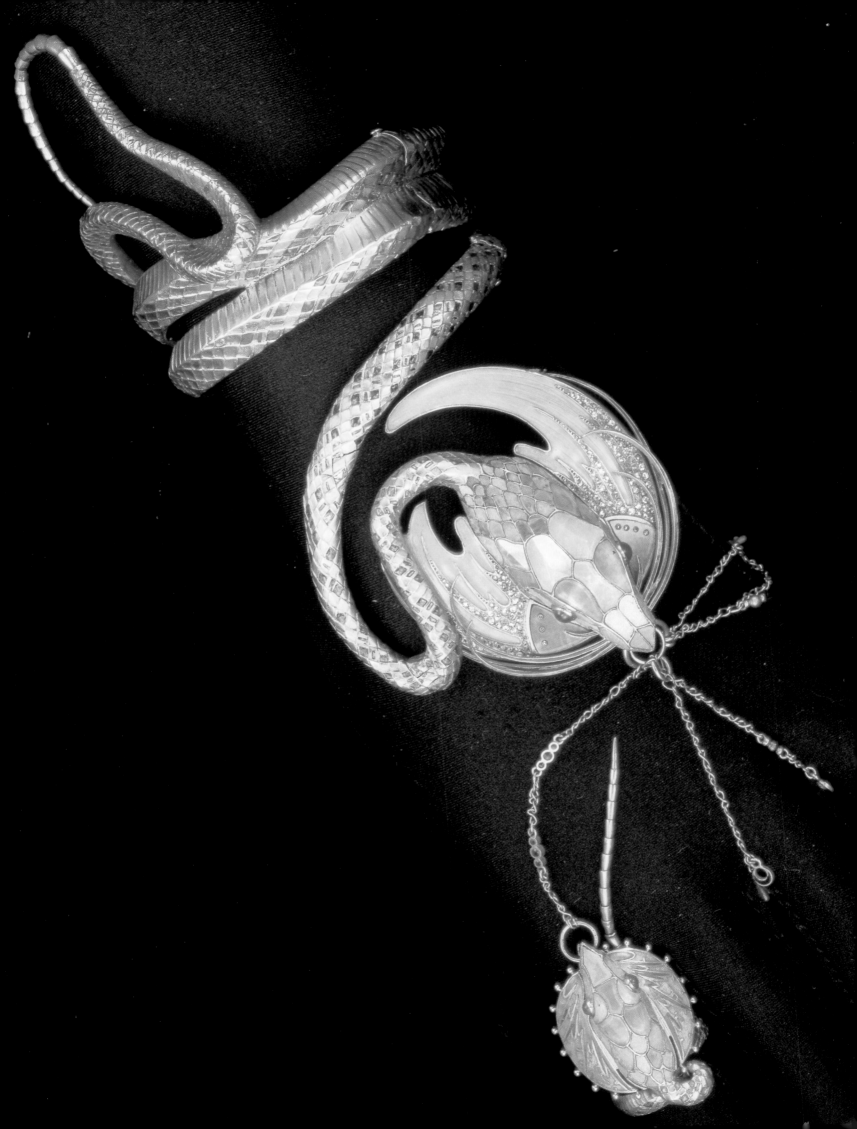

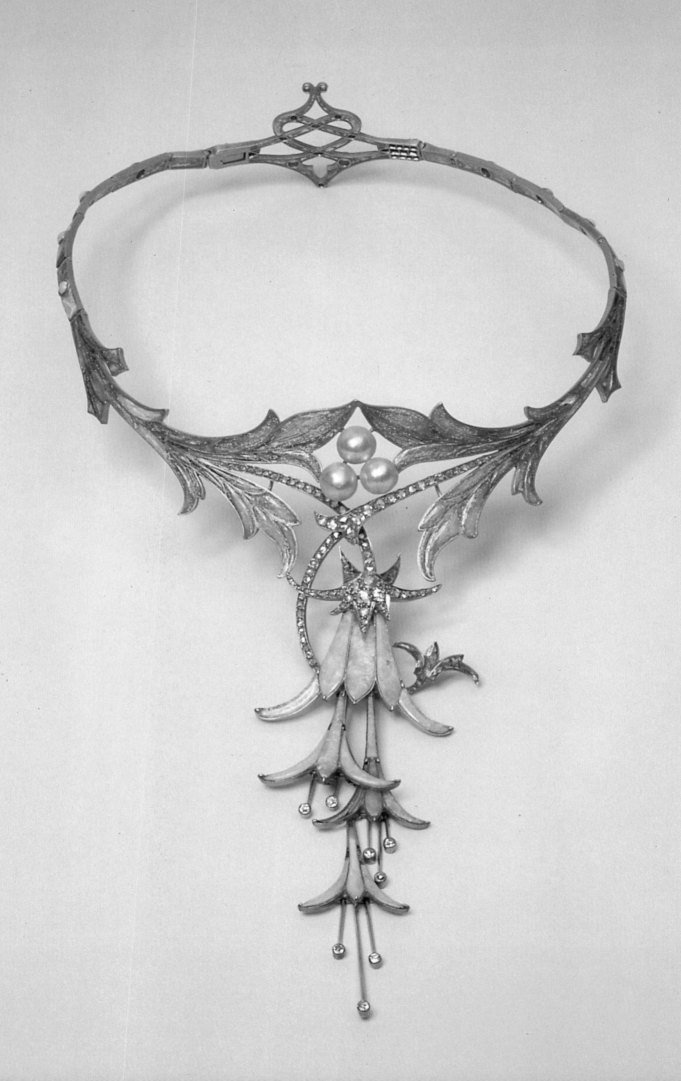

Fern Fronds
1905-1909
Designed by Mucha, made by jeweler
Georges Fouquet, gold, enamel, opal
(Paris, Petit Palais)

Opposite:
Fuchsia Necklace
1905
Designed by Mucha, made by the jeweler
Georges Fouquet; opal, cabochon saphire,
brilliants, gold mount
(Paris, Petit Palais)

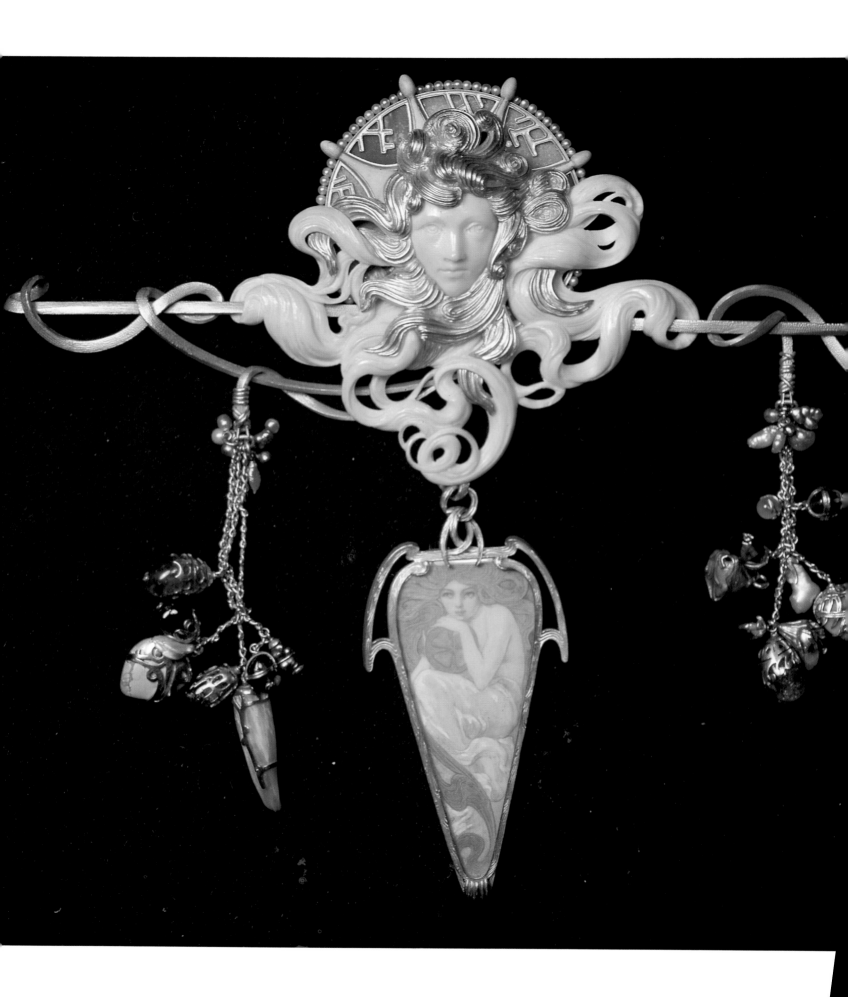

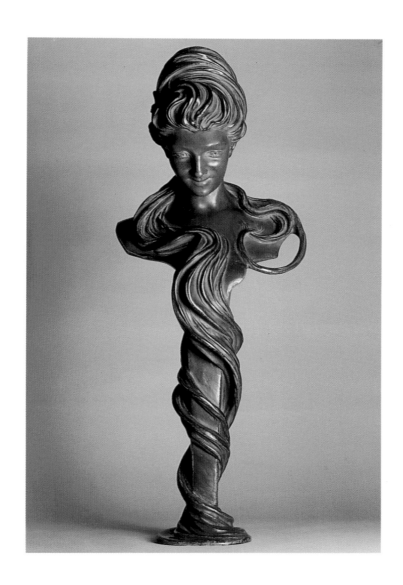

Bust of a Woman
1901
Bronze
30⅝ x 12 in. (78 x 30.5 cm)

Opposite:
1901
Brooch made by the jeweler
Georges Fouquet

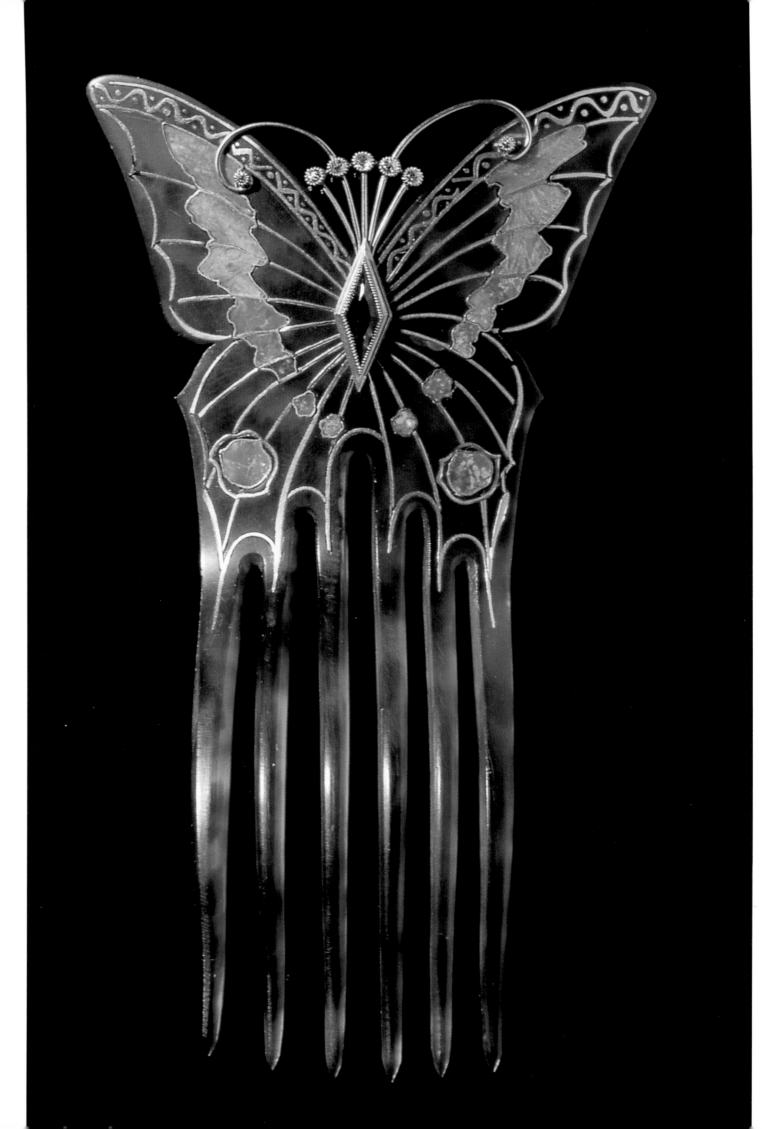

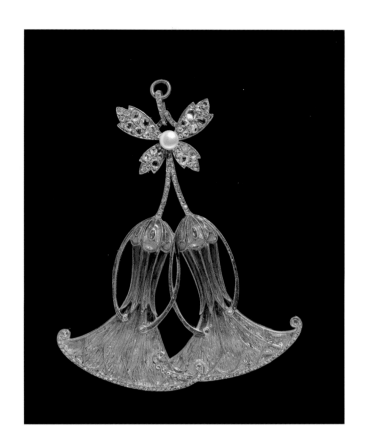

Jewel designed by Mucha
for Georges Fouquet
1901

Opposite:
Butterfly
Comb made by the jeweler
Georges Fouquet;
tortoise shell with gold fillets
and opal insets

Lucien Biart and *Rama* by Paul Vérola. If these titles are still known today, it is thanks to their illustrations.

Mucha was also a teacher. He began in a studio that he rented from Colarossi and then went to the Académie Carmen. The latter had been set up by Whistler for the benefit of one of his models of the same name whose future he wanted to make secure. The American painter promised to give some courses there, too; but Carmen, who also knew Mucha well, felt that she could count on her friend from Charlotte's *crémerie* to give lessons on a more regular basis. Whistler, a great admirer of Mucha's work, liked to exchange ideas on art with the Czech, but soon got bored with the project. Mucha also gave up teaching fairly quickly.

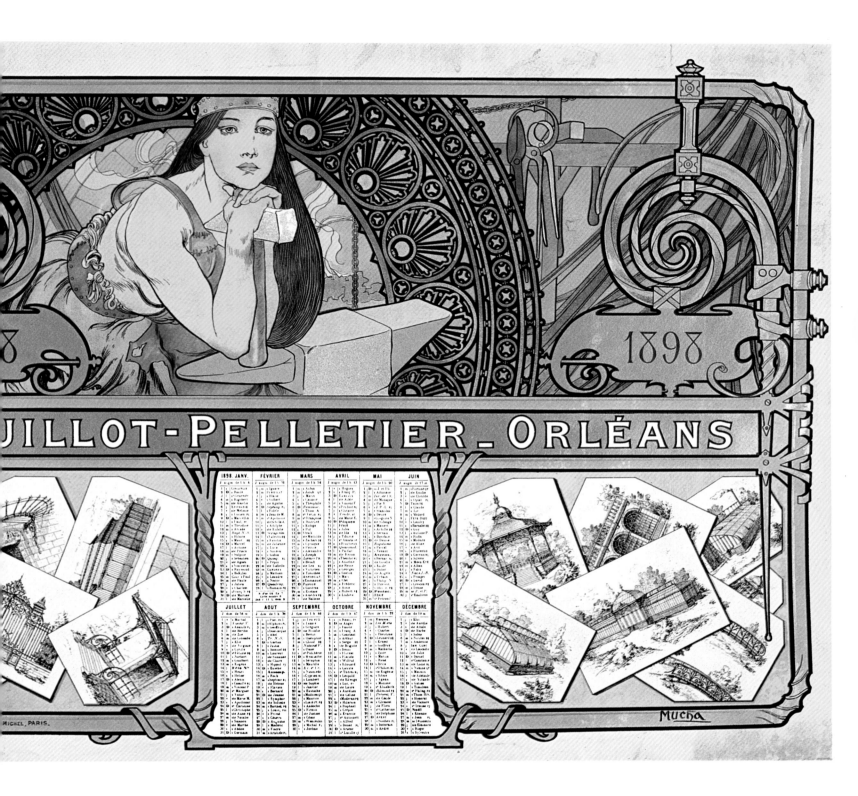

F. Guillot-Pelletier - Orléans
1897
Calendar advertising ironwork, only one
copy remains today
20½ x 13⅜ in. (52 x 34 cm)

Opposite:
Venice
Sketch for a biscuit tin wrapper, never used

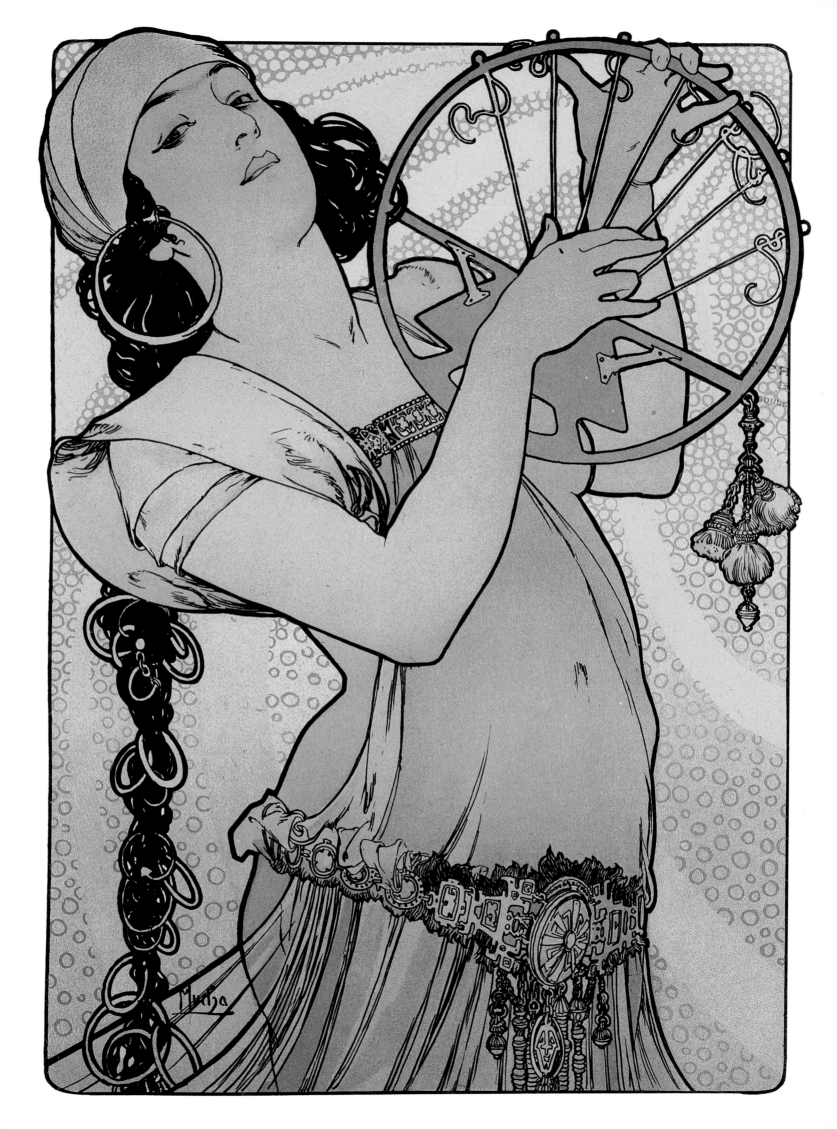

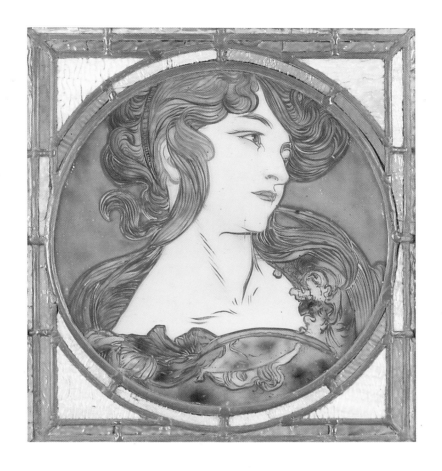

Stained Glass
1900
Designed for Fouquet's jewelry store
15½ x 14⅜ in. (39.5 x 36.5 cm)
(Paris, Musée des Arts Décoratifs)

Opposite
Salomé
1897
Color lithograph
16⅛ x 12¼ in. (41 x 31 cm)

Following pages:
Ivy
1901
Color lithograph
15½ x 20⅞ in. (39.5 x 53 cm)

Laurel
1901
Color lithograph
15½ x 20⅞ in. (39.5 x 53 cm)

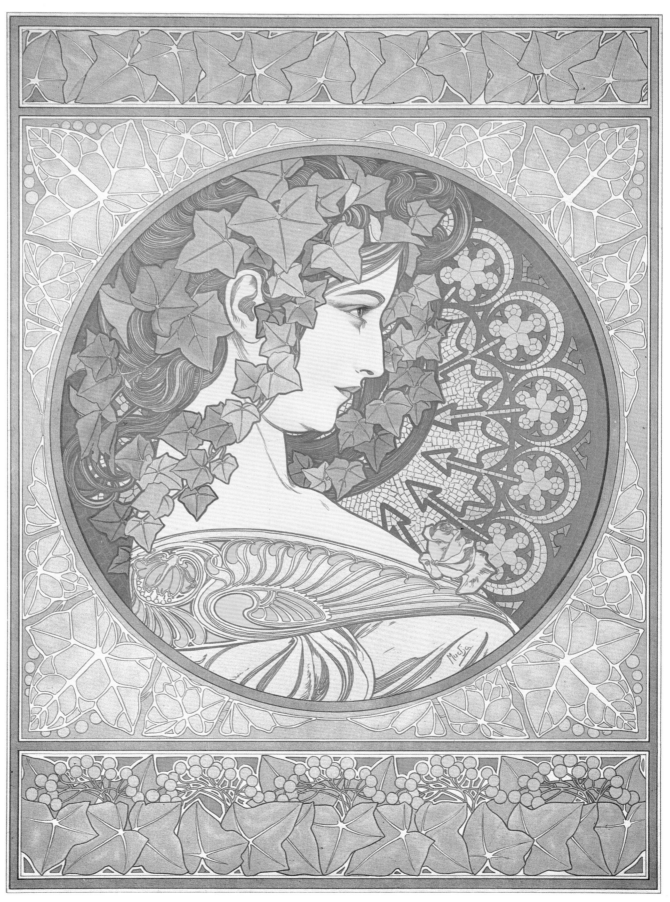

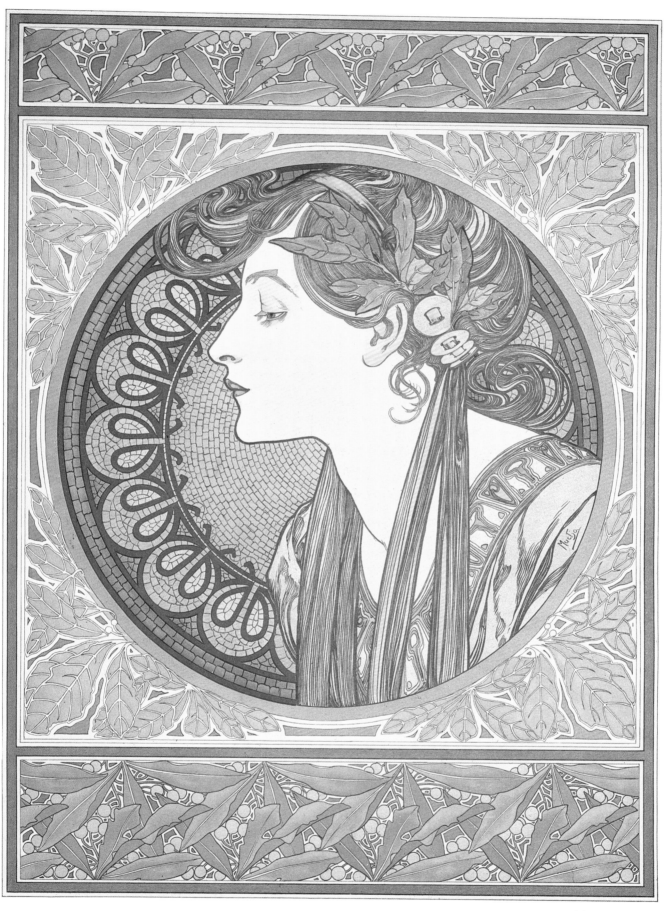

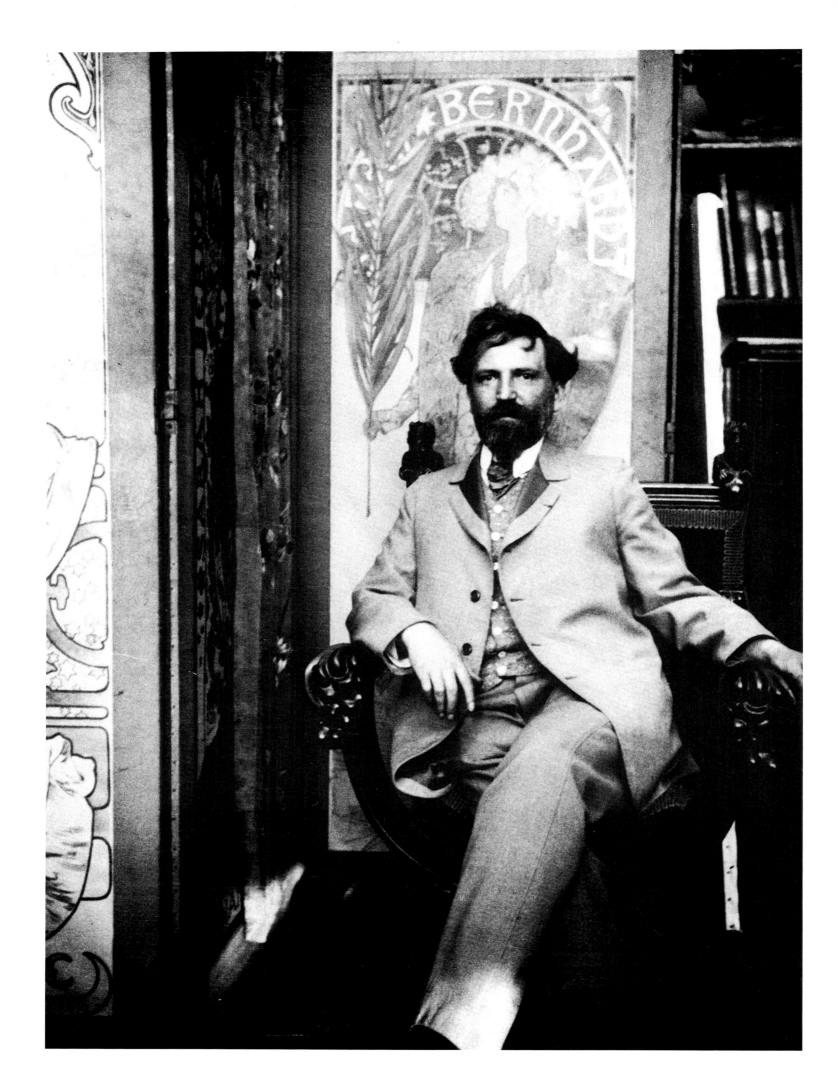

VI

A MAN WITH A NAME

AND A MAN IN LOVE

Alphonse Mucha had become a celebrity. In January 1897, the director of a small gallery, the *Bodinière*, known for the high quality of its exhibitions, organized a show of Mucha's work. Sarah Bernhardt's preface for the catalog, written in the form of a simple letter, made a tremendous impact. It is not hard to imagine the momentousness of the vernissage. Six months later, in July, another Mucha exhibition was held. This was an even more important event, for it showed a greater number of works—four hundred and forty-eight to be exact: posters, calendars, menus, programs, illustrations, genre subjects, all dating from the previous two years. This show, called the *Salon des Cent,* took place at a prestigious address, the salons of *La Plume,* a bi-monthly literary and artistic review. The magazine, which customarily dedicated an issue to the outstanding creators of the time, published a Mucha special for the opening of the show.

Prosperity had arrived and Mucha was now comfortably installed in his new apartment-studio decked with Byzantine souvenirs and Art Nouveau on Rue du Val-de-Grâce. He entertained a great deal and often in the company of a medium, for he enjoyed séances. The head librarian of the Ecole Polytechnique, the famous astronomer Camille Flammarion, and many others took part in these gatherings. The writers Anatole France, Claretie and Edmond Rostand, and the musicians Reynaldo Hahn and Gustave Charpentier were in attendance in addition to many socialites.

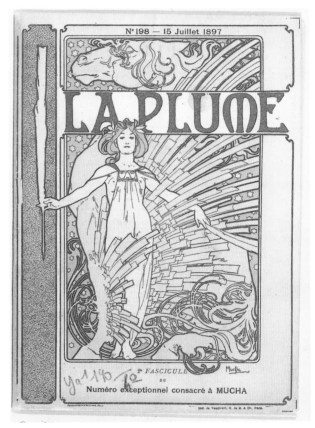

La Plume
1897
Cover of a special issue devoted to
the works of Mucha

Opposite
Mucha in his studio Rue du Val-de-Grâce,
circa 1901

Mucha's shyness with regard to the opposite sex intrigued his friends. He had the charm and manners to please the ladies and, indeed, he did please them. No one had any knowledge of a love affair, but this did not stop his friends from exchanging gossip and indulging in speculation. The same names always came up; there was talk of unhappy affairs, and Sarah's name was mentioned regularly. It was not Sarah, however, who occupied Mucha's thoughts, but Berthe de Lalande. Apart from her name, little is known except that she had been a governess in Russia like many young girls without means in those days. A portrait dated 1896, when she must have been about twenty-five years old, shows her seated in a comfortable English-style armchair reading a book. Her face has a very soft expression and she appears to be absorbed in her reading. This portrait was reproduced in the special issue of *La Plume* with the caption "Illustration for *Le Monde Moderne*," but it does not seem to have appeared in this magazine. The couple lived together for quite a number of years and we know from several postcards sent by Berthe to Mucha's sister that the couple was still together in 1904. That year, however, the painter became very involved with a young Czech woman whom he was to marry two years later.

In 1905, during a transatlantic voyage to the United States, Mucha sent a letter to his sister from which we can gather that his affair with Berthe was over: "You should write to Lalande. She has been very understanding." Berthe was certainly a young woman with a pleasant disposition. Whether for bourgeois reasons of respectability or for other motives, Mucha took great care to hide all traces of Berthe's presence in his life, yet continued to send her money in a discrete fashion until his death. Jiri, the son he had with Maruska in 1915, found this out much later by chance, and also that Berthe lived on until 1957.

Maruska Chytilová was twenty-one years old when she entered Mucha's life. She, too, felt herself to be profoundly Czech. Her family was a member of the local gentry and the patriotic bourgeois elite, a fact that could only please the son of a modest court usher with social ambitions. She was unusually well educated having attended excellent schools and was familiar with the best that Prague had to offer in the way of the theater and music. For the time being Maruska was living in Paris with relatives and working as governess for their children. This occupation gave her little time to fulfill her dream of entering the Académie Julian. She finally got up the courage to send Mucha a letter of introduction from her uncle, a prominent art historian at the University of Prague. Soon after meeting Mucha, Maruska returned to Bohemia. A long courtship, sustained by correspondence and visits to

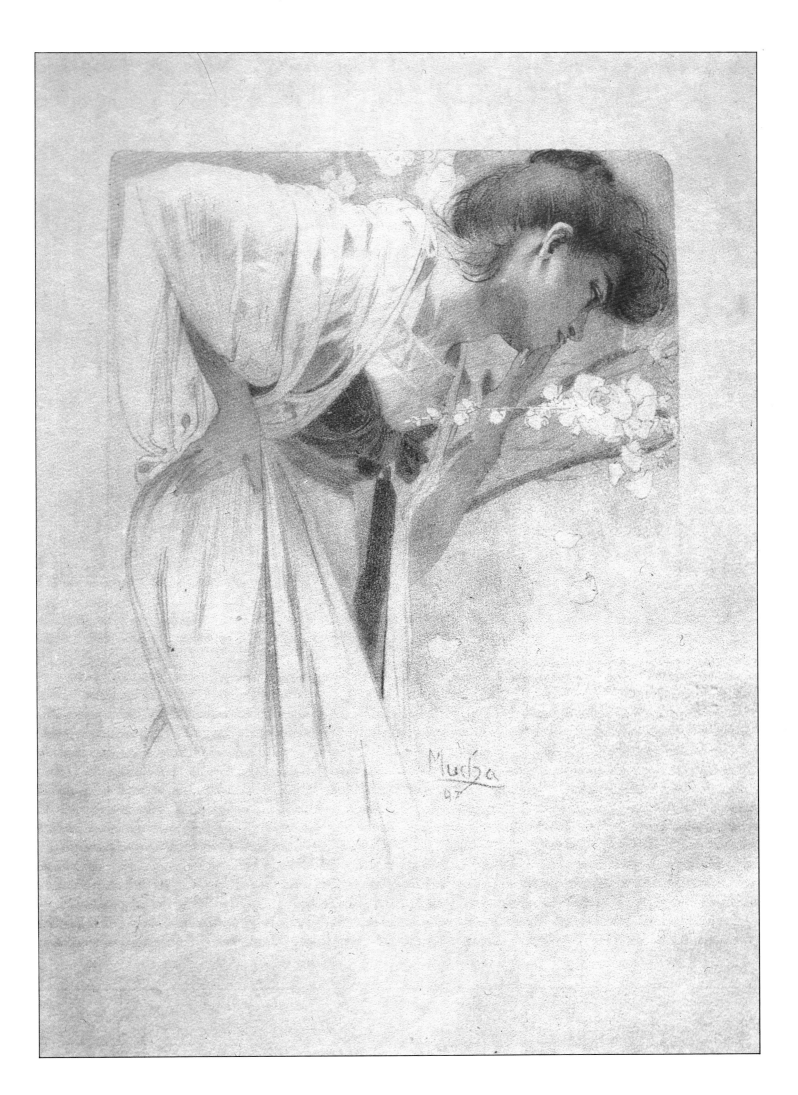

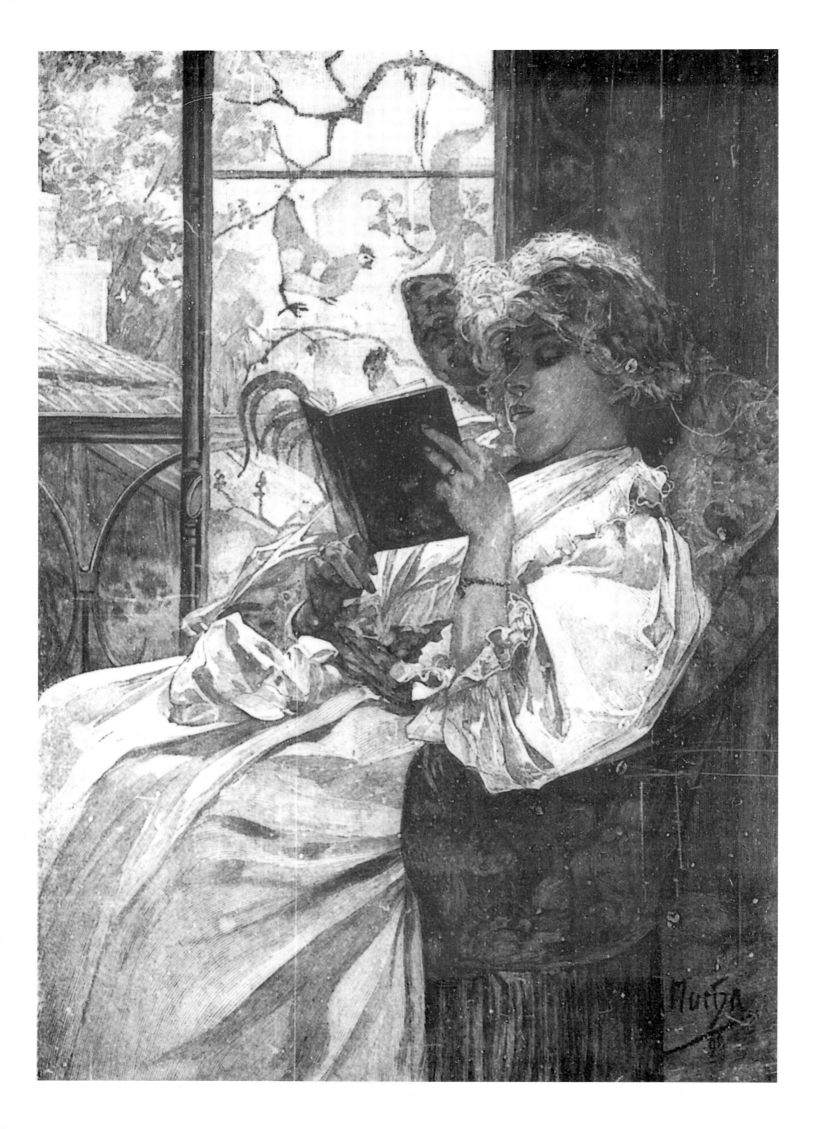

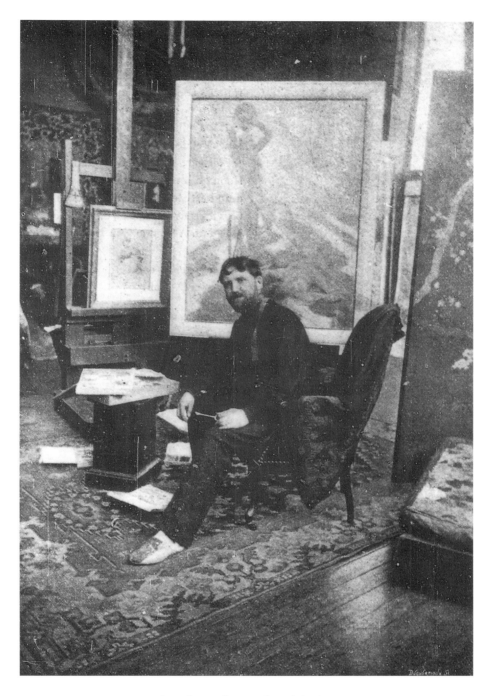

Mucha in his studio Rue du Val-de-Grâce,
circa 1901

Opposite
Berthe de Lalande
In the studio Rue du Val-de-Grâce, published
in *La Plume* in 1897

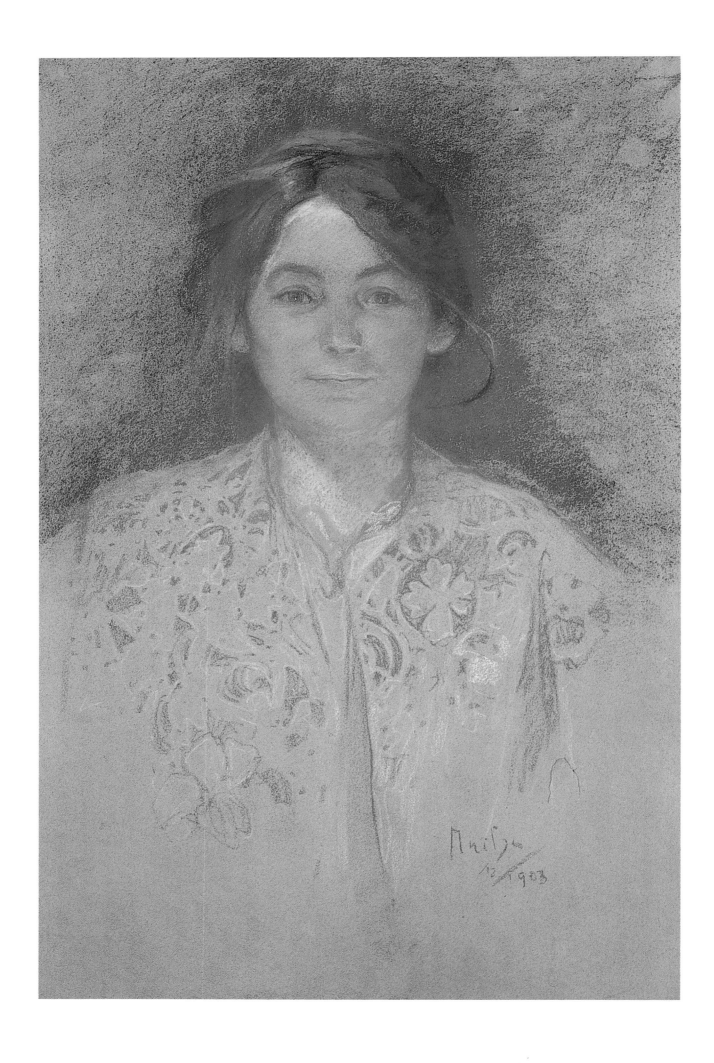

each other in their home country, deepened their sentiments for each other. Mucha's many letters to his fiancée are very revealing of what was on his mind at that moment: his great success as a commercial artist proved a heavy burden. Deep down, he wanted to propagate, through his art, ideas that would contribute to spiritual awakening and express his patriotism and his religious faith. These hopes were frustrated for he was literally overwhelmed by promotional orders, even though he had not renewed his contract with Sarah. Moreover, he was much in demand in social circles and often solicited to attend first-night performances. In an undated letter to Maruska he announced: "Tomorrow *Thaïs* at the Opera in a box shared with friends of the Rothschilds." From another letter: "Just back from the Renaissance Theater where *L'Adversaire* by Emmanuel Arène is playing. Always the same scene: marital infidelity, pitiful characters and sad relationships." On one of his typical evenings, February 20, 1904, he went to the Ritz Hotel on the Place Vendôme where Mrs. Palmer of Chicago had organized a concert for the young and brilliant Polish violinist, Bronislaw Huberman.

NEW AMBITIONS, NEW HORIZONS

Mucha often spoke to Maruska of his visits with Baroness Salomon de Rothschild, but never told her of the conversations that took place. He was very tempted to follow the advice of the Baroness, who encouraged him to go to New York, where he could find a private clientele from her circle of friends. She was, indeed, close to many of the influential people in America: the Vanderbilts, the Astors, the Hydes, etc., all members of that rich High Society which dreamed of a Versailles-like splendor and, accordingly, encouraged the arts. The news of his forthcoming departure came as a shock to Maruska: "I am well-known in America, perhaps even more so than in Europe. I am told that I can get better work there than here." On February 25, 1904, the evening before he left, he announced: "I have my first commission already lined up in New York, a portrait arranged by Madame de Rothschild... She has given me letters of introduction to the Goulds and the Vanderbilts. I have direct entry to High Society". He then added with good common sense: "But let's not put the cart before the horse."

Mucha was certainly well enough known in America for his arrival to be an event. The distinguished supplement of the Sunday *New York Daily News* gave him its first and last pages with the headline: "Mucha, the Life and Work of the Greatest Decorative Artist in the World." Art societies and clubs organized banquets in his honor. The first commission

Opposite
Maruska
1903
Pastel on paper
28³/₈ x 19⁵/₈ in. (72 x 50 cm)

Above:
Friendship
Front page of the color section of the
New York Daily News, dated April 3,
1904, homage to Mucha

Below
Friendship
1904
Poster with Mucha; for the
publication of the color section of the
New York Daily News

for a portrait came from Mrs. Wissman, one of Madame de Rothchild's cousins. Mrs. J. P. Morgan, Mrs. Cornelius Vanderbilt, the beautiful Mrs. Mackay and Elsie de Woolf, who was still a force in High Society after the Second World War, came to see the portraits in his studio. Journalists interviewed him on his opinions. *The World* quoted him: "American Women Superb Says This French Artist. … she is infinitely superior to the most beautiful women of Europe. The anemic type of Parisian beauty in which all our artists find their ideals is a false one. Here, the women are strong, vigorous—both svelte and solid." Mucha didn't do things halfway; he understood the nature of the aspirations of the American aristocracy. His only aim was to earn as much money as quickly as possible so that he could devote himself entirely to Art. At the same time, however, like most newly-arrived visitors, he was carried away by the vigor of the pioneer spirit of this young country.

As usual, Mucha spent a great deal of time with the Czech colony of New York. Every few days he would visit a young painter named Svoboda, whose father, a former *gendarme* from Ivancice, had also emigrated to America. The painter's mother cooked excellent Czech dishes and his sister was married to Kovarík, the conductor of the New York Philharmonic Orchestra. All the Czech musicians on tour gathered at this home.

The priest of the 72nd Street Church, was another regular guest. Father Prout, well aware of Mucha's religious faith, decided to use the artist's reputation to spread the influence of the Catholic Church. At that point America was very much a Protestant-dominated country. The priest understood very well that he could ask anything of the artist merely by saying that working for the Lord was far superior to designing posters for cigarette paper or champagne. Mucha gave substantial donations to church charities and painted a large mural for the Convent of the Sacred Heart. Barely had he begun to work on it when the good Father suggested that he do a portrait of Archbishop Farley of New York. The persistent clergyman acquired yet another piece for his own church in the bargain—a painted banner with the effigy of Saint John of Nepomuk. An article from *The New World,* a daily Catholic newspaper, spelled out the course on which the priest was embarking: "We fervently hope that Mucha can be induced to remain permanently in America. …here beyond all question he could found the greatest school of religious art in the world; he could inculcate the grand principles of the Catholic tradition in the minds of thousands of pupils… and America, born to civilization through the Church, might be regained to Catholicism thanks

North Star
1902
Study for a series on the stars,
pencil and wash
22 x 8½ in. (56 x 21.7 cm)

La Sorcière
Sketch for a theater poster
Wash

Detail of the upper frieze for the Bosnia-Herzegovina pavilion at 1900
World's Fair (Exposition Universelle, Paris)
Tempera on canvas (Paris, Musée d'Orsay)

to Mucha's artistic revival." Mucha never received any remuneration for his work for the Church. He was so caught up in it that when he was asked to exhibit the works that he had done since his arrival in New York, he could only send three portraits, and two of these had been done without payment.

In 1904, when he returned to Bohemia to be with Maruska and to see his parents once again, he had less money than when he had left France the first time. He was back in Paris working relentlessly on commissions that were behind schedule, all the while trying to re-negotiate former contracts.

Baroness de Rothschild believed that married life was incompatible with the life of a creator, and when she heard the news about Mucha's forthcoming wedding, she took it very badly. Mucha, who frequently found guidance for his daily life in the occult workings of the supernatural, asked a certain Madame Vitousek for the help of her second sight. The reputable fortune-teller suggested to him that Maruska send a letter of explanation to the baroness, with the result that the latter, in a fit of rage, decided to have nothing more to do with her protégé.

Mucha then seemed to have run into a spate of bad luck. Nothing went right for the next few weeks. His letters to Maruska detail a long list of unhappy circumstances. The only area in which he felt he was making progress at the time was in learning English. Commercial jobs poured in submerging him in a routine from which he hoped to extract himself in order to get back to his own work. He fell behind, and, since he was unwilling to give up his habit of going out at midnight after a full day's work, he always came back home exhausted. At last, Christmas came around and he was planning to leave Paris for Bohemia to celebrate the holidays with Maruska. His joy was to be short lived: a nasty flu kept him in bed and he was scheduled to take a boat returning to New York at the beginning of the new year.

BACK TO THE LAND OF PLENTY

When Mucha arrived in America once again, New York society was swept up in its great extravagances, oblivious to the hostilities brewing between Japan and Russia. In January 1905, he wrote to his fiancée: "One of my millionaire friends (there are so many of them) is organizing a ball in the style of the 18th century at the court of Louis XVI ...which is to exceed anything held so far. He is bringing the great actress Réjane from Paris and has asked me to do a large portrait of her for the ballroom and to oversee the decoration."

Meanwhile, his family circle in Bohemia was growing

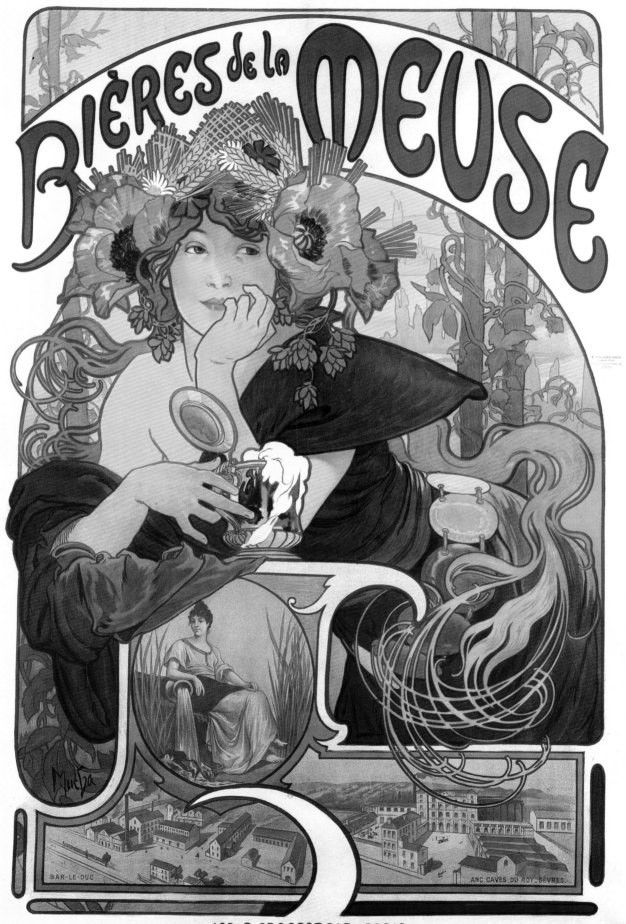

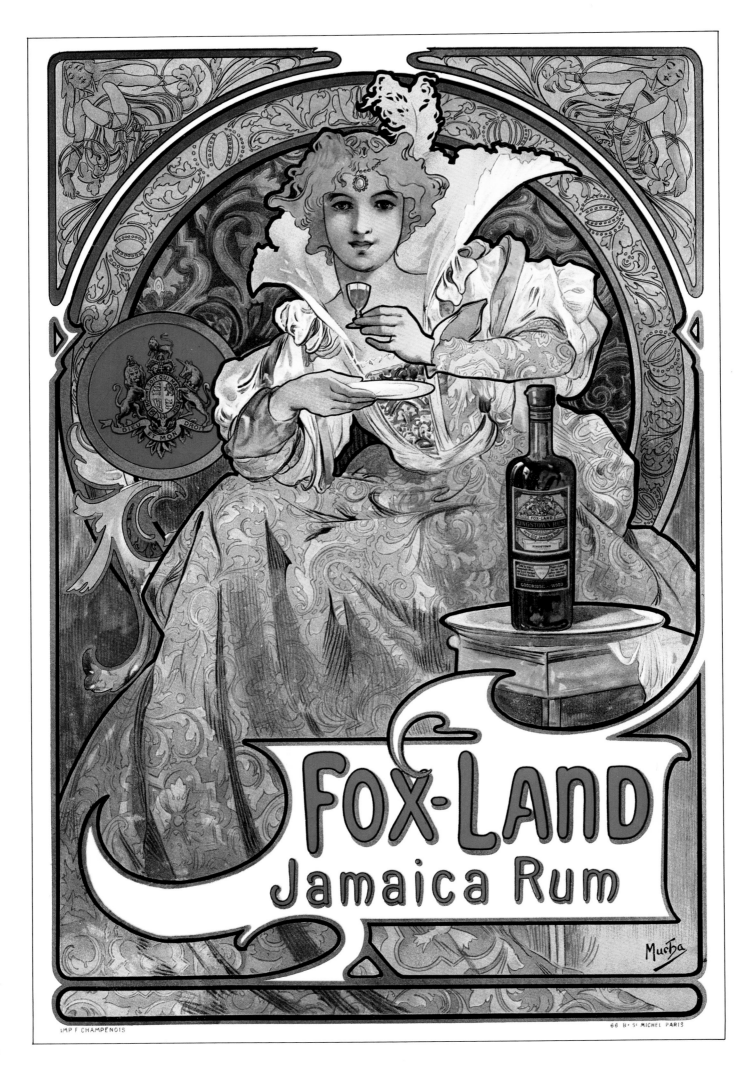

FOX-LAND

Jamaica Rum

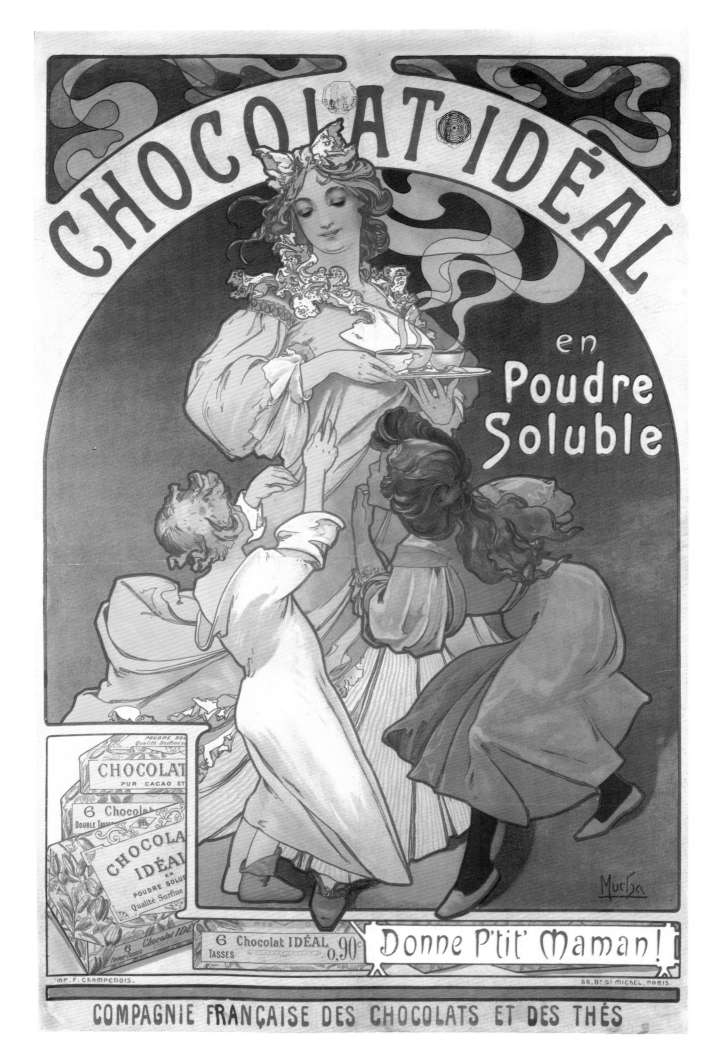

THE WEST END REVIEW

PRINTED BY LEMERCIER
IN PARIS

Savon Mucha
1907
Four soap-box tops printed on a decorative screen-like
cardboard frame in gold ink for indoor display; the only
product combining the artist's name with a brand
24 x 16½ in. (61.2 x 41.9 cm)

Page 156
Fox-Land Jamaica Rum
1897
Poster of which there is only one remaining copy
$11^3/4$ x $17^1/4$ in. (30 x 44 cm)

Page 157
Chocolat Idéal
1897
Poster
$30^3/4$ x 46 in. (78 x 117 cm)

Page 158
Bleu Deschamps
1897
Indoor display poster for a whitening agent
$9^7/8$ x $13^3/4$ in. (25 x 35 cm)

Page 159
The West End Review
1898
Mucha's largest poster, for a London literary review
$85^7/8$ x $120^7/8$ in. (218.4 x 307.3 cm)

Page 160
The Passing Wind Takes Youth Away
1899
Design for a fan, also for the facade of the Pavilion to Man,
color lithograph, for the 1900 World's Fair, Paris
$17^7/8$ x $24^1/2$ in. (45.5 x 62.2 cm)

Page 161
Bleu Deschamps
1903
Indoor display poster
$13^1/8$ x $19^7/8$ in. (35.5 x 50.5 cm)

impatient. In August, he wrote to Maruska's mother: "Most revered Madame Chitilová… It is true that I had counted on getting married to dear Maruska last year. Unfortunately my work in America has gone slowly because I have been ill." Letters were exchanged until the end of April 1906 when he sent one with a list of orders for the next year which amounted to five thousand dollars in gold. It was not until May the 2nd, however, that a New York daily newspaper announced: "Mucha, the poster artist has found the ideal beauty in his future wife. The man whose work is so adored by women is going to celebrate his marriage near Prague." The ceremony took place on July 10 in the chapel of a monastery near the Czech capital. The couple spent the next six weeks in a small Bohemian village. It seems that these were not the plans that the young wife had had in mind for a honeymoon. However, the weeks were well spent, for they allowed the artist to take stock of the situation at a crucial moment in his life.

When Mucha brought Maruska to America, they traveled directly to Chicago, where Mucha lectured at the Art Institute for two months. Mucha spent more and more time in the United States. He moved the entire contents of his studio in the Rue du Val-de-Grâce, brought over Louise, his old cook, and set up house in the Middle West. Maruska was entirely devoted to her painter-husband and his art and had a very positive influence on him. She persuaded him not to neglect art dealers. Kobler, one of the best in town, put on an exhibit of the original illustrations of The Lord's Prayer (*Le Pater*). This edition, which included Mucha's own commentary had been published in Paris in 1899 by Piazza.

Alphonse Mucha then found himself confronted with a serious crisis. His son, Jiri, analyzed the situation to perfection in a book that he wrote about his father. Art Nouveau disappeared as fast as it had appeared, as did its German equivalents, the Secession and the Jugendstil. The Fauve Movement began to dominate the scene paving the way for Cubism. Abstract art, thanks to friends like Kupka and others, was taking over. The Nabi painters turned all their efforts to art and gave up making posters.

PORTRAITURE: PROFITABLE BUT UNREWARDING

During his American years, Mucha never really stopped illustrating the most widely-read magazines of the day. He found it easier to meet the demands of commercial art because of the solid reputation he had built up while teaching at the Chicago Art Institute. Nonetheless, the artist eventually decided to abandon his career as "the greatest decorative

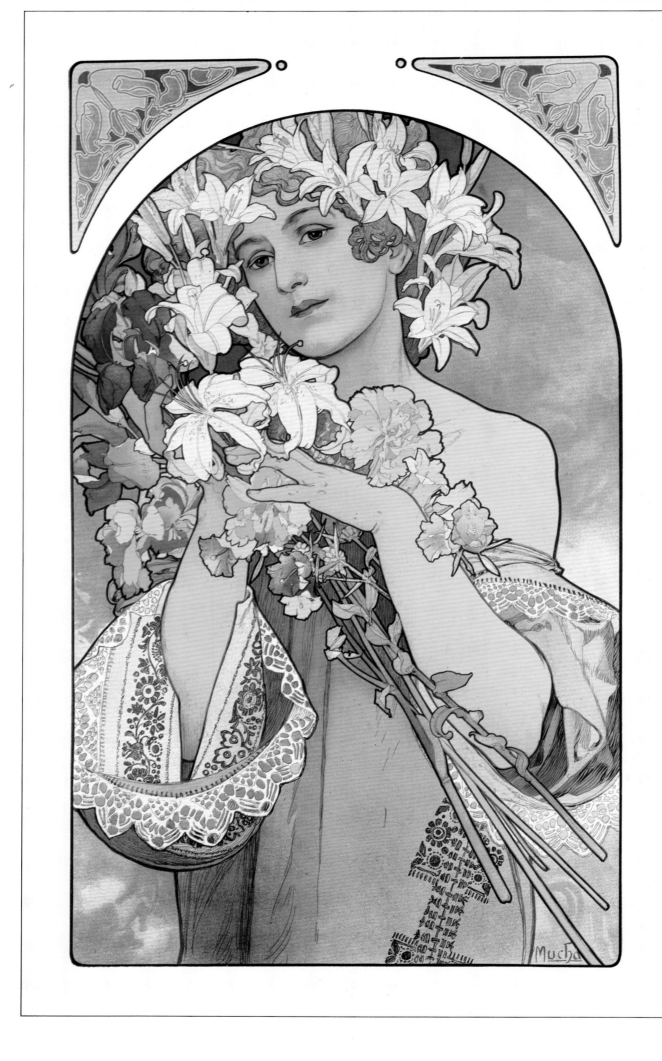

painter in the world." Painting portraits of American women paid well. "If I must sell myself," Mucha declared, "I will ask the highest price." Painting portraits of celebrities, although never fully satisfying, was the best sort of publicity for the painter and made him feel that he had crossed the boundary separating a decorative painter from a full-fledged artist. As he became more and more in demand, Mucha had every reason to believe that he had made the right decision in settling in the United States.

The master of American portraiture at the time was John Singer Sargent and Mucha was acquainted with this artist's immense talent. Mucha would cheer himself up by saying that he could do just as well, and then get bogged down in details. He devoted too much time designing the curtains for the portrait's background because he was so taken by his own ability to render them. His portrait painting never reached the perfection of line to which he aspired and no amount of effort ever brought him closer to it. Another difficulty that the artist had to confront was that he was uncomfortable painting in oils and preferred tempera as a medium. While working on posters or decorative panels, he could idealize the women who posed for him. In portrait painting he was obliged to stick to resemblance and hope for inspiration. His female clients were middle-aged ladies who were lacking in charm, both physically and spiritually. His son Jiri reported: "He was neither a cruel realist like Goya nor a cynical flatterer like Sargent." Therefore, his portraits were boring and without spirit, like his models. Mucha overlooked the fact that these ladies had their portraits done out of vanity and that they could not see any reason to sit for an artist if the result was to be identical to what they saw in their mirrors. However, he did not have to contend with these difficulties when portraying children, and for this reason his best portrait is that of young Milada Cerny. On the other hand, his *Portrait of Maruska* (1903) displays mild academicism somewhat highlighted with impressionistic accents.

He then went through a period when he accepted commissions for the strangest reasons. He would agree to do a poster for a corset manufacturer or design the invitation to a children's party, but refuse to work on a decoration project or design jewelry. Fortunately, the lectures and courses he taught in Chicago, New York and Philadelphia provided the couple with a regular income. The newlyweds continued to broaden their social circle, accepting invitations to the wealthiest homes even if this no longer brought any commissions.

Opposite:
Flower
1897
Color lithograph
17 1/2 x 26 in. (44.4 x 66.2 cm)

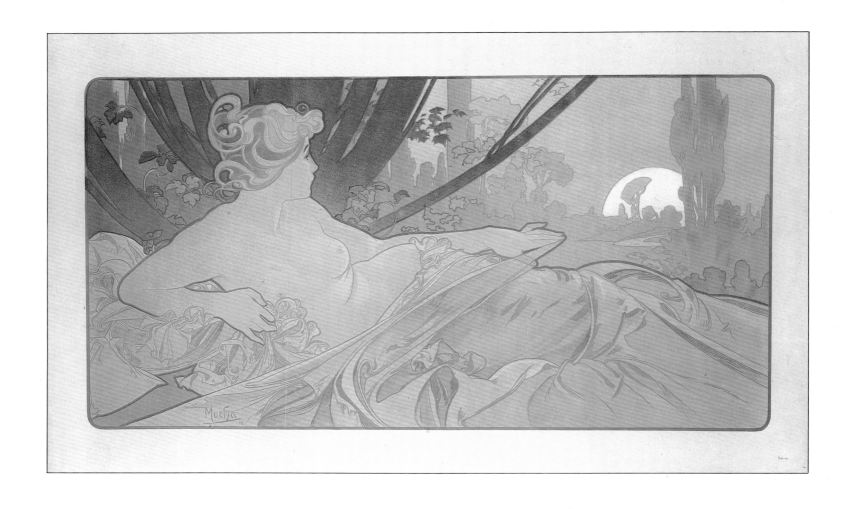

Left and right:
Dawn and **Dusk**
1899
Color lithograph, in landscape format, 1000 copies printed
on parchment paper
39³/₈ x 23⁵/₈ in. (100 x 60 cm)

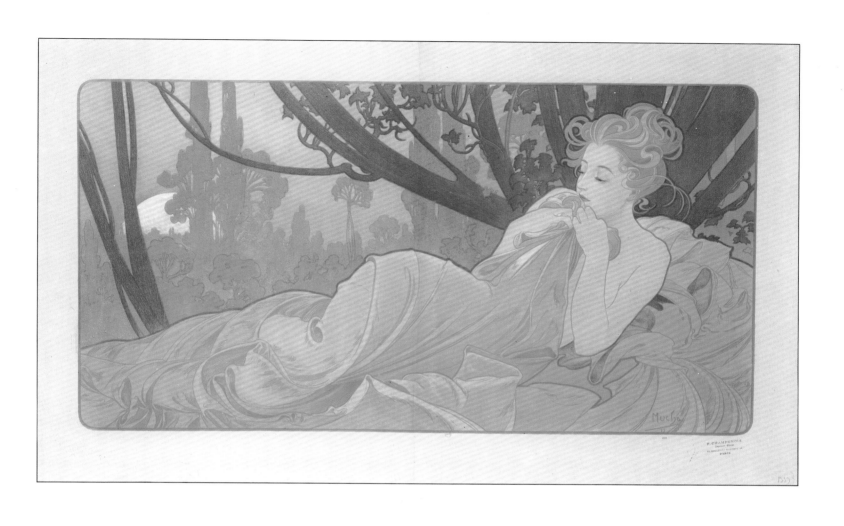

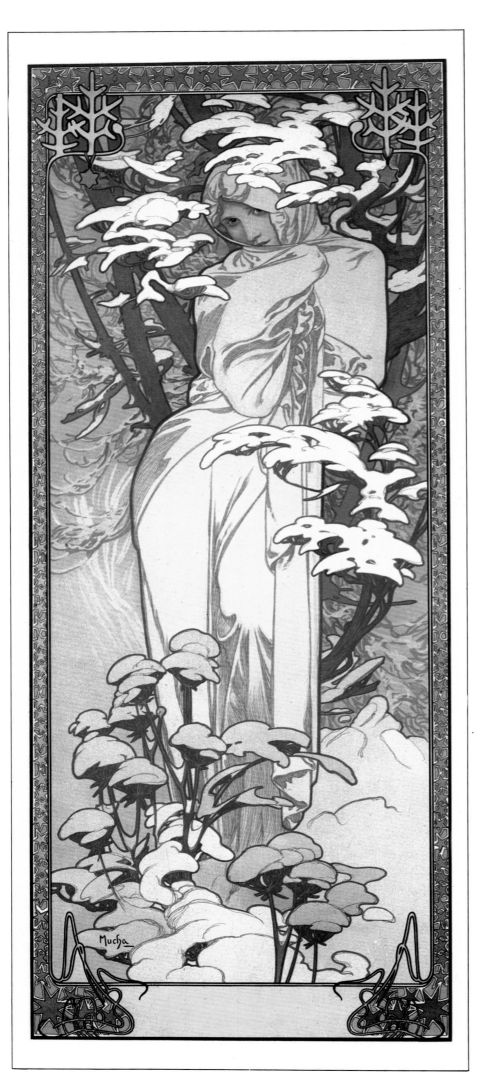

Winter
1900
Decorative panel printed on satin
12⅝ x 28¾ in. (32 x 73 cm)

Sylvanis Essence
1899
Small Color lithograph for indoor display of a newly-
launched perfume
8¹/₄ x 24 in. (21 x 61 cm)

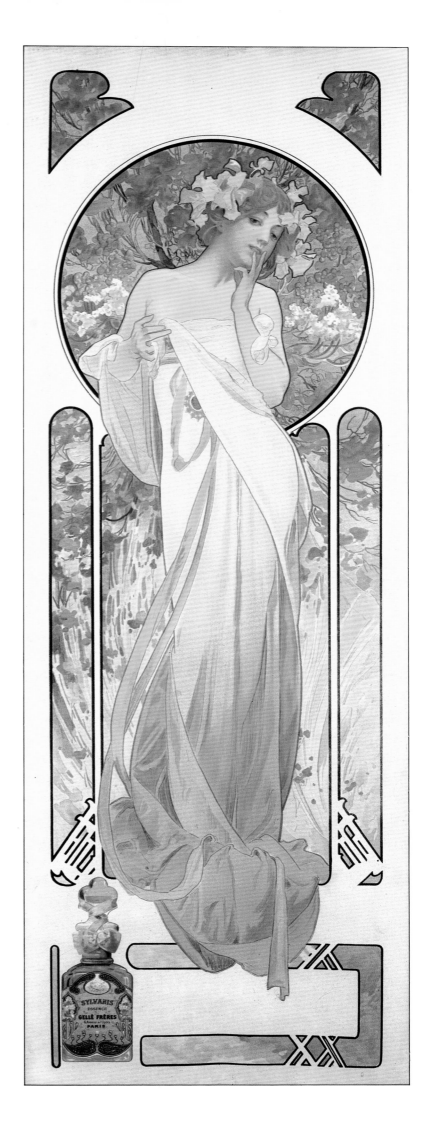

Twelfth Night
1908
Maquette for the German Theater in New York
Pencil and watercolor, white gouache, highlights on paper
18⁷/₈ x 24⁵/₈ in. (48 x 62.5 cm)

THE THEATER YEARS

In the spring of 1908, Mucha executed his last important Art Nouveau work—the decoration of the German Theater in New York, built by a group of German-Americans. Always on the alert, Maruska wrote to him from Chicago: "Don't accept words for payment, and four months is too short. It has to be finished on September 1, if not, you will have to pay a fine. I know you only too well, you think that you have all the time in the world." The job was finished at the very last minute. The critics and public found the paintings and decorations glorious. Regrettably nothing is left of the building, which was torn down in 1929, and all of its contents destroyed.

His next venture in the theater world was doomed to failure. A singularly eccentric spendthrift by the name of Caroline Dudley, when deserted by her millionaire husband, sought revenge at any cost. She joined a theater company directed by Belasco, the most prominent agent of the day, and started off on a successful acting career, using her ex-husband's name, Leslie Carter, as her stagename. When the flighty divorcee decided to remarry, Belasco let her drop, too. In another vindictive mood, she proceeded to take over a theater directly across from the one run by Belasco. There, she staged a grandiose play called *Kassa*, based on Hungarian folklore. When Maruska heard that her husband had accepted to design the sets for this over-ambitious production, she wrote him: "Be careful of Mrs. Carter. Don't let her flirt too much with you. She has a terrible reputation here. She is always getting sued." When *Kassa* folded after only a few performances, Mucha never received payment for his work, and although there were several lawsuits by other creditors, the artist had to back down because a contract had never been drawn up.

As later events have proved, all his work for the theater did not turn out so badly. He had met the actress Maud Adams when she came to Paris to see Sarah play *L'Aiglon,* before taking on the role herself. Maud, the daughter of a famous actress, had been on stage since the age of three. She had just been crowned with huge success in Barrie's *Peter Pan*, which ran for 771 performances. During this time a stage electrician who arranged the lighting was so infatuated with her that he had to be committed to a mental institution.

Then Charles Frohman, an important theater agent, proceeded to fall madly in love with Maud while she was preparing Schiller's *The Maid of Orleans*—under his direction—to be performed only once for the largest audience ever assembled in the Harvard University stadium.

Its extraordinary success provoked a minor and funny technical incident: frightened by the applause, the herd of sheep on stage with Joan of Arc fled in all directions. Frohman had asked Mucha to design the scenery and costumes for the production. Once again, nothing remains today, but the press reviews report that Mucha's contribution was very much admired. Only one token bears witness to it—a very moving poster quite different from the Art Nouveau poster that he had made for Leslie Carter. His work for *The Maid of Orleans* production was very well paid, as was everything else he did for Frohman.

In the spring of 1909 in New York, Maruska, who had just become the mother of a little girl, Jaroslava, was mystified by the new commission that Frohman had just given to her husband. She wanted more information about it and sent the agent a press-clipping on which she wrote: "What is this all about?" The article relates: "Miss Ethel Barrymore will devote most of her leisure time during the remainder of her stay in Chicago to sitting for Alphonse Mucha, the distinguished painter who has just received by cable from Charles Frohman, who is in London, a commission for an oil portrait of the star of *Lady Frederick*."

Warner's Rust-Proof Corsets
1900
Postcard of the poster

Opposite
Warner's Rust-Proof Corsets
1909
Poster, only one copy remains in good condition
$39^3/_8$ x $103^7/_8$ in. (100 x 264 cm)

Mucha with his students at the
Chicago Art Institute
1906

Opposite
Sioux Indian
1908
Study, tempera on canvas
23³/₄ x 18 in. (60.5 x 46 cm)

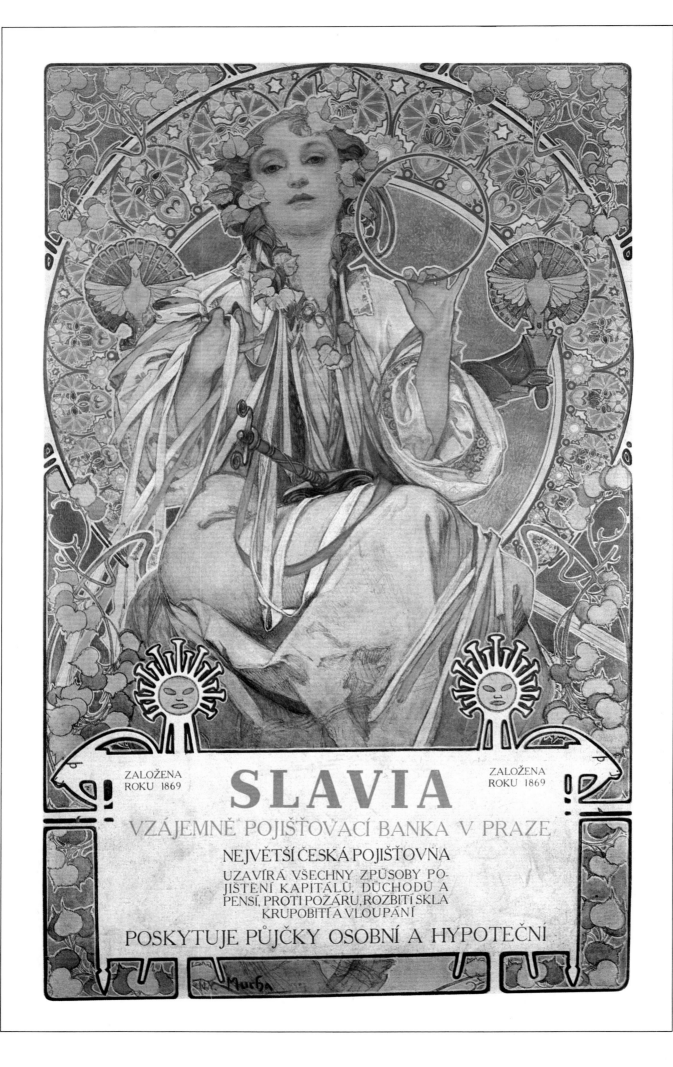

VII

SLAVIC NOSTALGIA

Opposite
Slavia
1907
Poster for a Czech insurance company
14¹/₈ x 21⁵/₈ in. (36 x 55 cm)

Rubbing shoulders with millionaires was really a waste of time, Mucha learned, for he did not feel that this type of potential client knew how to enjoy art properly. Convinced that he was finally reaching his goal to crusade in favor of Czech National Art, Mucha dropped all his commissions, only to find himself in the same situation that he had experienced in Paris: without a regular income. According to him: "Each nation has its own art, as it has its own language. Its tradition is not the property of one artist but of the entire community. Humanity is no longer grouped into clans but into tribes and nations." In Chicago, Mucha even professed that American artists should liberate themselves from European tutelage and create an artistic expression characteristic of their own civilization. He aired views that had always been his own and that he had never ceased to apply, even while composing a Nestlé or a Moët poster.

After a long, dull period of uninspiring work, Mucha had another lucky break. He chanced upon a remarkable millionaire unlike any of his other rich acquaintances, Charles R. Crane, who ran a very successful plumbing and elevator business. In 1905, Crane set up a large factory in Saint-Petersburg, Russia, that sold his wares all the way to China. His knowledge of the inner workings of the Kuo-min-tang was such that, in 1909, President Taft appointed him ambassador to Peking. Crane, however, gave up this assignment almost immediately in order to devote himself to his more idealistic

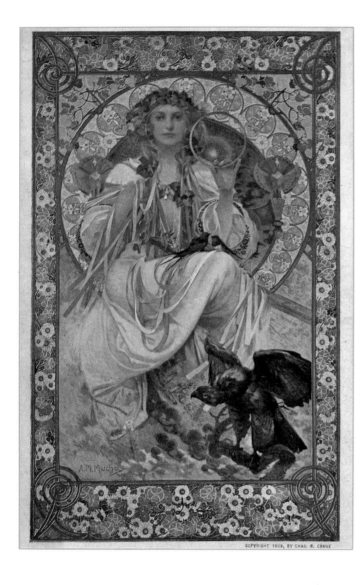

Josephine Crane
1909
Postcard commissioned by the millionaire
C. Crane who funded Mucha's *Slav Epic*

Opposite
Moravian Teachers Choir
1911
Poster
31⅝ x 42¾ in. (79.5 x 108.5 cm)

aims. His point of view was that money should only be spent on good causes. Deeply interested in Central European history and politics, he had played a very active behind-the-scenes role in the intricate field of Slavic politics and was a staunch Russophile. He subsidized a Russian symphony orchestra in New York and helped pay the expenses of many visiting musicians when Mucha entered his life. Crane put great efforts into encouraging Mucha's pan-Slavic dream, an objective close to his heart. He admired the artist's altruistic desire to work for his country without personal profit.

For some reason, the decor and scenery for Mucha's German Theater project appeared to have been painted in a borrowed boat-house near the Cranes' summer residence in Massachusetts. The affluent business man, often accompanied by his friend Woodrow Wilson, the future president, would visit the painter at work and listen to his panegyric on the destiny of the Slavic people. Crane commissioned Mucha to paint a portrait of his recently-married daughter, Josephine Bradley, in the symbolic dress of *Slavia*—a striking example of Crane's commitment to the Czech cause. The story of this composition with an American heiress portrayed as a Slavic goddess does not end here; Mucha's *Slavia* was later used as the central motif on the first Czech bank notes printed in 1918.

Crane then asked the artist to paint his second daughter, Frances Leatherbee, who later became the daughter-in-law of Tomas Masaryk, the future President of Czechoslovakia. This portrait was not a success, however, and the sitter is said to have cut it into pieces in a fit of anger. Mucha, caught up in the Leslie Carter imbroglio over *Kassa*, put it aside for a while and then could not continue because Frances Leatherbee was pregnant and unable to sit for him.

MUCHA PUTS HIS CARDS ON THE TABLE

At this uncertain moment in his career, Mucha nurtured a monumental project called *The Slav Epic*. He announced his intentions to Crane: to devote the rest of his life to twenty monumental paintings narrating the history of the Slavs from Antiquity to modern times. Ten were to be devoted to the history of Bohemia and ten to the other Slav nations. Mucha hid none of the financial difficulties that still beset him in spite of his apparent success and solicited a contribution from his American patron. Crane's immediate reaction was positive, perhaps owing to the insignificant amount needed for this project compared to the cost of his other gestures in favor of pan-Slavism.

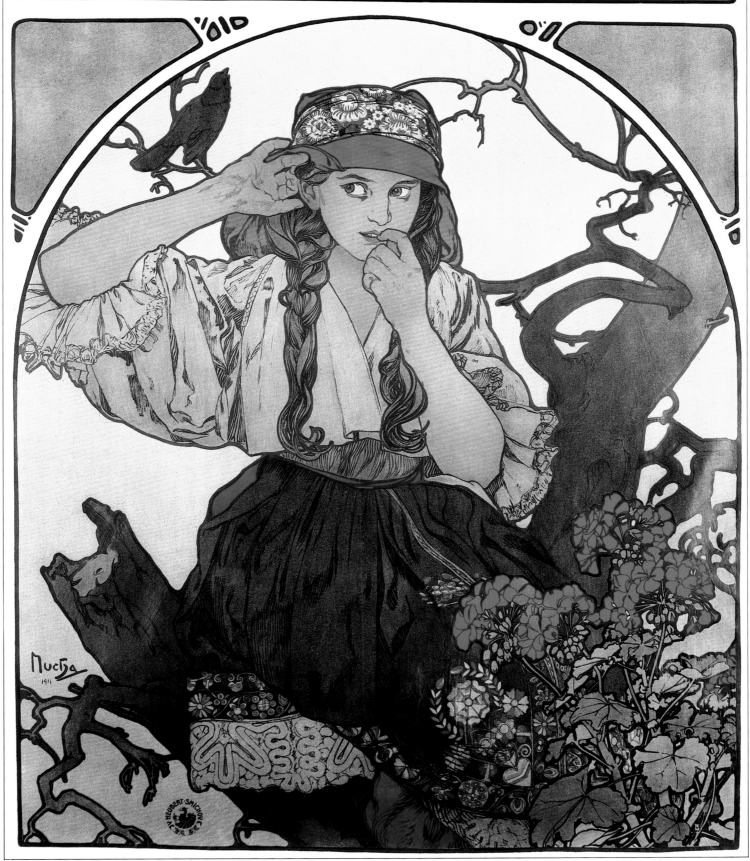

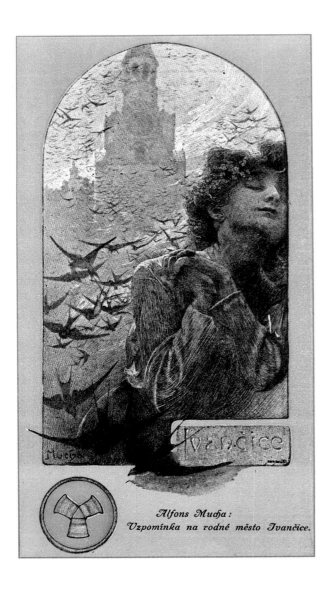

Ivancice
1909
Postcard in homage of his birthplace

Crane was very moved by Mucha's fervor. Since he knew about the social and political situation in Bohemia from Masaryk, he wondered whether the artist's mythical dreams could withstand reality. The philanthropist postponed his decision and left for a trip to Egypt.

Faithful to his habits, Mucha put the cart before the horse and resigned from the Art Institute. He sent Maruska back to Bohemia to look for an appropriate studio for the huge project that could only be executed in his native land.

His first contacts with fellow artists in the Czech capital were not good. The relationship that he had maintained in New York with the diehard Czech priest did not help matters and gave Mucha the reputation of being a somewhat sanctimonious conservative. "Because of your friendship with Father Prout," wrote the clear-thinking Maruska, "the Czechs have taken you for a reactionary. They are entirely wrong because you certainly are not. But today the clergy is the enemy of the people. Once, priests were the messengers of good tidings. You have been absent from Bohemia for such a long time that you cannot realize how much things have changed." The Czechs had indeed changed. They were tired of being considered as a second-rate nation and they burned with the desire to cast off what was left of the Habsburg yoke, even if it was no longer very heavy. The Church, however, was not so anxious to upset the applecart.

The construction of Prague's new Municipal Hall had just been completed in the purest Art-Nouveau style. The building housed exhibition halls, an auditorium, a restaurant, a café, etc. The mayor feared that the building's interior decoration would succumb to a certain Germanization imposed by the followers of a Movement of German and Austrian artists known as the Secession. Such concern was equally shared by Mucha, who offered to paint the decor himself. Firmly committed to his principles, he offered his work as a gift to the Nation, accepting no money, only the reimbursement of his expenses. As a result, when the Prague artists found out about Mucha's offer, they accused him of attempting to avoid the normal competition for this commission. They unleashed a slanderous campaign. "You just can't imagine the shameless attacks being made on you. They're dragging your name in the mud, and they laugh at your patriotism," wrote Maruska. The Municipal Council eventually arrived at a compromise: other artists besides Mucha would execute the decoration of the building.

The quarrel was at its height when Mucha took a second initiative that further provoked his fellow artists. With only *The Slav Epic* in mind and sure of Crane's support, he wrote to the mayor stating that he would donate his *Homage*

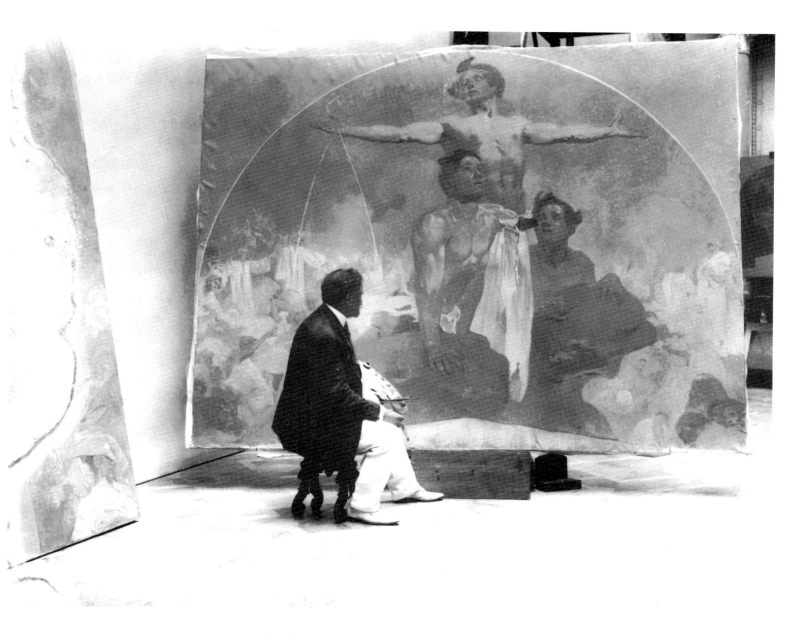

Mucha photographed painting for Prague Municipal Building
1911

Opposite:
Zdenka Cerny
1913
Poster for a European tour of the great Czech-
American cellist. The concerts were cancelled due to
the War
43¼ x 74⅜ in. (110 x 189 cm)

to the Slavs on condition that the city of Prague meet the costs of a building to house the works. Maruska wisely wrote to the American philanthropist to explain why Mucha's latest endeavor had only made the situation worse. In November 1909, she wrote to her husband: "The township is not well off, according to the mayor, and I am afraid that there will never be funds to carry out such a project... If they don't accept it, then you can't offer it to the Nation... Why did you stipulate the place where it had to be?" Mucha's adversaries were excited at what they considered a blunder.

"The main thing is to have the contract with Crane," thought Maruska. Probably Mucha felt the same way, being so sure of his luck. He calmed his impatience by executing a wood and plaster model of his future house in the country. This surviving maquette demonstrates that Mucha, the great devotee of Art Nouveau, had chosen a very simple structure adopting Adolph Loos' and Frank Lloyd Wright's rational principles of architecture. (Coincidentally, Loos was born only twenty miles from Ivancice.) Mucha imagined his family life in this house: "Near the forest but also close to town, a big garden with fruit trees, flowers, vegetables and, if you would like, sugar beets for the animals. We will raise our own poultry, have apples all year round and make our own jams and jellies. A tennis court, perhaps not, then everyone would come over and play." The projects for the interior decoration were much more luxurious. It was easy for Maruska to be carried away by her own dreams.

In 1909, Mucha was still toiling over the portrait of Mrs. Leatherbee with hopes that, once finished, he would be paid by her father. A new event was about to take place on Christmas Day at the Leatherbee house. In the American and English tradition, the chimney was decked with colorful stockings stuffed with presents. There was a big one with Mucha's name written on it and containing a telegram wrapped up in several layers of tissue paper, announcing: "Tell Mucha that all is well. Williams." (Roger Williams was Crane's secretary.)

Now, everything that the painter had hoped for his last years was about to come true. Soon, he received a first check from Crane for seventy-five hundred dollars. The same day, Mucha told the heroic Maruska that he had bought all the necessary material to begin his great project and that he wanted it to be honestly thought out and honestly executed. Immediately he wrote to his wife again: "Ten years of bad luck, after the World's Fair everything went downhill. In January, the climb uphill began. I would have paid dearly for the right to work in peace." He accepted a few more commissions, such as the decoration of the ceiling of a dining

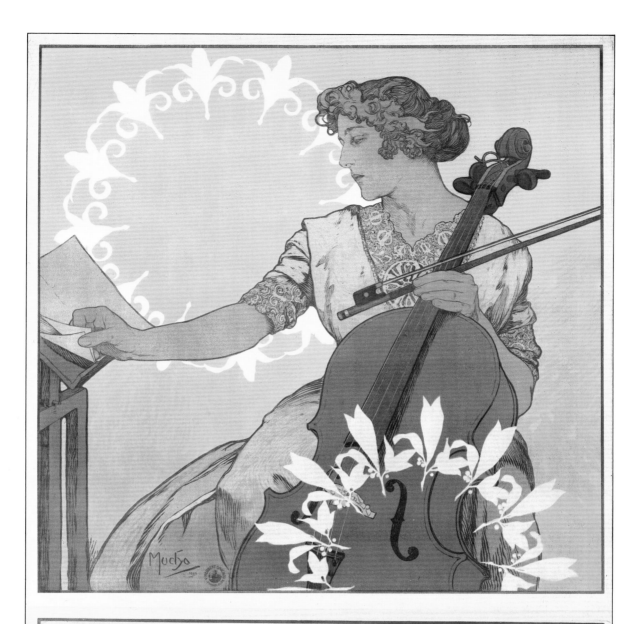

ZDEŇKA ČERNÝ

THE
GREATEST BOHEMIAN
VIOLONCELLIST

room for a grand hotel in Chicago, but this project fell through when the owners ran out of money.

PREPARING THE *SLAV EPIC*

Mucha was entirely absorbed with his project for *The Slav Epic*. He needed sufficient space to create this gigantic work. In 1910, he was invited to visit friends who were renting an apartment in Castle Zbirov near a forest filled with game. There, he found an unoccupied wing with exactly the proper light and space. The owner, Count Jerome Colloredo-Mansfeld, offered it to him and he continued to live there with his family for the next twenty years. It was a godsend for the artist to have discovered space where several canvases measuring 18 by 24 feet (6m x 8m) could be placed next to each other, where he could work on all of them at the same time. He had a scaffolding erected that allowed him to move from one work to another far above floor level. Maruska lived in dread of a fall.

He systematically sought advice from scholars, sociologist and experts on Slavic culture, and made a special trip to Paris to consult Ernest Denis, the great historian of the Czech people. His old friends, the academic painters Detaille and Clairin, insisted that he show them his latest work "to help them in their struggle against Cubism—because now everything is square."

Returning to America once more, he drummed up a few commissions, passed through Paris again on his way back home, only to leave immediately on a study-tour of the Slavic countries: Russia, Poland, Serbia and Bulgaria. Everywhere he traveled, by stage-coach or mule, with a sketchbook and camera in hand, he proselytized. He was determined to convert to his cause monarchs, artists, scientists and even monks in the most remote mountain retreats. This journey led to an amusing episode. In Montenegro, he asked for some cow's milk instead of goat's milk, but was told that the only cow in the country belonged to the Queen. The King got wind of his request and summoned him to court. Although a saying has it that "the same thing never happens twice," the clothing problem that he had experienced before the performance of *Gismonda* posed itself once again for his presentation at court. He had to borrow a tail-coat, could not find matching trousers to fit, and finally had to wear his own wrinkled ones that hardly appropriate for the occasion.

In spite of the sympathy bestowed on him by the Balkan Slavs, with their curved Turkish sabers, oriental slippers and embroidered shirts, he found them mere curiosities, just worthy of a wax museum. The courts of these

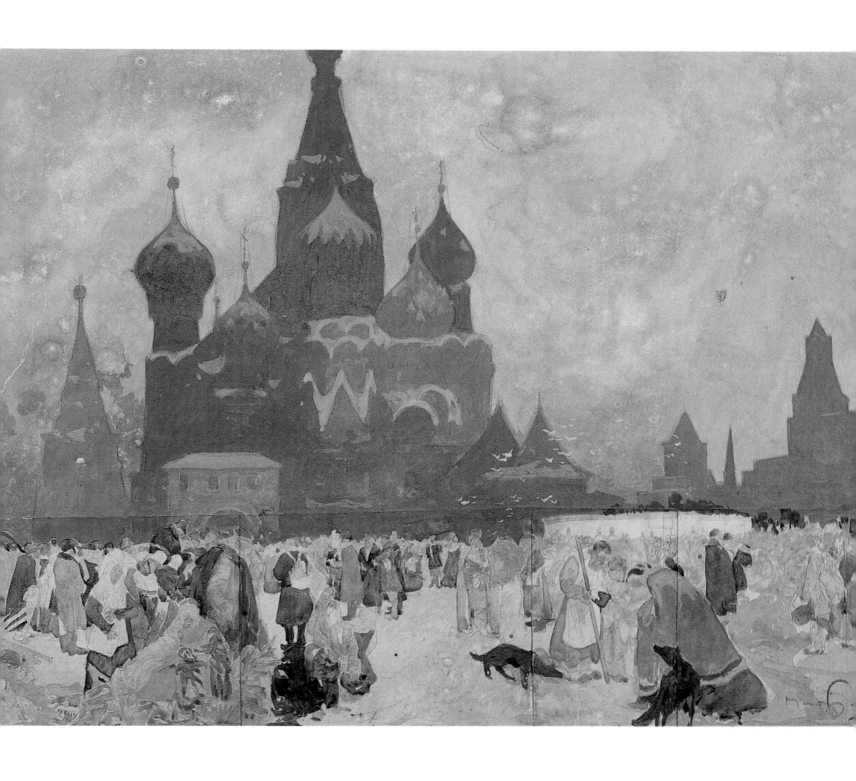

191

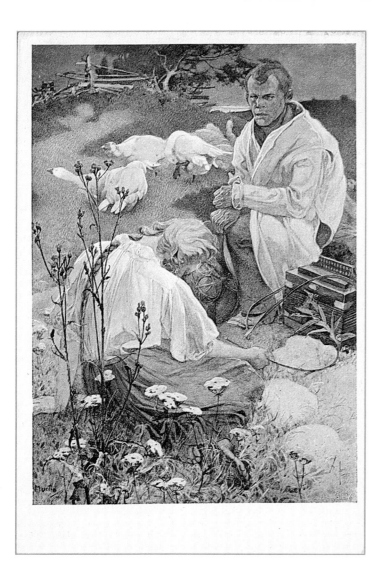

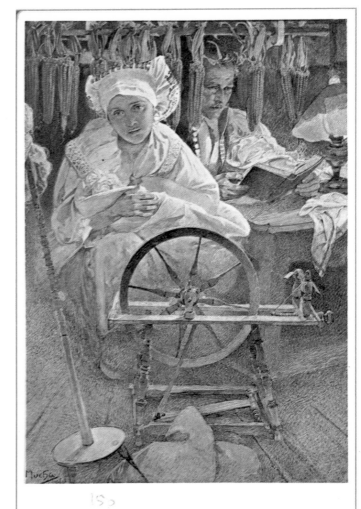

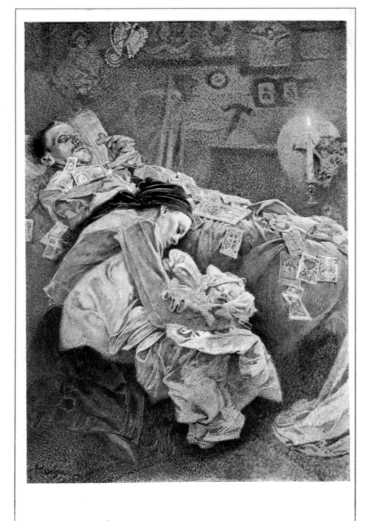

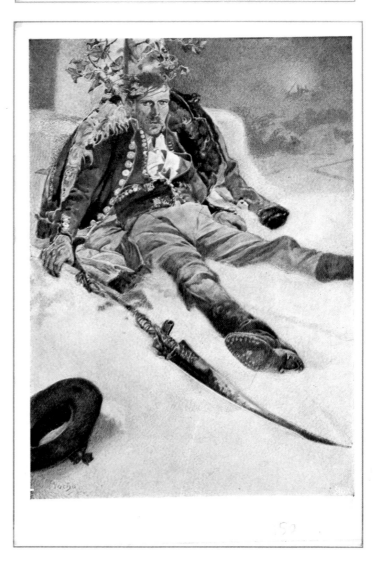

pompous little kings, still in full regalia and often of German origin, reminded him of scenes from an opera.

MOTHER RUSSIA

At last the gates of this old Slavic country opened to him, just as he had always imagined it: a world of golden domes, icons, ancient chants, troïkas and crazed pilgrims. In Holy Russia, he recognized his own origins; yet, it bothered him to belong to these masses and to move among them as a stranger.

He had much to report to Maruska: "Music and singing, all profoundly Byzantine and Slavic. It's like living in the 9th century. People kneel and pray, but do they know why they bow their heads all the way down to the ground? Are they in a trance provoked by so much glittering of gold and other bright colors? I watched two old women dressed in black aprons with red kerchiefs, their feet wrapped in bits of rag held together with string, wander about the church, peeping like thieves from behind the pillars, at times speechless with open mouths, gazing around, shaking their heads. Then, in ecstasy they approached the gold and silver iconostasis that portrays the haloed saints; gold everywhere, and the smell of incense. One of the old women joined her hands together and repeated over and over 'this is heaven, this is paradise.' Such is their religion: paganism from time immemorial. Nothing has changed for two thousand years. Only the names are a bit different." These comments are interesting. They were written by a man with a discerning eye and described an essential aspect of Russian culture at the beginning of the century. But more importantly they reveal Mucha's search to uncover the Slavic soul to better celebrate it.

The artist remained passionately involved in this difficult task and was oblivious to the disappointments that might be inflicted on him from the developments taking place in the Arts. Entirely immersed in his Slavic past, he did not realize that even in other parts of Russia new forms of art were evolving.

AN INEVITABLE FUTURE

Through a quirk of fate, yet another event turned the tide of destiny and launched Mucha into a new era. Back in New York once again to finish some work and to get back to Frances Leatherbee's portrait, not to mention catching up with his friends, he spent some time with a group of intellectuals in Greenwich Village. They gathered at the home of Mabel Dodge, a wealthy patron of the arts who kept open

Opposite
The Beatitudes
1906
Illustrations for
Everybody's Magazine, supplement to the December
issue, volume 15

Opposite left:
"Blessed are the poor in spirit..."

Opposite right:
"Blessed are those who seek peace..."

Opposite below left:
"Blessed are those who mourn..."

Opposite below right:
"Blessed are those who are persecuted..."

The artist at work
1896

house in Montparnasse as well as in New York. She was always at home for tea and liked to lead discussions on art, literature and philosophy. She put her words into action, however, and focused her energy on causes like freedom of expression, psychoanalysis, modern painting, poetry and birth control. Mucha enjoyed the atmosphere, the company and the conventional comfort of Mabel Dodge's salon. Over many cups of tea, an exhibition of contemporary art was organized due primarily to the determination of John Quinn. This brilliant and hard-working New York lawyer became one of the first and rare collectors of contemporary art along

with Gertrude Stein and her brother, who were both living in Paris at the time. Were it not for Quinn's generous donation, there would be no important paintings by Seurat in the Louvre Museum.

THE ARMORY SHOW

Artists from both sides of the Atlantic responded to the show with so much enthusiasm that the organizers found themselves with one thousand six hundred works on their hands. Mabel Dodge and her cohorts, who were never floored by any situation, quickly found a locale to exhibit the whole lot. They rented the 69th Regiment Armory on Lexington Avenue between the 25th and 26th Street. In just a few weeks they made the most of this inhospitable space by setting up partitions, arranging the lighting, installing sculptures and potted plants; then they hung the paintings. On February 17, 1913 the show was inaugurated and became one of the major milestones in the history of 20th-century art.

To be sure, the assembled works represented a totally incoherent selection of the art that had been created in the last ten years. As a sort of introduction, the first room was a survey of French painting from Ingres to Cézanne. In the company of the American artists' more conventional modernism, Cézanne still seemed like heresy. Going through room after room, even more controversial works emerged: Van Gogh, Gauguin, Seurat... It was perceived as a hall of horrors. Then came the supreme affront with the likes of Rouault, Matisse, Picasso and other Cubists, followed by abstract artists like Kandinsky and Delaunay. Marcel Duchamp's *Nude Descending a Staircase* provoked the public's utter indignation. This painting alone brought the Armory Show to the front pages of the daily newspapers. Nationwide, the local press published a caricature of the work that became a *succès de scandale*.

Mucha, who attended the opening in the company of the cream of New York High Society, described the event to Maruska: "It was extremely interesting: the best European art of the Futurists and Cubists. I had to stop in front of some of them to laugh. It's the affair of a group of cranks. A typical psychological phenomenon during periods of great change. The modern masters are changing from some inner necessity and the dabblers feel that they have to push their way to the front. They are stuck in eccentricity because they do not have their feet on firm ground. I was very pleased to have seen it all and my opinions have been made clearer. I was particularly happy about two things: that my American friends sent very fine paintings and that there is unanimity

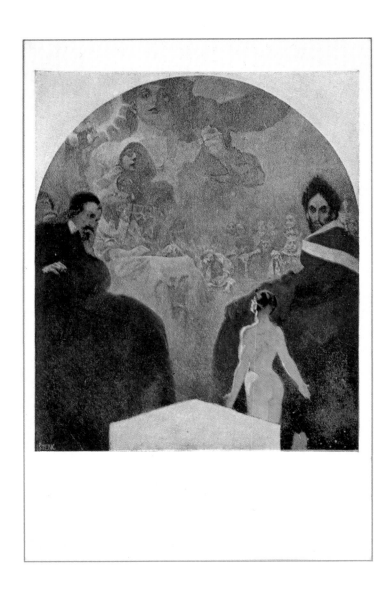 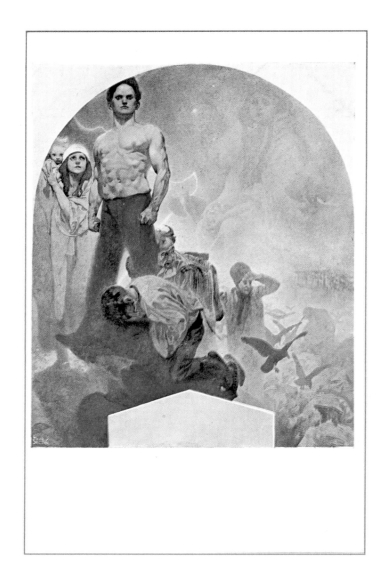

Murals painted for the Municipal Hall in Prague
1912
Postcards published for the inauguration
Above left: "Accept the love and enthusiam of your son, O Mother of the
Nation."
Above right: "Enslaved and tortured, you will rise again, O my Country."
Opposite above: General view of the hall
Opposite below: partial view of the ceiling

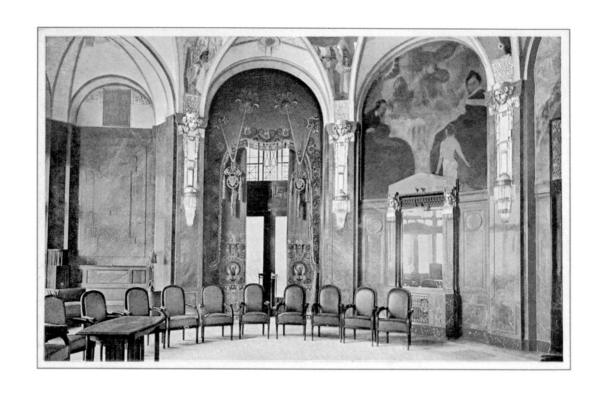

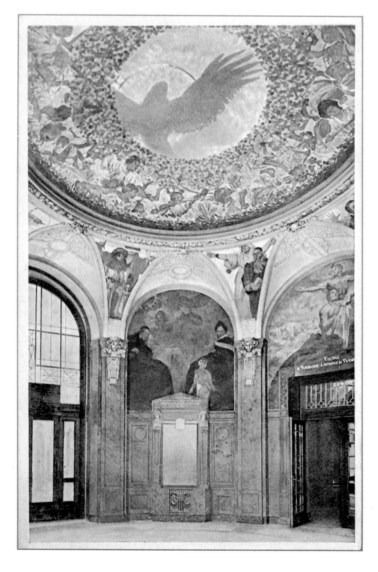

197

among artists, critics and the public that the "eccentrics" aren't even worth being made fun of..."

Mucha agreed with the indignation of such figures as the famous Italian tenor Enrico Caruso, or Louis C. Tiffany, the New York jeweler, and R. Cortissoz, the most influential critic; all three felt that Cézanne had been a complete dunce, that Van Gogh was a madman and that Picasso a total hoax.

Jiri Mucha never let his loyalty to his father dull his lucidity. Even with his father's letter in hand, he came to his own conclusions about John Quinn's remark on the disparaging criticism of the modern artists at the Armory Show: "Don't laugh old men, it is you who are dying."

Mucha, however, even if he was no longer in the mainstream of artistic life, was fully conscious of other realities. During the Armory Show in February, he gave a long interview to the *Chicago Examiner*. It was titled "Mucha, the world-famous artist is here to put the finishing touches on a portrait of Mrs. Leatherbee." After the usual comments, the article went on to quote his views on the state of the world: war was about to break out in Europe, and England and Germany would be involved in a life and death struggle for supremacy. Why was this dream-merchant spouting off about side issues? In retrospect, Mucha's foresight was prodigious even if the events did not come about for another year.

THE WAR YEARS

In anticipation of the outcome of the war, into which he put so much hope for his country, he went on working on his great task while continuing to design posters for local events like the Ivancice fair in 1911 and Prague's Spring Music Festival in 1914. In 1916, he designed the sets of a play, *The Court of Love,* written by a Czech playwright for the National Theater. Mucha never made any money from this work, because his various employers, once having obtained from him what they wished, would forget about payment.

In 1915, Maruska then thirty-five, bore him a son, Jiri. A year later, when a teaching job became vacant at the Prague Fine Arts Academy, it was not offered to him because the authorities in Vienna felt that he did not show warm enough sentiments towards the Habsburgs. Now and then a suspicious Austrian official would come to see his paintings and ask him what they stood for. Mucha got away with it by saying that they were "fairy tales." Soon, however, he thought it wise to have metal cylinders made so that he could roll up the canvases and hide them in the park each time a visitor was to come.

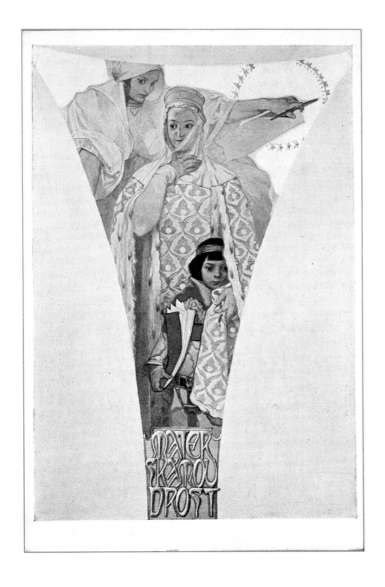 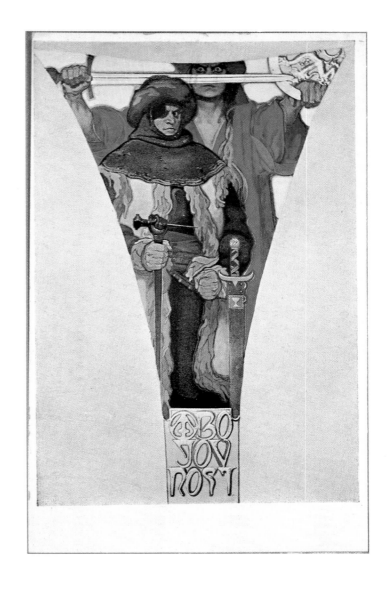

When the allied victory became imminent, he decided to put himself at the disposal of the new State. At the same time he pledged not to accept payment for any work for his Nation. Even before the end of the hostilities, he was asked to make sketches for postal stamps. As soon as the design for the ordinary postage stamp was selected, he was asked to have it ready within twenty-four hours. Stamps with other rates had to be finished within three days. Then he started designing the different bank notes, using his own daughter's

Murals for the Municipal Building in Prague
1912
Postcards published for the inauguration
Above left: Mother Love
Above right: Combativeness

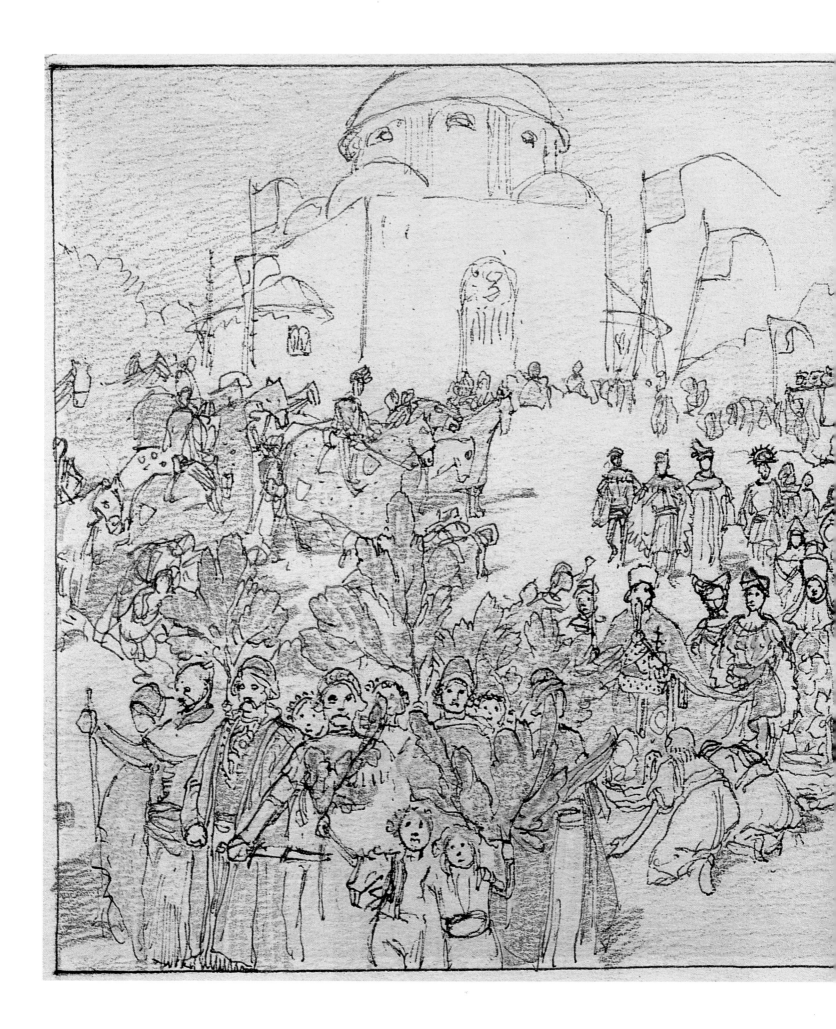

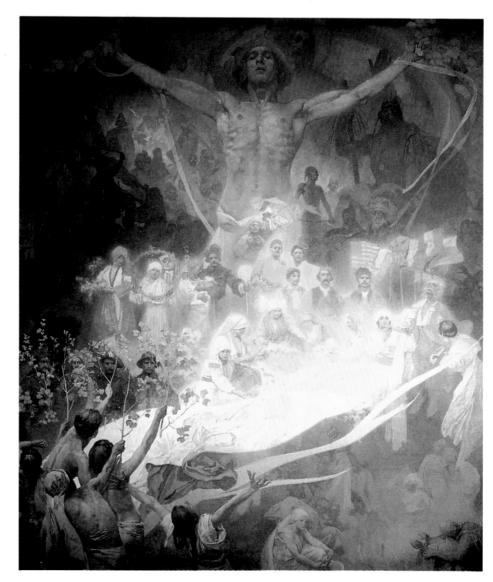

The Apotheosis of the Slavs
1926

Opposite:
**The Coronation of the Serbian Tzar Stepan Dusan
in 1346**
1925
Ink and pastel on paper
4¼ x 5⅛ in. (11.5 x 13 cm)

head as model for the reverse side of the bills. Besides postage stamps and paper money, Mucha created many other items for young Czechoslovakia, ranging from the national emblem and the stained-glass window at Saint Vitus's Cathedral, to police uniforms.

SLAVIC MISSION

In Mucha's mind the long-awaited birth of free Czechoslovakia was of great significance, even greater than his *Slav Epic*. In 1919, at the inauguration of the seven first paintings of this work in Prague, he made a long speech. He argued that the Latin and Germanic peoples had achieved their objective of developing a European spirit. It was now up to the Slavs to make humanistic and social ideals triumph thanks to their own renewed vigor. The show was a great success. The public was more impressed by the forthright significance of the works than by their form. However, young intellectuals and artists who belonged to avant-garde tendencies found the paintings too realistic and felt that they carried a message of common chauvinism.

At the end of the exhibition, the eleven paintings were sent to the United States. John Quinn's prediction was coming true, but the American public, still eager for Art that they could "understand," fortunately loved the show. In January 1921, after Chicago, it moved to the Brooklyn Museum in New York, where it was greeted by six hundred thousand visitors. The directors of the Museum had intended to charge an entrance fee, but the artist refused any thoughts of having the public pay to see his *Slav Epic,* much to Maruska's dismay. The critics declared that only Puvis de Chavannes' frescoes at the Panthéon in Paris could be compared to these eleven paintings, and Mucha's were considerably better. This favorable review brought in many commissions. Mucha thus spent two more years in America and Maruska returned home to Bohemia with the children. In his letters, Mucha listed the commissions that he had accepted and those he would not do. Rather than design the covers of *Cosmopolitan*, he preferred to do those of *Hearst Magazine*. All 1922 issues of the biggest monthly periodical appeared with covers by Mucha. They demonstrate that the artist had lost none of his inventive qualities nor his graphic talent with its supple character, but they did not resemble his earlier "Mucha Style" (except the poster for the Brooklyn Museum exhibition). After completing this work, he returned to Europe in March 1921, with the conviction that he would soon be right back in New York. From the *Aquitania*, his favorite transatlantic steamer, he wrote to Maruska to say that

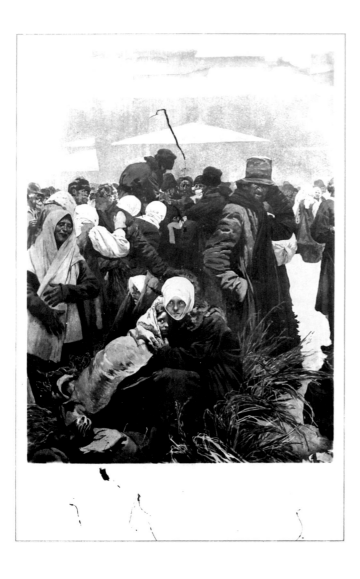

The Abolition of Serfdom in Russia
1914
Postcard-size reproduction
of a detail from *The Slav Epic*
for the 1928 exhibition

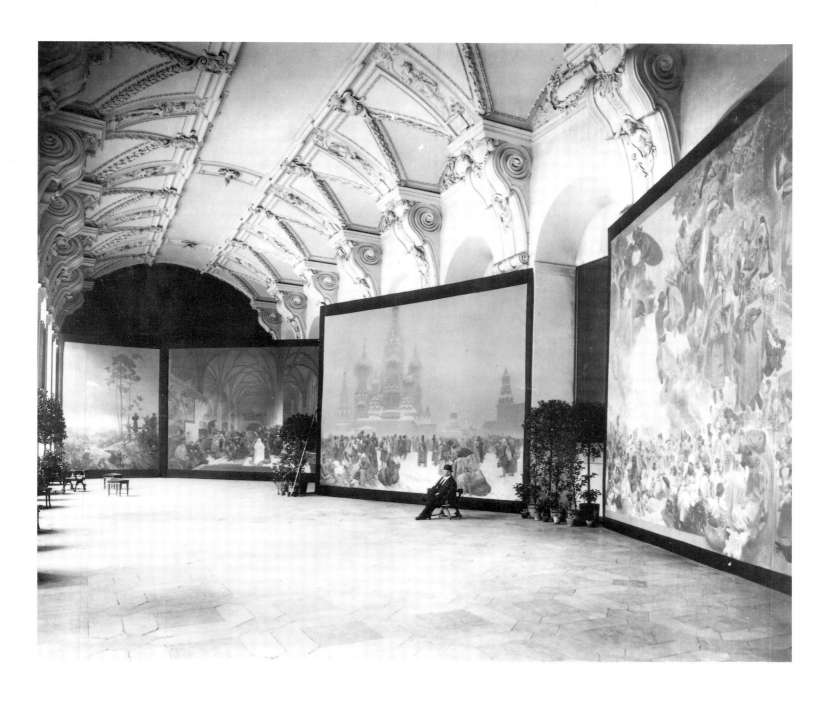

Mucha seated in front of *The Slav Epic,* at the vernissage of
the first eleven paintings of the series, Clementium, Prague,
1919.

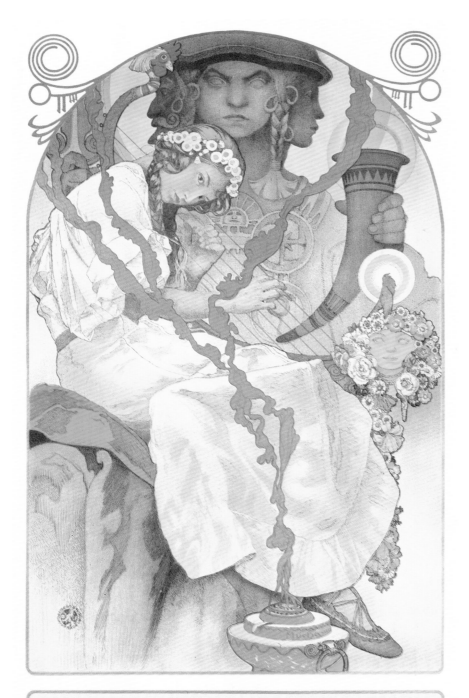

The Slav Epic
1928
Poster for the first exhibition
$31^{7}/_{8}$ x $72^{1}/_{4}$ in. (81.2 x 183.6 cm)

Opposite:
VIIIth Sokol Festival in Prague (1926)
1925
Poster for a grandiose demonstration on the
theme of Czech history

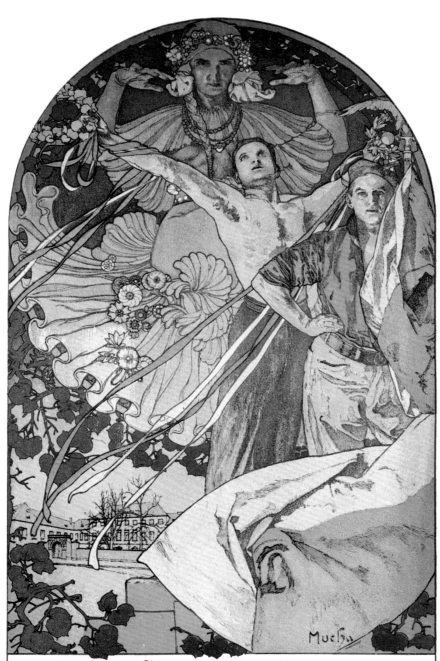

VIII SLET VŠESOKOLSKÝ v PRAZE 1926
SLAVNOSTNÍ HRA
❀ NA VLTAVĚ ❀
SLOVANSTVO BRATRSKÉ

Dle námětu br. Karla Hlavy a br. Alfonse Muchy napsal br. Fr. S. Procházka. – Hudbu složil br. Lad. Prokop. – Výtvarná část: br. Alfons Mucha a br. Lad. Šaloun. – Režie: br. Emil Pollert, Jos. Gotlieb a univ. prof. Niederle. – Hudbu řídi br. Prokop Oberthor.

DNE 3. 4. 5. a 6. VII. 1926 v 9 hod. večer.
VSTUPENKY: Kč 15·⁻, Kč 10·⁻, Kč 5·⁻, Kč 3·⁻.

EDICE UMĚL. TISK. NAKL. JAN ZIEGLOSER PRAHA XII–1093.

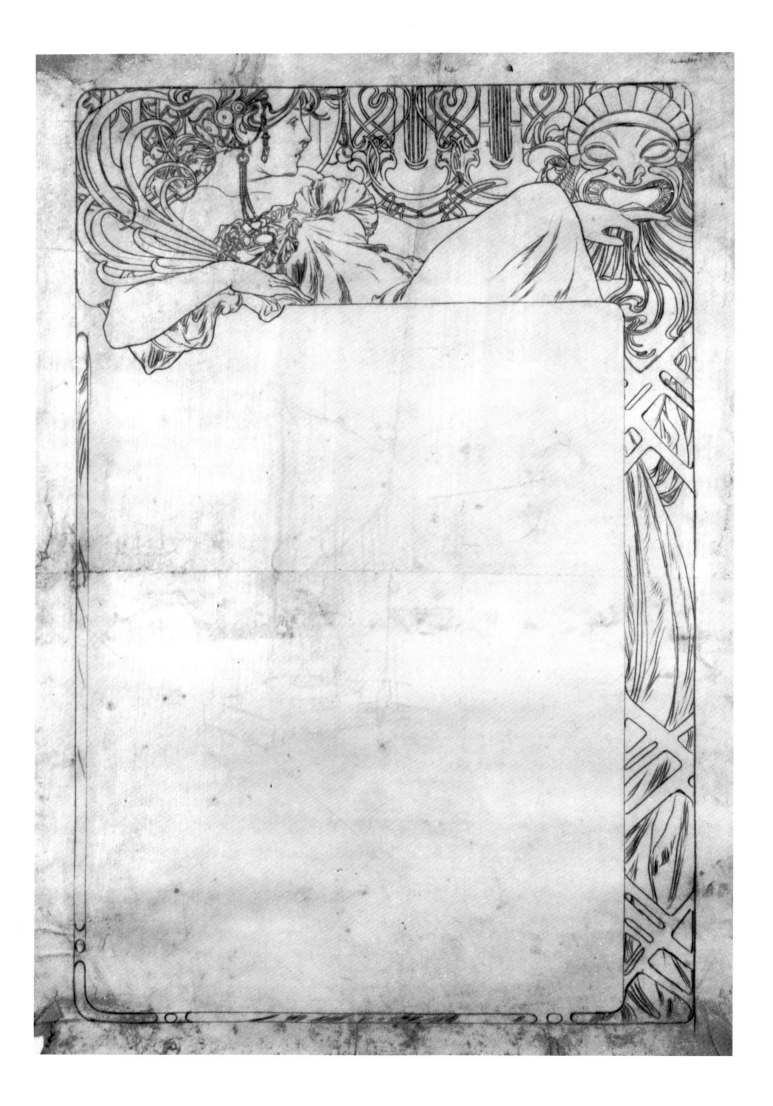

CASINO DE MONTE CARLO

MERCREDI 29 MARS 1922
à 3 heures de l'après-midi

CONCERT CLASSIQUE

SOUS LA DIRECTION DE

M. Léon JEHIN

Maître de Chapelle de S. A. S. le Prince de Monaco

AVEC LE CONCOURS DE

Mme Madeleine MOUSSON, Cantatrice
M. G. MARCELLO, Basse

1. **Symphonie en Si bémol** (N° 4) **BEETHOVEN**
 a. Adagio molto vivace. — b. Adagio.
 c. Allegro vivace. — d. Allegro non troppo.

2. a. **Air** de **Don Carlos** **VERDI**
 b. **Idéale**, Mélodie **P. TOSTI**
 M. G. MARCELLO.

3. **Prélude à L'Après-Midi d'un Faune** . . **DEBUSSY**
 (D'après MALLARMÉ).

4. a. **Air** de **Didon** **PICCINI**
 b. **Air** d'**Alceste** **GLUCK**
 Mme Madeleine MOUSSON.

5. **Polonaise en Mi majeur** **LISZT**

Au piano : M. Louis NARICI

PRIX DES PLACES : **5** francs Imprimerie de Monaco

ROBAUDY - CANNES

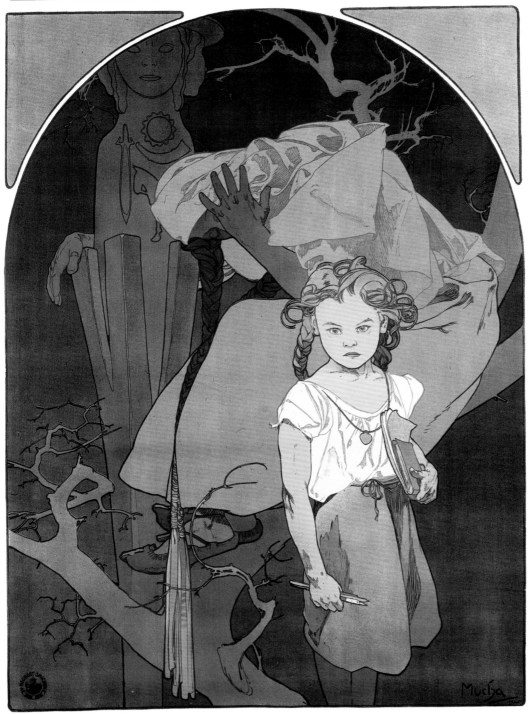

Preceding pages:
Monte Carlo
1897
Sketch for an omnibus poster for the Casino
21¹/₂ x 30³/₈ in. (54.6 x 77.2 cm)

The Monte-Carlo Casino Concert Advertisement
1922
Frame for a poster
21¹/₂ x 30³/₈ in. (54.6 x 77.2 cm)

Opposite:
Lottery
1912
Poster to promote lottery ticket sales for the construction of
schools in Moravia
39³/₈ x 74¹/₂ in. (100 x 189.2 cm)

an important movie company wanted to make a film of his *Lord's Prayer* and that he was working on the subject during the crossing hoping to send the filmmaker a script upon arriving in Cherbourg. For one reason or another, this project did not materialize and Mucha was never again to leave Europe.

He set off anew on a trip to the Balkans to visit the secluded orthodox monasteries of Greece. Nothing could deter him from trying to assimilate the traditions of his nation in most minute details. His vivid recollections of a visit to Mount Athos are depicted in a scene bearing this title. It is considered one of the most successful of the series.

Besides his studio in Zbirov, Mucha also had one in Prague to paint works of normal dimension and design or photograph his models. One of these women, who later married in the United States, was so spiritually in touch with Mucha that when one of the two picked up the telephone to call the other, the one about to receive the call would already be on the line. Maruska had a word to say about this relationship. She was not happy either about the intimacy that her husband was entertaining once again with fortune-telling and occultism.

ART AND POLITICS

In September 1928, *The Slav Epic* was officially donated to the City of Prague though Mucha continued to work on it until his death. The response was mixed. Many connoisseurs saw in it merely a gigantic chronology of Slavic history. *The Slav Epic* was a romantic idea that would have been more suitable to the historical context of 1848, at the moment of the Czech Renaissance. For this reason it was not well received or well understood in spite of the artist's sincere efforts. Soon political issues became involved. On July 27, 1935, *Rudé Pravo,* the official organ of the Communist Party devoted an entire article to its seventy-fifth anniversary. The author criticized the monumentalism of the work "measured in meters" and declared that it lacked reality, and that this string of paintings could only benefit the *bourgeoisie.* The traditional right wing, of course, was satisfied with the patriotism expressed in the work. In 1936, however, it was the publishers of a socialist newspaper who embarked on a campaign to have *The Epic* housed in a locale worthy of its subject-matter and its artistic qualities. World events had quickened. In Paris it was considered good form to show interest in the art of a country born under the protection of France a large exhibition was organized at the Jeu de Paume Museum in June 1936. In rather incongruous fashion, it

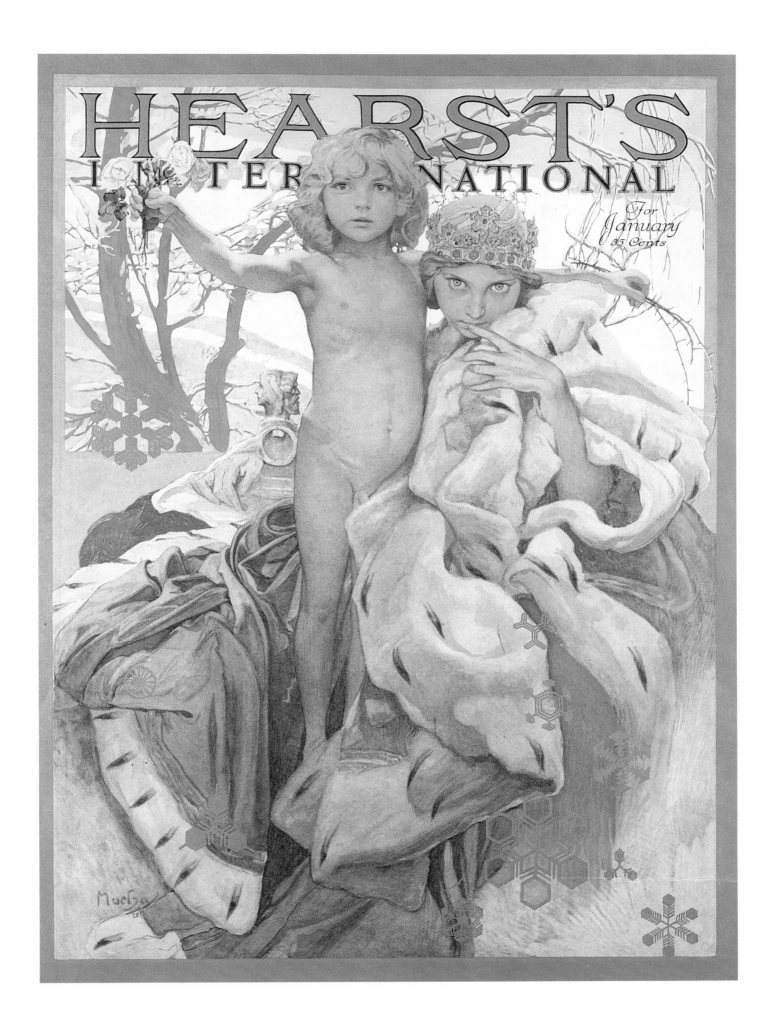

showed Mucha's work next to that of Kupka's; it must have seemed more diplomatic to display the quality and the diversity of the art of a friendly country. However, it certainly didn't make the slightest impression on Hitler.

On March 15, 1939, German troops entered Czechoslovakia and Mucha was one of the first to be questioned by the Gestapo. The artist, suffering from pneumonia, was released after an interrogation by Nazi policemen, still feeling their way around during the first days of the occupation. The fascist press was already treating Mucha as a "flunky of the Jews and the Free-Masons." In May, after the Germans took over Prague, the "authorized" newspapers announced that the population had to exchange the fifty-crown bills that were being taken out of circulation. They went on to say that the designers of these bills were being put in prison because the man in the center of the bill was not an Aryan, that the hammer and sickle was a sign of Bolshevik leanings, and that all this had been done to discredit Czechoslovakia in its relations with foreign countries.

LAST MOMENTS

Still suffering from his lung infection, Mucha could no longer work. He had not given up hope and was prepared to write his memoirs, convinced that the country would recover its freedom.

Jiri fled to Paris and stayed at the Rue Val-de-Grâce studio which his father had always kept. He was trying to raise a Czech legion when he received word of his father's death on July 14. His mother, Maruska, twenty years younger, lived on until 1959.

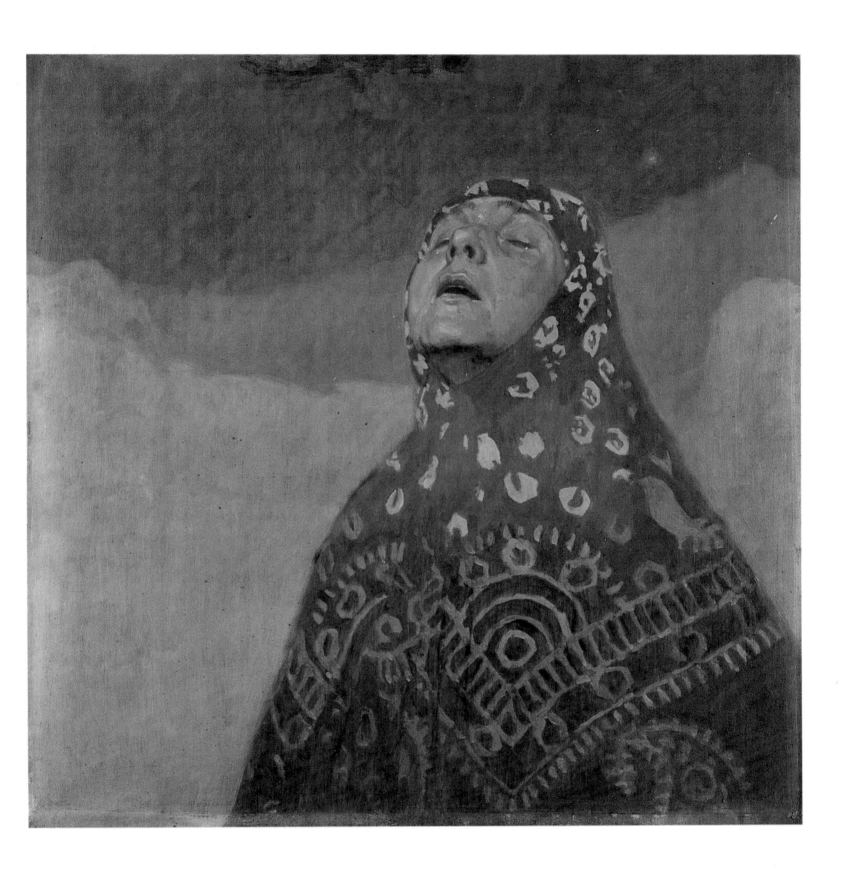

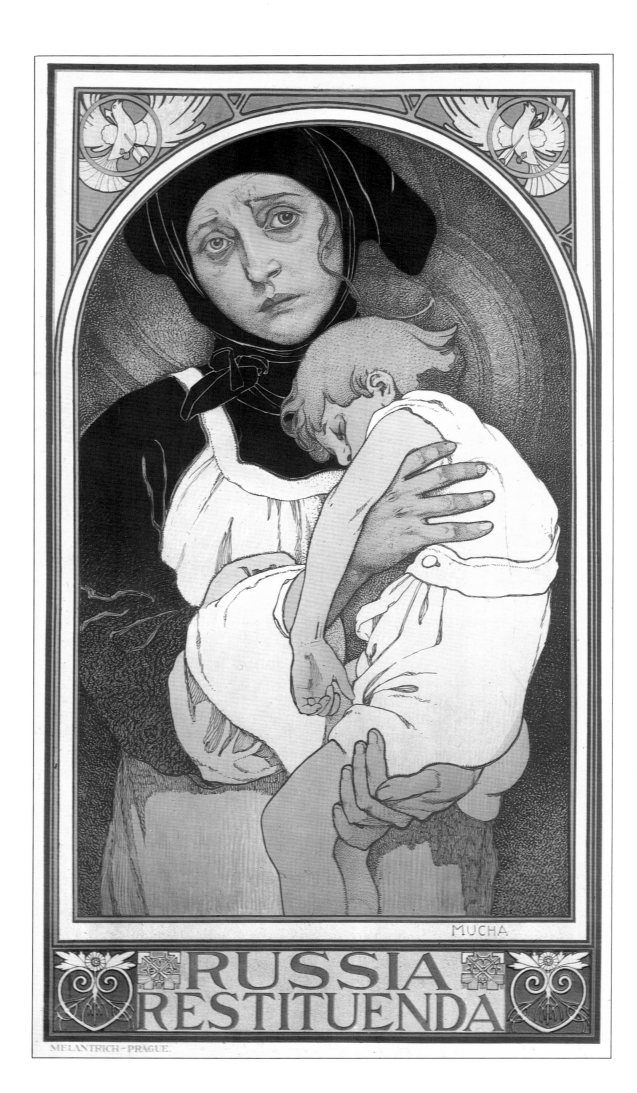

RUSSIA
RESTITUENDA

De Forest Phonofilm
1927
Poster for the presentation of one of
the first musical sound films at the
Adria Theater in Prague
29⁷/₈ x 60³/₈ in. (76 x 153.5 cm)

Opposite:
Russia Restituenda
1922
Poster to aid starving Russian
children
17⁷/₈ x 31³/₈ in. (45.7 x 79.7 cm)

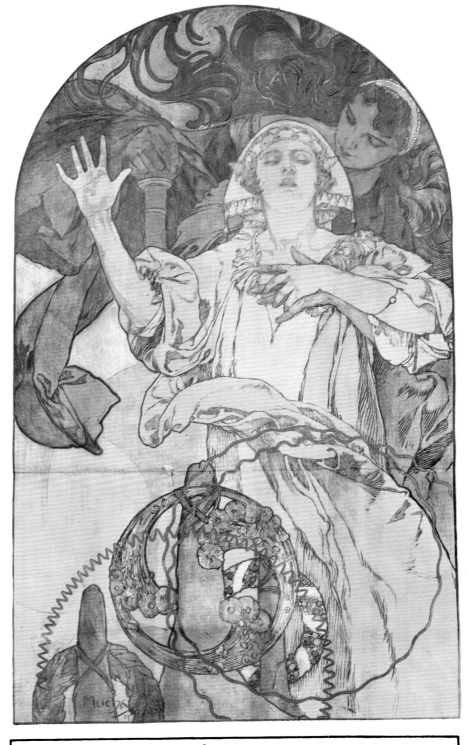

MEZINÁRODNÍ VÝSTAVA SLEPECKÉHO TISKU
V PRAZE II., VORŠILSKÁ.
POŘADATEL: SPOLEK ČESKÝ SLEPECKÝ TISK V PRAZE.

INTERNATIONALE BLINDENDRUCKAUSSTELLUNG
EXPOSITION INTERNATIONALE D'IMPRESSION DES AVEUGLES
INTERNATIONAL EXHIBITION OF PRINT FOR THE BLIND
MOND-EKSPOZICIO DE BLINDULA PRESO.

8./V.–31./V.1935.

VSTUPNÉ 2·-Kč STUDUJÍCÍ, VOJSKO A DĚTI 1·-Kč

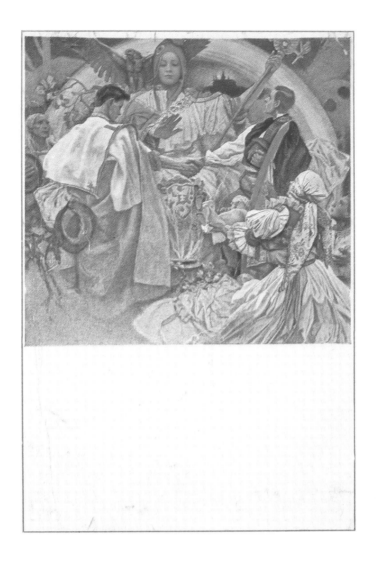

Reconciliation of the Czechs and the Slovaks
1928
Postcard reproducing the illustration of a calendar in
commoration of the tenth anniversary of the founding of
Czechoslovakia

Opposite:
Thanks from the Blind
1935
Small poster for an international exhibition
13³/₈ x 19¹/₂ in. (34 x 49.5 cm)

† 14. VII. 1939.

Alphonse Mucha photographed in his rose garden.
1939
Last photograph of the artist, published as a memorial postcard after his death on July 14, 1939

Opposite:
Jaroslava
1920
Portrait of the artist's daughter
Oil on canvas
$28^{3}/_{4}$ x $23^{5}/_{8}$ in. (73 x 60 cm)

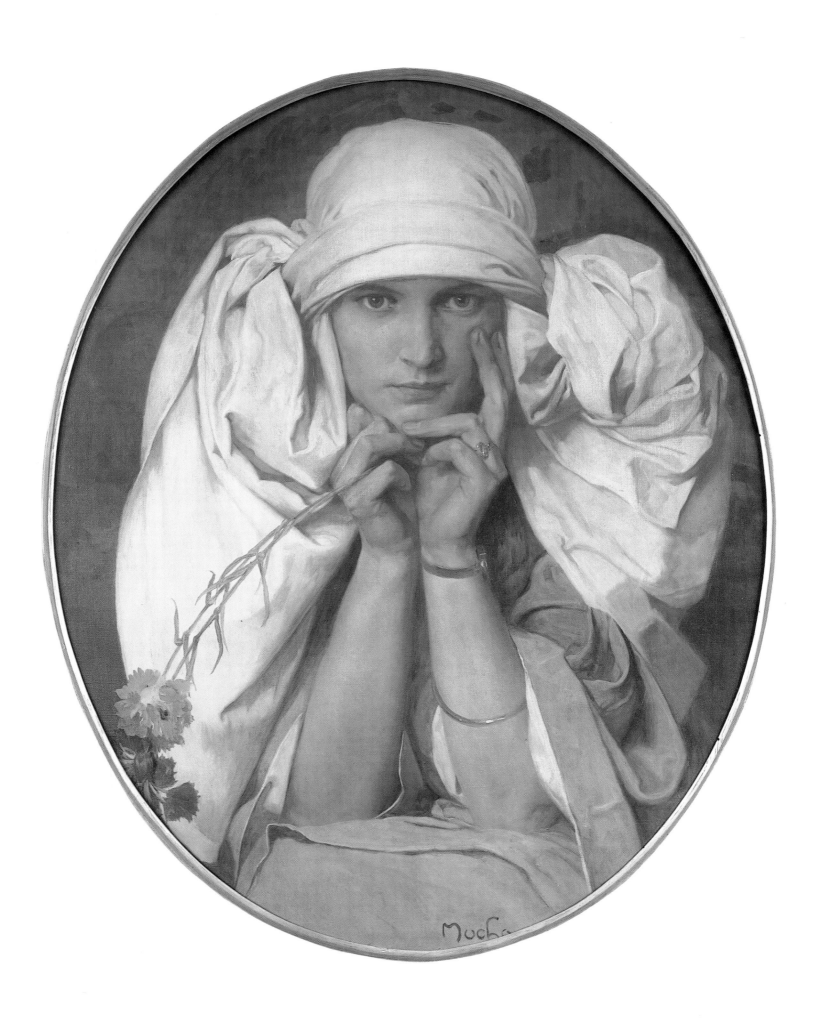

Mucha's house in Prague in 1992

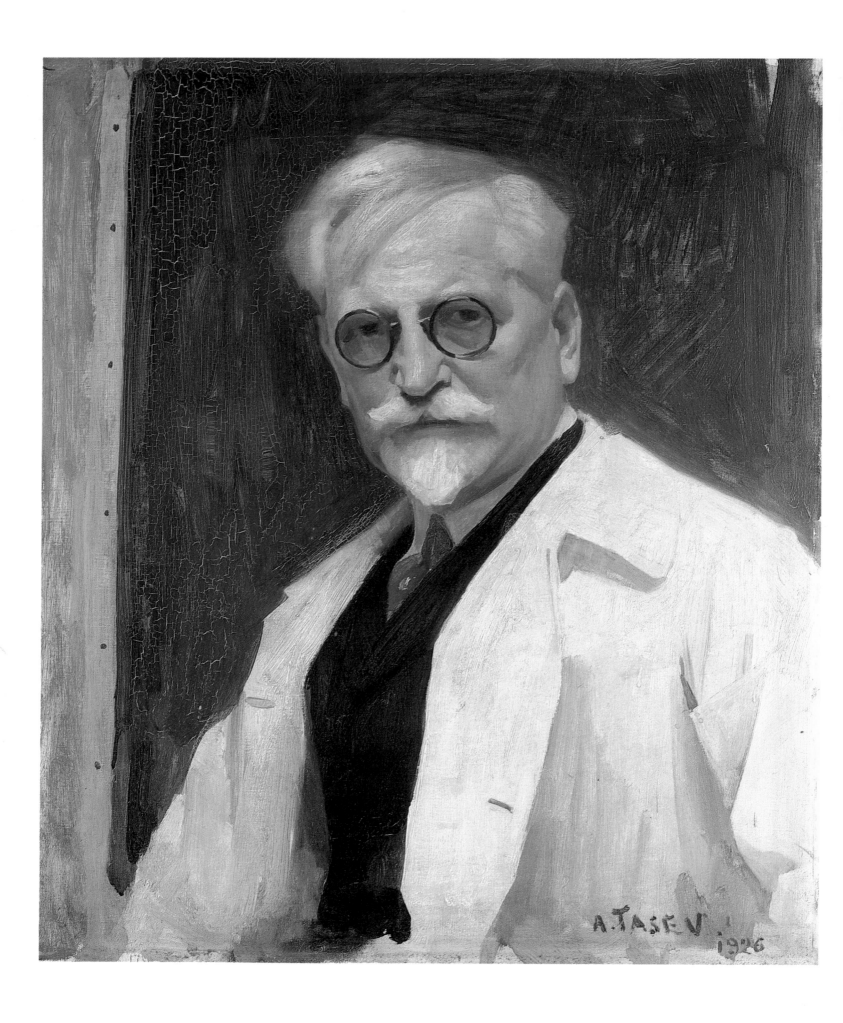